Someone With Me

Someone With Me

The Autobiography of
William Kurelek

McCLELLAND AND STEWART

The Canadian Publishers
McClelland and Stewart Limited
25 Hollinger Road
Toronto M4B 3G2

CANADIAN CATALOGUING IN PUBLICATION DATA

Kurelek, William, 1927-1977.
 Someone with me

ISBN 0-7710-4564-6

1. Kurelek, William, 1927-1977. 2. Painters –
Canada – Biography. I. Title.

ND249.K85A2 1980 759.11 C80-094081-4

Printed and Bound in Canada

FOREWORD

About six months before my late husband, Will, died of cancer in November, 1977, I noticed he was spending more and more time writing instead of painting. He was doing so much writing, in fact, that I asked him if he was thinking of changing his career. To my surprise, he replied, "I don't know yet."

Perhaps he drove himself so hard because he wanted to see this autobiography published in his life time. I suspect that by the time he had finished the final draft towards the end of July, he had had a premonition of the seriousness of his illness.

I do know that he wanted this book to help others find peace of mind as he had. He firmly believed that the true story of his conversion to Catholicism after his hospitalization would inspire others with hope and perhaps joy. Since that time, in one way or another—in his paintings, his public talks, and now in this book—he has been trying to bring this message to anyone who would listen.

His commitment to this cause can best be illustrated by a note I came across while going through his papers. Referring to his desire to avoid in any sense blaming his parents, he said:

> As a matter of fact, until recent years, I even concealed my stay in psychiatric hospital and my suicide attempt at my parents' request. But eventually, Dr. Carstairs, who was once my doctor and now is one of Britain's leading psychiatrists, persuaded me I'd be doing more good to more people if I told the story as it really was.
>
> I do apologise to my parents and the rest of the family for the hurt they may get from this book. On the other hand, if this blanket apology hurts even more, appearing to be hypocritical, then I don't

apologize. What I'm trying to get across here is that I am prepared to do anything short of not publishing this book at all in order to avoid hurting anyone.

I would like to thank Dr. James Maas, whose original printing of the autobiography for his psychology students at Cornell University gave Will the impetus to rewrite his story. I am also deeply indebted to James McConika, C. S. B. , Donald Finlay, C. S. B. , Dr. Raymond Shady, R. M. Schoeffel, and Mrs. Helen Cannon for their guidance and counsel. Finally I wish to thank Max Layton, the editor, who had faith enough in this book to encourage its publication.

Mrs. Jean Kurelek
Toronto
December, 1979

CHAPTER ONE
The Maze

The year 1955, when I was twenty-eight, was the turning point of my life. I had gone over to England in 1952 with two express purposes. One was to complete my art schooling – at that point in my life I was already convinced my vocation was to to be an artist – the other was to get into a hospital where I might find a cure for my chronic depression and my inexplicable eye pains. I eventually ended up in Netherne Psychiatric Hospital, high on a hill overlooking the Brighton road, just south of London. On a clear day, from the top of this hill, I could see two other large psychiatric hospitals tucked into the wooded valleys on either side. It was here that serious mental and emotional misfits were shunted. I hadn't been shunted. I had freely chosen to admit myself as an inmate.

I am obliged to point this out because even in our enlightened age there is a tendency to think that anyone who has been in a psychiatric hospital must be "mental." Depressed, unhappy, emotionally disturbed, yes; mental, no. In fact, there were many patients in there who were not mental at all in the demeaning sense of the word. But knowing what people would think, I kept my hospitalization a secret for many years upon my return to Canada. It was only later, when I realized that I could help a lot of unhappy people, that I decided I would tell my story as it really was. The important thing is that this story has a happy ending. I eventually did come out of Netherne to lead a normal and successful life in society. But more than that, while I was there I found a purpose and meaning for my life, something which I had been searching for during all my many years of unhappiness, often without realizing it.

In telling you this story, I will have to be quite open. Actually I have no choice but to be quite open because I'm not a good writer. Yet I still think the whole story should be told. My one hope in holding your

7

interest lies in my belief – to vary a phrase – that truth is often stronger than fiction.

* * *

I still remember with gratitude how quickly and sympathetically the English people took me under their wing when, in 1952, I turned up at Maudsley Psychiatric Hospital in London. Although only a day had passed since my ship had docked in England, there was no difficulty whatever about the fact that I was Canadian. I had decided on Maudsley while still in Montreal, having found its name in a library book listing English institutions. To my amazement, within minutes I was being interviewed by a doctor. That doctor arranged two very important things for me: one was temporary lodgings near the hospital and the other was a definite date for me to move into the hospital for observation. During those pre-hospital days I began a half-hearted search for an art school in London. I guess my half-heartedness could be traced to my attention-starved childhood for, in art school, I would also have to compete for attention and I wasn't sure I was talented enough to deserve it. In the hospital I was guaranteed attention, albeit clinical.

Iris Lorraine, my first English landlady, gave me a great deal of affectionate non-clinical attention. When I appeared at her door in the lush Forest Hill district of London, I discovered her place was not a house but a flat. She was only thirty and looked even younger, more like twenty-five. She had a graceful spring to her step caused by the fact that she was an ex-ballerina. I had worshipped ballerinas as elusive, fairy-like creatures since my university days. There was nothing elusive about this one however. In next to no time she had confided to me that she was a widow of five years. Her husband's death had been such a shattering experience that she had barely pulled herself together with the help of her religion and by throwing herself into her new work as a nurse.

She also confided that she had a yearning for children of her own and sometimes it seemed to me that much of the attention she showered on me derived from that desire. For instance, no less than fifteen minutes after our first meeting, my hand had unconsciously gone up to my face to pick a lesion. "Don't do that!" she snapped and slapped my hand. I was shocked at her familiarity and yet at the same time pleased with my composure in facing the petty humiliation of it. It even got to the point, which I resented, where she was preparing my bath and fussing

about whether or not I'd shined my shoes.

I was only paying her for the room. When I ate out, if at all, it was at the local government restaurants. I didn't dare mention the even cheaper "tea room" which I frequented near the Forest Hill Electric Railway Station. Gradually, however, she formed the habit of bringing me coffee during the day, then biscuits with the coffee. Finally she was giving me whole meals at her own expense. Her hospitality was embarrassing but she wouldn't listen to my protests and I was too poor and too grateful to protest too much. She did my ironing, took me for walks around Forest Hill and introduced me to people who might help me get into art school. She explained her strange familiarity as a reaction to her husband's untimely death.

One familiarity which made me apprehensive because it was so physical was her occasional request that I massage the back of her neck. Sometimes on her evening visits to my room she would read me her own efforts at writing poetry. Finally, one evening, she brought me one of her religious books. At the time I had no use for religion whatsoever. As I held that booklet in my hand, trying to think of a nice way to suggest she take the thing away from me, she suddenly blurted out that her husband had killed himself. Then, without another word, she turned and plunged out of my room into her own. I could hear her sobbing through the wall but I didn't know what to do. An hour or so later, she brought me a photograph of the two of them taken early in their marriage. Serious and close human relationships were woefully foreign to me, and I handed the picture back to her without a word after I'd stared at it a long time searching in vain for something appropriate to say.

But there was a gay, roguish streak in her too, which eventually made it hard for me to part with her. For example, in the very week of her sad revelation, while we were walking along the side of Forest Hill which overlooks the main city, we noticed that a man was standing on the path focusing his binoculars on the panoramic view. Well, she stopped in front of him so that all he could see was the back of her head while she pretended to be pointing something out to me. I could see it was deliberate because of the twinkle in her eye. This playfulness made it possible for us to rib each other and be so chummy I began to fear I was falling in love with her. My head told me I should marry a Ukrainian girl, but such a concentrated dose of closeness with this English woman was weakening my resolve.

In one of my hospital entry interviews I expressed concern about the

9

situation. The doctors suggested I follow my common sense: Iris' being five years older than me stood out as the most cogent reason to part company with her. I couldn't tell her that in so many words, so I got around it by telling her what was true anyway – that I was soon to enter Maudsley as an in-patient. Her big round eyes blazed at the news. She insisted there wasn't a thing wrong with me that I couldn't handle myself. According to her, I was "quite normal." Normal or not, the fated day of parting arrived. When she saw me emerge from my room with suitcases packed, she grabbed them and wouldn't let go. I tugged in one direction, she in the opposite. Exactly how that tug-of-war ended I can't recall, but she finally had to let me go.

At Maudsley I was given a bed in a general dormitory in the men's wing of the hospital. Ours was a motley assortment of mostly young men like myself and a casual observer of our bunkhouse camaraderie, especially in the morning when the cry, "Wakey, wakey, rise and shine!" went up, would have said there was nothing abnormal about any of us. Still something, however secret, must have brought each of them there for observation. We ate together in a common dining room on our floor. There were actually four meals because of the English insistence on "tea time." Everyone had to help with the chores, washing dishes and polishing floors. I pitched in willingly because I suspected these tasks were designed as items of observation, revealing a patient's degree of withdrawal from reality. I was sure that the ward orderlies and maintenance staff were really spies for the doctors. We were also watched at the socials: dancing, for example, revealed our reaction to physical contact with the opposite sex. Then there were sports, some with more body contact than others – tennis, field hockey, cricket. Every day except Sunday there was occupational therapy.

Actually the reason Maudsley was a comparatively lively place, as far as mental hospitals go, is that it was a training hospital for psychiatrists and psychologists. The patients were migratory birds, too. If their trouble was serious they'd be sent to more permanent institutions on the outskirts of the city. On the other hand, those with minor problems would be treated at Maudsley or often released with instructions on how to cope on their own. Ken Staunton, the first friend I made there, and Frank Edwards, both belonged to the second category. I, as it turned out, ended up in the first.

My doctor's name was Dr. Charatan. Ken, who took a dislike to him, renamed him "Dr. Charlatan." I saw him once a day, sometimes every

second day. He started off with a complete medical checkup of my body and nervous system, which reminded me of the ones I'd received from the nerve specialists back in Winnipeg. Then he did a little psychoanalytical probing of my sex life. Eventually, we got round to tackling my eye trouble. By sheer coincidence, the evening before I had dipped into a medical journal in the reading rack on our ward. There I found an article on psychosomatic illnesses and, as I read it, I came across the flat statement in italics that psychosomatic eye pain could never actually cause its victims to go blind. I told Dr. Charatan about that article the next day and he said, "Yes, that's quite true." Within an hour the pain had disappeared! I did a lot of paintings in that hospital, many with fine detail, but there was no eye pain. I was exultant.

Each of the two patients I became friends with had his own peculiar British characteristics. Frank was an out-and-out hedonist as well as an intellectual who worshipped classical music. I recall attending a Beethoven concert with him in Albert Hall. We stood all through the performance – the cheapest tickets were all we could afford – and heard the Ninth Symphony with its famous choral movement. Two years later, at my lowest, most bitter ebb, I was to use that experience in a viciously satiric work titled, "Behold Man Without God." But at the performance itself I had to admit the enthusiasm of my companion was infectious and filled me with emotion as well.

Ken Staunton on the other hand was stone deaf to good music. His company charmed me because his intellectualism was spiced with a good deal of cockney humour. In our conversations he would playfully call me a "colonial." Both of us knew it was only a joke, but underneath I really did feel inferior to Ken simply because I looked up to all Europeans as being more mature and interesting than North Americans. Therefore, I was quite consciously suspicious of Ken's attachment to me: he seemed so eager for our continued contact after we both left Maudsley. My concern about Ken's possible homosexual tendencies were short-lived, however. He got married that fall and I almost became his best man. After that, my fear of being close to him had to find other rationalizations to work under. Could it be he wanted to convert me to Marxism? Even in the hospital I could see by his reading matter that he was anti-American and a Communist sympathizer. It was at his house that I read a good bit of Marx's *Das Kapital* (and incidentally all of Hitler's *Mein Kempf* – Ken had suggested I compare the two philosophies.)

As a Marxist he, of course, had no use for traditional morality. Like

Frank he believed in sexual liberation: "What have the 2,000-year-old beliefs of an obscure nomadic tribe to do with life today?" he would ask. (We were both under the influence of amateur Freudian psychology while at Maudsley.) His theory was that a young man like myself, emotionally handicapped by childhood terror of his father, could gain mental and emotional health simply by having intercourse with a woman – any woman. The rationale for this home-style treatment was that the sufferer would be liberated after proving himself equal to his father in this most basic of masculine functions.

Ken and I also used to run down our parents to each other thinking it to be therapeutic, although he was probably more contemptuous of his mother than I was of mine. When the time came for me to be recalled to Maudsley Hospital, Ken reacted in a peculiar manner: it was as if he expected me to get him back in there too, and when I failed to do so I felt strangely guilt-stricken. I did a painting of this feeling at the time which I titled "Remorse."

I was out of Maudsley for over half a year. A panel of doctors had decided that my case could best be handled in an out-patient arrangement. I was unhappy about leaving the hospital, for it had literally become a second home to me. I tried to console myself with the thought that I was finally being assigned to one permanent doctor who would see me right through a course of psychotherapy. He was Dr. Bruno Cormier, a French-Canadian. I had once or twice a week sessions with him in an office at Maudsley during which he invariably sat behind his desk while I languished in a chair facing him. Within a very few visits I had sized him up as too distant and ineffectual, and we never did "hit it off," as they say. I was deeply disappointed. My judgement must have have been shallow indeed, for imagine my embarrassment when I recently discovered that he'd gone on to become one of the leading prison psychologists in Quebec.

I will describe how I became one of his first delinquents, but before I do that I should tell you about my trip to the Continent and my London Transport job.

The idea behind the job was to help me save my Canadian funds during the psychotherapy sessions, while the trip to the Continent was actually the last phase in my half-hearted search for an art school. My main stop was to be Paris where I thought a school most likely would be found. I approached Paris in a round about way with a special art pilgrimage to Vienna first – I just had to see the great collection of

Bruegel paintings there. I recall feeling lonely and depressed on the journey. Since I travelled by train, my stay at youth hostels was illegal – hostellers are supposed to hike. Nevertheless, they offered the cheap accommodation I was after. Despite my gloom I was excited at least by some of the countryside, particularly Flanders. And in Belgium I saw the great Van Eyck altarpiece as well as a few Bruegels and Bosches when I visited the galleries.

My train crossed the frontier into Germany at Aachen in the dead of night. Immediately I ran into trouble: I'd neglected to obtain a military visa to cross Germany. "I'm sorry. It's not my fault that we're an occupied country," said the customs man, obviously feeling sorry for himself. However, by paying an extra "fee," I got one from him anyway, but it was a mere transit visa and I wasn't allowed to stop over.

To get into Vienna I had to pass into the Russian occupied sector of Austria – I was scared. I've always been scared. I was scared of trees crushing me in the bush when I was a lumberjack; of people robbing me in flophouses; of rattlesnakes biting me in the desert when I hoboed down to Mexico. All these things, had they happened, would have had my father pointing an accusing finger: "See, I warned you!" All my life he had painted a frightening picture of Europe – the Old Country – as a place where people were malicious, deceptive, and thieving. England had helped dispel some of that image. But behind the Iron Curtain? The Cold War was on and one heard rumours of travellers being spirited away. What if Father was right? In Vienna, as I emerged from the station and glanced across the square, I saw something that seemed to confirm my worst fears. Towering over the station on an enormous billboard was a portrait of Stalin, and printed underneath in big letters was "GLORY TO STALIN." So all that Western propaganda I'd been hearing about the Communist state and the Cult of Personality was true after all! Years later, when I finally visited the Soviet Union, Stalin, as prophesied in Orwell's shrewd observation of modern totalitarianism, had become an "unperson." Every vestige of his name had been so thoroughly erased that you'd never have guessed such a man had even existed, let alone ruled the country for thirty years.

I stayed at the youth hostel on the edge of the Vienna woods. In the evening of the day I arrived, a group of young English-speaking hostellers started an impromptu songfest in the lobby. The Austrian at the desk called for order, shouting in broken English, "If you want to sing and dance, go do it out there in the Vienna Woods!" Perhaps it's only my

peculiar sense of humour, but I'll never forget the comic relief his reference to Strauss' famous tune provided for my general depression. The next day I was treated to another kind of temporary happiness – the Bruegel paintings in the Kunst Historisches Museum. At least eight of his largest works are hanging there and I spent three whole days feasting my eyes on the details of them. There's no doubt in my mind to this very day that Bruegel was one of the greatest painters in history. Every brush stroke reveals his genius.

Unfortunately, this too was depressing, for my brush strokes so far had revealed absolutely nothing. I was brooding so intently upon this melancholy fact that, on my way back out of Austria, I failed to get off the train at Salzburg and ended up in Germany again. As luck would have it, my temporary visa had meanwhile expired and this saved me a longer trip inland. I was confined to the railway station at Passau and then placed on the first train headed back into Austria.

After a few days spent fruitlessly searching for an art school in Paris, I was grateful to arrive back in England in not much worse shape than when I had left. The job I found on my return was as a labourer with the London Transit Commission. London had just done away with streetcars and I was put on the gang taking up the rails. Mostly this involved picking up the cobbles and other rubble that remained after the rails had been torched into pieces and lifted out. The English still remain more class-conscious than North Americans, and so I found I fitted even less well into this group than I had on labour gangs in Canada. I really felt the chill of their mocking glances when I wouldn't join in their telling of dirty stories. And it must have been quite obvious that I was impatient to get back to work while they were intent on dragging out their tea-breaks as long as they could. I was fascinated by the genuine Cockney character and yet couldn't go along with their double standards.

Part of the job was to separate scrap metal, even the smallest bars and nuts, from the rubble in the railbed. But, in fact, a good deal of it was deliberately thrown on the back of the truck. When the trucker arrived at the dumping ground, he'd collect the iron off the top and sell it, giving a cut to his collaborators. When I refused to throw any iron on the truck, this made me a scab in their unofficial union and I was ostracized for it. Finally, I decided to quit and I told the officials at the Commission Office my motives for leaving. They stared at me incredulously and let me go.

Ken Staunton also thought I was naive. I told him of my troubles with the Cockneys because I wanted to do a painting of the job site and I

needed more detailed information. Since I wasn't too sure what my reception would be, I asked him to go out there and photograph the job in progress. The painting proved to be successful and it was eventually bought by the L. T. C. It was my first ever sale, not counting the small painting bought out of charity by a tourist back at the art school in Mexico.

I never did get another job in England till 1956, four years later. Because of the electric shock treatments I received in 1955, the sequence of events preceding my re-entry into Maudsley is a hazy jumble now. Did I try to find other work? I recall I had a large single room in London's Sydenham district during the L. T. C. job on a street called Jew's Walk. But when was it that I lived in that disused shelter in London's Underground where so many found refuge during the bombing of London? And when and why did I go out on that land army job? Somewhere south and east of London was a camp barracks where young people and itinerant labourers were hired daily by farmers in the surrounding area to pick potatoes and turnips and cut kale. I lasted two weeks, I remember. The men and women came together from their respective bunk houses for meals in the main mess hall, and in the evenings there were discussions and movies. I recall reclining on my cot, half-hearing a political discussion in a group nearby, and being very, very unhappy.

Was it the camp's folding up for the season that sent me back to London to seek proper lodgings? I seem to recall that Ken's wife, Joy, found me the Newmans' place, and I do know that my living with the Newmans coincided with a major career decision: "This is it! Now I'm officially an artist by profession. From this point on I'm going to paint pictures and sell them for a living." Paying room and board while painting up a stock of works for sale meant depleting my Canadian bank account, and I now find it hard to believe I was really that brave and reckless.

The Newmans, fortunately, were a warm, likeable family. They had a four-storey row house in Penge. On the ground floor was a bedding shop which opened on the main street, and they also owned a small bedding factory nearby. In that factory they remade old mattresses – a filthy job, really, because of all the human secretions that soak into them over the years. Mrs. Newman was the strong, loving one of the family while Mr. Newman was occasionally immature and irritable. They had a teenage daughter, Margie, who was as chirpy as their budgy. Besides the bird, they had a dog they called Rinty and a cat. I recall being jealous of the affection showered on these animals by Mrs. Newman. There were

two other young male boarders who shared the family table. The food was quite simple because of the emphasis on economy, "scrounging," Mrs. Newman called it. She served us predominantly starchy foods like bread and dumplings and, of course, tea. For some strange reason, perhaps because she felt I wasn't paying enough, Mrs. Newman seemed to expect me to help at the factory. But beyond helping carry a few mattresses and making one van delivery with Mr. Newman, I refused to be distracted from my own work.

My room was in the very peak of the house and unheated in winter. There, after my decision to start being a full-fledged artist, I worked on my first "masterpiece" – with frequent interruptions to warm my hands over the paraffin burner. It was an oil, "Nature versus Printed Matter." A montage sort of work, it was twenty inches wide and four feet high and took six weeks of painstaking work because it was very detailed in style. Unfortunately, this painting was later to deteriorate badly because of a poorly applied undercoat of gesso. Then came the London Transport painting. About four feet wide and three high, it was a *gouache* water colour on masonite. This was followed by a detailed pencil drawing with water colour wash over it which I titled simply, "Penge." It showed a panoramic view of the district from my attic window beginning down in the Newmans' backyard and leading to the very horizon in Sydenham. I worked at a small table in a very tight style so that my expenses in equipment and materials were really negligible. Looking at those three works I could see even then that I had "arrived" as a productive artist. The only two questions now were would they be bought and were they of lasting value? They were obviously liked by my immediate friends and acquaintances but these people were not collectors or critics. During that winter I did attend some half-dozen evening classes at a local art school, but I dropped out when I found I wasn't making any impression on the teachers.

Meanwhile, I was going steadily down hill in morale, getting more disillusioned with psychotherapy and more desperate for a cure-all. My money was running out and I hadn't accomplished what I'd come to England for. I was being pushed closer and closer to the edge of destitution and, if I didn't make some progress soon, I was going to plunge over. If the paintings didn't sell, my stepping back into the working world again would call for a sociability which I obviously didn't have. I was actually angry now with the psychiatrist. Here is part of a note I wrote to Dr. Cormier in a big, bold hand on a large piece of paper:

16

You and Dr. Charatan have accused me of irrationally asking for a snap cure. That's not true. But I want *right now* to *begin* the cure. I want something to work on day by day so I can see myself making progress; I want you to tell me what to do. It must be a deep emotional experience or series of experiences compared to which our talks are trivial. It's not enough just to *know* what my problem is – *SOMETHING HAS TO BE DONE*. The interviews are too few, too short. You say you have too many patients and can't spare more than 3/4 of an hour each week so I'm selfish to expect more. Maybe that's so but I'm no less frustrated. Either give me a stimulant – drugs – hypnotism, or whatever, or else interviews that last 3 to 5 hours.

You are too vague in your guidance – in fact you don't guide at all. Solid advice, if there is any, is buried under words. Tell me what to do during the rest of the week; give me some hard work to do. Then I'd have a distinct challenge and be compelled to face it. If you were to tell me to burn a hundred dollar bill or stand on my head, or any such crazy thing toward a cure, I'd do it. Perhaps as a psychiatrist you aren't allowed to actually get personally involved in a patient's problems – but I do expect that you are dedicated to a high standard of work and committed to serving mankind. If you were, you'd be snapping up every scrap of information you could get about me so these interviews wouldn't be wasted on mere "getting acquainted sessions." You're not even coming half way to meet me for you've not read the two scribbles of autobiography I gave you.

But Dr. Cormier refused to budge from his smiling, serene, professionally aloof position. "If he isn't going to do something to break this stalemate, then I'll have to do it myself," I mused bitterly. In the loneliness of my room, I decided that violence against myself was the only way I could attract attention. Having planned it all carefully beforehand, I exposed my arm up to my elbow on the evening before the next interview and, with a new razor blade, made a series of cuts from the wrist up. Then I reverently bound up the arm with bandages to soak up what blood came out of these cuts, which were actually superficial. With my arm in my coat-sleeve at breakfast the next morning, the Newmans never realized what I had done in their house the evening before. Now at last I had something concrete and obviously serious to show Dr. Cor-

mier. And I did. He blanched, but showed little or no evidence of panic, inquiring instead into the circumstances of my deed. A day or so later I was invited by the hospital to re-enter as an in-patient.

Dr. Cormier had had enough of me, and transferred my case to Dr. Carstairs. I took an immediate liking to Dr. Carstairs, and somehow I had the feeling that he possessed more than the average doctor's wisdom and insight. He would come to my room twice a week for our interviews. I lay on the bed with him sitting on a chair behind my head, out of sight. Perhaps if we'd gone on like this something might have come of it. I say "might" because I was conscious that I was half play-acting. I believed so firmly in the science of psychology and wanted so badly to somehow break out of my feeling of deadness! But that break-through never came. The Carstairs sessions were cut short when two or three months later I was moved to Netherne.

While at Maudsley, much of my psychoanalysis had in fact been conducted by myself. This consisted of writing, continually writing, by a kind of free association method, all the thoughts that came to my mind. I've looked back on these notes recently and I must say that I find them rather disgusting. There's a sick preoccupation with sex and an over-riding note of complaint and self-pity. Again, I was play-acting the role of a patient in the hope of effecting a break-through. I felt that I had to convince the staff to keep me in there long enough for the breakthrough to occur.

One of those ways was to make a display of my ability as an artist. The occupational therapist, Margaret Smith, brought me some painting supplies and I began by working on a small painting of a lumberjack sawfiler; then a larger one of children's games in Western Canada, reminiscent of Breughel's well-known masterpiece.

The next stage was to prove to them that I was also a psychologically interesting artist. "The Maze" was conceived as a kind of pictorial package of all my emotional problems in a single painting. This I contrived to do by fitting the various problems as little vignettes into the compartments of a maze inside my skull, which was cloven in half and lying open on the ground. The ground is a wheat field in Manitoba. It was my firm belief that my problems stemmed in the main from my father's farm failures, his habit of taking his frustrations out on me because I was so useless at farming. My helpless dependence on the doctors was represented symbolically by a white rat knotted up in the middle of the maze. I had picked up that idea from the two-unit course

in psychology I took at the University of Manitoba. Margaret helped me collect some wheat as a model for the backdrop from a field adjoining another psychiatric hospital. The anatomy of the middle of the skull I found in a detailed medical book in a Charing Cross Road bookstore during one of my leaves from the hospital. I had to use my imagination and memory for the rest of the picture. An example is the dung heap seen through the nose of the skull. The implication of this Swiftian image is that the world is a dung heap and the human race a cloud of flies crawling over it to suck out a living.

My bitterness towards life continued in other psychological paintings. But as I look back on them now I can discern the gradual shifting of these clinical psychological symbols to images with spiritual connotations. True, they're as savage as Jonathan Swift's images, but his became more savage as he declined into insanity. I, however, was able to turn on my decline, call it by its proper name, and make a comeback to wholeness. This is represented, it seems to me, by a painting done in 1954 which I later retitled, "Behold Man Without God." At the time I renamed it I also painted over the strongest Swiftian images. I suppose in future years, if my paintings stand the test of time, art experts and restorers will strip back the over-painting to reveal its original horror. I, of course, will be long dead and won't be able to stop them. They will find under the anthill and beehive two giant women in labour spawning the teaming masses that make up the cannon fodder of the world's warring armies. Under the dead, wormy rat is a pile of human excrement. And the weeping child is really a boy wiping his bottom using Shakespeare for toilet paper.

CHAPTER TWO
Help Me Please Help Me Please Help

Netherne Psychiatric Hospital is at the end of a long walk up a hill called Couldson Common. When the day of my transfer finally arrived, I walked out of Maudsley under my own steam carrying a light suitcase and boarded the Southern Electric train for Couldson, Surrey. A Maudsley van was to deliver my paintings a few days later. Although the move to Netherne meant the security of an indefinite stay, I was going to miss Maudsley and I could sense that the "fun" of being a patient was over: If I were not to become permanently immersed in chronic gloom, I would have to try even harder to get to the bottom of my problems. In that way, I had to admit, Netherne was really a step forward. Isolated out there in the country I would at least have two important prerequisites for meditation – plenty of time and plenty of room for long walks. At Maudsley the grounds had been so hemmed in by the huge metropolis of London that, to anyone with an aerial view, my brisk comings and goings must have resembled a squirrel operating a treadmill.

At Netherne I no longer had to prove I was in a bad way. I knew I could stay indefinitely and the quiet of the countryside was, or should have been, soothing balm for the soul of a former farm boy. I merely had to walk into the pine forest to the south or drop into the steep valley to the east for the villas of the deranged and the depressing Netherne watertower and smoke stack to be completely cut off from view. Only a haze on the northern horizon was a reminder of the proximity of London. Sometimes fog would roll in over the whole country and wrap me up in an even tighter cocoon of isolation and detachment.

This was the famous English countryside that had inspired so many of its poets to great lyrical heights. I, too, saw and heard the larks of Couldson Common; in the quiet peacefulness of the woods, the song of

21

the English robin. But I was conscious of no poetry welling up in me whatever – just a dull, grey tangle of interior obsessive ruminations. If the doctors could not or would not help me then I would have to escape from the maze by my own will power. I still believed that science could do the magic trick of curing my depersonalization and depression, just as it had my eye pain. My amateur psychological knowledge said there must have been some traumatic experience in my past which had trapped me in this pit; if I could just grope my way back to it then I might be in a position to set myself free.

Back at Maudsley, for example, while still an out-patient with Dr. Cormier, I had deliberately contrived a self-help experiment designed to cut my umbilical cord to the past. I tried to establish in myself the image of what the public often imagines a temperamental artist to be. First, I carefully painted a water colour with as beautiful a choice of colours as I could find. It was of lumberjacks felling a giant tree. Then, just as deliberately, I tore it into four ragged pieces and showed them to Dr. Cormier. He only blanched a little. Another time I sat down to an art experiment which disproved (to my mind anyway) the theory that a patient can relieve himself of aggressive feelings by painting them out. I mustered all the forces of my imagination and pretended I was in our garage in Winnipeg. I represented myself as if, having captured my parents and stripped them, I had mutilated their bodies with a butcher knife and strung them from the rafters by their tongues and other organs. I heard later that even the most hardened doctors were shocked when Dr. Cormier showed them the picture. Yet no matter how intensely I painted out my accumulated store of fears, hates and disillusionments, they still remained with me as an immense psychological burden. Perhaps sticking pins in the effigy of an enemy relieved the mind of a primitive, uncomplicated person but, by the end of my own series of experiments, I had a different response: "Baloney!"

So I walked and walked, crossing Couldson Common in every conceivable direction, trying to figure things out. I knew it was hopeless to leave the hospital and try to lose myself in travel and hectic activity. I'd already spent several years doing just that. With each leave-taking from home, each throwing of myself into a new adventure, I had said, "This time I *will* be happy, this time I *will* come back a changed person, this time I *will* make a fresh start." But I carried my wretchedness like a heavy stone sewn up inside me and the resulting inertia destroyed my peace of

mind. How well I remembered all those charts for self-improvement I had copied out of books or invented myself and pinned on my study walls. Even the attempts I had made to follow the suggestions of others, by at least pretending to be happy, turned out to be pathetic farces. I put on a strained smile but I was crying inside; people could read it in my eyes.

The irony is, these suggestions ultimately had a negative effect: It made me gloomier than ever to be reminded that I was regarded as a "sad-sack," a social "undesirable" in a universally fun-seeking society. The more I was lectured about keeping my chin up and waiting for the sunny days, the more depressed I got. Sure, sunny days did come from time to time, but in my case I had noticed them growing dimmer and rarer with each passing year. I was hindered from throwing myself into the pleasures of life—games, sports, dancing, drinking, you name it—because these all presupposed an ability to relax, and I found I could not. The harder I tried the more tense I became. And now this tension was even threatening to seep into my lonely enjoyment of books, paintings, music and nature. Art and nature require some interior peace in order to be appreciated. But with my mind racing like an over-choked car engine, or like that rat in the maze seeking escape, how could I achieve that inner peace?

I kicked at the chestnut conkers in the pathway and tried to comfort myself with various observations. For one thing, the chronically-ill patients of Netherne who were walking round and round like myself, but within the cages of their fenced-in villas, were worse off than I. At least I still had the possession of my reason. But what good was reason? Here I was, relying on my own intellect to figure out the whole mess, and yet the harder I tried the more confused I became. I seemed to be like the proverbial man who sank deeper into the mud the more he struggled to get out.

I had already passed through the hands of three doctors by then and now was in the care of Dr. Yates, a woman. It was pointless shopping around the outside world for yet another. I had neither the money nor the contacts to be able to approach the world's most renowned psychiatrists and, outside a hospital setting, the people who can or will help a person with interior problems are few and far between. My own suspiciousness and shyness about meeting new people and my continuing string of failures trying to form lasting friendships certainly did not help either. At least in the hospital I was being treated with sustained,

23

though clinical, kindness and acceptance. In that respect I never in my life felt more at home.

Nor could I return to Canada – to parents, brothers, sisters – even though one's family is supposed to be a place of refuge. This was out of the question precisely because, as everyone knows, almost every psychiatric illness begins in some childhood maladjustment, and home and school were where my troubles all began. That was plain from the doctors' investigations. Bitter as I was towards my parents, I was honest enough to admit that, had I come home then, they would not have realized anything was wrong. Apart from a few scars left by the cuts I'd made for Doctor Cormier, there was no outward physical symptom – no disease, no deformity. Even years later, long after I'd returned to Canada, they still believed my hospital stay had been a mistake.

And my brother John? We'd drifted apart altogether. It wasn't until a year later, when news of my suicide attempt reached home, that I received a letter from him expressing brotherly affection and concern along with an apology for his past indifference to my troubles. But then suppose the shoe had been on the other foot and he had had the breakdown. Would I have given him moral support? Money? I doubt it. The Kurelek family was not yet as intimate as it was later to become.

The only member of the family I did feel affection for was my second sister, Nancy. She doted on me and I loved her as a big brother should. I used to write long brotherly letters to her. What was it that bound us together? Was it my having been nursemaid to her when she was a baby? I can still remember singing to her and entertaining her by using my fingers as puppets while Mother was out working in the fields. I used to get angry at her too. Especially when I would be listening to the Lone Ranger on the radio and she wanted to be put on the potty behind the house. Later, when I left home, I used to visit the farm now and then and I recall one night when we went for a long walk and I tried to confide in her my intense unhappiness. But she was only a little girl in the middle grades of public school, and an adult in emotional trouble cannot very well turn to a child for help.

My other sister, Winnie, was the more logical one to turn to and, in fact, something peculiar happened shortly after I entered Maudsley. I was standing in the corridor outside my room, half a world away from home and family, when who should I see coming toward me but my sister Winnie! She was crying, and her friend Pamela who was with her

24

looked worried. The two of them had come to tour Europe on a shoe-string budget and, calling in at Canada House in Trafalgar Square to leave their forwarding address, had happened to see my name. My address was given as Maudsley Hospital. Winnie, of course, didn't know Maudsley was a psychiatric hospital so she jumped to the conclusion that I'd had an accident. But as we sat chatting in the corridor by the open window, with summer in full bloom outside, I could see the worry fading off her face as if she were saying to herself, "Oh, is that all your trouble is?" And so she went on her way to complete her tour of the continent.

While in hospital, both Maudsley and Netherne, I had nothing to complain about concerning my vocation, for I'd never in my life been better set up for the production of paintings. I no longer had to worry about selling my works: I had a small sunny room for my studio, all my materials were supplied and I was free to work as much as ten or twelve hours a day. The cot was quite comfortable and someone would call me when meal-time came round. What more could a dedicated artist ask for? Fame and acknowledgement? They even tried to help in that: staff and patients would drop in to admire my progress while the doctors took samples of my work to prominent artists for evaluation.

But what about the more ordinary vocation of husband and father? Typical of solicitous parents everywhere, my own had begun to pressure me in my twenties to get married. The responsibility would bring me down to earth, they maintained. But whenever I contemplated the prospect it simply appalled me. For one thing, I'd have to get to know and love a woman well enough and there was no such woman in my life. And even if there were, how could I undertake to maintain a home when I couldn't even keep myself? Marriage, I grimly realized, was definitely not the answer. There were just as many married as unmarried people at Netherne.

The only female friend I still had was Margaret Smith, the occupational therapist I'd met at Maudsley. There, besides providing me with paints, she had given me an hour of her own time at the end of each day so that I could talk over the things that were weighing most on my mind. Soon I had found myself waiting for her knock on my door.

What was it about this woman, I wondered, that secured my total confidence and trust, whereas I felt nothing but a cold clinical gap between myself and the doctors? There seemed to be aura about her. In fact, it was in one of those sessions with her that an amazing thing hap-

25

pened: I suddenly burst into tears as I made a painful confession. I distinctly remember being amazed even as it happened, for I'd never had such an experience before. I can't remember now whether she actually put her hand on my shoulder or whether it was just the expression of sympathy on her face, but I experienced a deep sense of relief.

One day in our discussions we had discovered a mutual liking for poetry. So, the following afternoon, she brought along a small book of her favourites, the dust jacket of which I found to be made out of newspaper. Looking at it more closely, I noticed it was a Catholic newspaper and something clicked into place. Was she a Catholic? I put the question to her the next time I saw her and she replied simply, "Yes, I am." At first I teased her good-naturedly about her faith. I was a staunch atheist at the time and I recall arguing with a Jewish patient who was always reading his Torah in the evenings. But I didn't manage to shake his faith, or Margaret's either. She joked back to my teasing or simply smiled and said nothing. She made no attempts whatever to out-argue or convert me.

I was becoming curious about her faith anyway. Was that aura I mentioned – call it strength or serenity or whatever – was it something that derived from her faith? I began to ask a question here, a question there, gingerly working around the edges of a subject which I still had no use for. Sometimes she couldn't answer these questions to her satisfaction so she'd bring along a pamphlet or a booklet. Dipping into these I found out about the Catholic practice of praying for others. Finally I asked her if by any chance she were praying for me. Once again came the simple answer – nothing more, nothing less: "Yes, I am."

Once I had been transferred to Netherne the situation could, and certainly did, change. In addition to praying for me, Margaret now wrote me letters – a necessity in view of the many miles between us – and she could visit as a friend on her days off. Eventually she invited me to come to her flat in London whenever Netherne allowed me out on leave. There I got some of the physical signs of affection which I had missed so in my past. In my perplexed state of mind I wondered if I'd fallen in love with her. But she knew better. She knew I wasn't ready for marriage because what I really needed was motherly affection. In other words, I had to receive love first as a child before I could give it as a mature adult. So she firmly drew the line in our caressing. Sometimes this peeved me since I half-thought I was in love with her and I had the usual worldly notions of romance. On one occasion, in a letter to her, I hinted that she lacked passion. In my heart I knew this wasn't true, because she had told

me how, in her early years, she had had a long, secret love. In fact, she had even been engaged. Back came the impassioned reply and it certainly put me straight on her feelings and convictions: "Do you realize, I wonder, what a strain our friendship is on me? There is a man shortage in this country because of the recent war, and many a woman here wouldn't hestitate to take advantage of you in your present helplessness. Giving into 'passion,' as you call it, may seem alright to you, but that does not make it any the less wrong for me."

I knew then, as I paced the hospital grounds at Netherne, that I could not possibly get more heroic help. This was further proved during one of Margaret's Sunday visits. As we took the pine woods road to the south I said to her, "You know, I'm almost positive that if I could just give someone a good swift kick in the backside then I might snap out of this depersonalization thing that's got me." "So why don't you try it on me?" she offered. I dropped back a pace and did just that. For one long moment she turned to stare at me in utter disbelief, but then it penetrated to her English sense of the ridiculous and she burst out laughing. I myself could only manage a rueful smile.

Shortly after this incident it occurred to me that I would not find relief by burdening others with my personal problems. I was determined not to use Margaret as a wailing wall any longer. This meant the end was approaching fast for I had exhausted every human resource for help, both my own and others. There was only one possibility left – religion, which I had begun to dabble in after an extraordinary experience on the third night of my move to Netherne.

I awoke, for no accountable reason, sometime after midnight and sat up in my bed. The moon was shining brightly on the cabbage field outside our villa and on the pine woods beyond. The other patients in the dormitory were all asleep, making no more noise than my work-mates in the bush camp used to after a hard day's work. It was a peaceful scene and yet I became aware of a sense of complete and utter abandonment, the like of which I had experienced only a few times back in childhood. Oddly, the presence of the other sleeping patients didn't seem to comfort me in the least. I was a consciousness lost in the universe. I wanted to wake one of the patients or call the night nurse and say, "Could you help me please – I feel abandoned." But that would have made me seem childish and I decided not to. I don't know how long I sat, completely at a loss as to what to do, when it occurred to me to try what Margaret might suggest. For the first time since I was a boy of eleven in Manitoba,

I tried praying from the heart to God. But even as I made the attempt I realized I didn't know how or what to say. I decided to ask the Catholic chaplain at the hospital about prayer. Somehow this decision alone did the trick, for it gave me enough peace to lose myself in sleep for the rest of the night.

Father Scott visited Netherne only at certain regular intervals, so it was two days before he turned up at our villa in response to the message I had given the hospital staff. By that time I was rather ashamed at having let that midnight experience influence me so much, but I decided to face him anyway. To my surprise, as soon as I told him that I wasn't a Catholic, he seemed ready to move off. He did chat with me for half an hour at my request and suggested the Lord's Prayer. He also asked me never to give up hope, almost as if he had a premonition of what was coming a few months later. He said he might call again but he never did.

During my walks of the next few months I did try the Lord's Prayer – the words of which I found I had to relearn. I even formulated a few prayers of my own, but to no avail: I didn't feel a thing nor did it seem I was communicating with anyone or anything up there.

The winter was wearing on and still nothing had changed. I had done a painting shortly after arriving in Netherne which I had titled "HELP ME PLEASE HELP ME PLEASE HELP ME – PLEASE HELP." It showed me symbolically as a bird flying across the Atlantic with a bag around my head, the bag representing my depersonalization. Instead of untying it, a figure in a clinically white smock, resembling Dr. Carstairs, clips my wings, puts me in a cage and hangs it by a hook on the White Cliffs of Dover.

Dr. Yates was well intentioned and obviously a good woman but no more effective than the others had been. Nothing I said or did shocked or moved her and she paid no attention to my appeals for some kind of radical new approach such as drugs or hypnotism. One grey day I went into the pine woods and, sitting on a pile of brushwood, cross-hatched the inside of my arm again with a razor blade. I showed her these superficial wounds the next day, but she didn't bat an eyelash and kept on talking. I'd had enough! I began for the first time to consider suicide. Since I was also considering religion, the question of life after death came up to stare me in the face. But it didn't stare very hard or very long. Theories about the after-life looked even more phoney than my psychological theorizing about worldly problems. I was tired of it all and didn't care any more. Talk, talk, talk, think, think, think – nothing led anywhere. I had no proof of life beyond the grave and plenty of proof that my pres-

ent existence was miserable. If there was no God, no after-life, no final justice, then suicide was reasonable. Only two things remained to be done: to plan the self-annihilation, and to do it.

Nestled in a small hollow at the top of Couldson Common was a tiny country graveyard where my walks on those grey days often ended. Phoney though I was, my motives for going there were neither melo-dramatic nor poetic. As I sat brooding upon its worn tombstones and wooden crosses, I realized my depersonalization had even robbed me of any "Elegy In A Country Churchyard" feeling of my own. I'd have been only too happy to have experienced Thomas Grey's wholesome and original feelings! Feelings! That's what I so desperately wished for. If only I could somehow experience death without actually going beyond the point of no-return, the shock of that plunge might snap me into full awareness of the opposite reality – life.

I no longer remember how much of my "suicide" was a form of pro-test and how much real conviction. The self-mutilation that went with it would suggest it was a mixed-up brew of the two motives. It was pre-meditated, that I do know, because I began to save my daily ration of sleeping pills. I didn't know how many taken at once would be lethal, but I aimed at saving eight pills. In the meantime, I presented Dr. Yates with one of my biggest, most pleasant works – a grim going-away gift to society entitled "I Spit On Life." There is only one tiny inadvertent shred of hope in one corner. As part of the whole montage of memories and social comments contained in the painting there was supposed to be a satire on religion. I never leave a painting unfinished if I can help it, but that little corner is unfinished to this day. I like to think it was an omen of some kind. For it was only religion that was as yet unfinished in my life and only religion that saved me.

A few days later, some time after lunch, I took the eight pills. Then closing the door on the little room which doubled as my studio, I used a sharp new razor blade to lacerate my face and arms. I vaguely remember looking a bloody mess as I crawled in behind a clothes curtain and lay down there alongside a floor railing used for drying shoes. I never did lose consciousness entirely, but the pills had the strange effect of telescoping time – dinner seemed to follow right after lunch. Through the grogginess I heard Ray, the houseboy, knocking at the door. Once, twice, the door opened, and then, "OH! OH! OH!" I heard him yelling in alarm as his feet pounded off down the hall. Again there was that strange telescoping of time, for it seemed in the very next second that there

were a half dozen male nurses in the room feverishly examining me, asking me questions and picking me up at the same time. The next thing I was aware of was being in an ambulance headed for the main building of the hospital, where my stomach was pumped and my cuts were bandaged. I had a good long sleep that night.

The sequence of events in the next few months are hazy to this day, though the events themselves are fairly clear. The cause of this was my Electro-Convulsive Therapy, or E. C. T. , or more simply, "shock treatments." I suppose it was the very day after the attempt that I was asked if I'd agree to receive them. I recall agreeing with joy. At long last, something definite was going to be done! I had seen the very marked improvement this treatment made on other patients in our villa and I had envied the cheerful though dazed buoyancy of their deportment after E. C. T. , compared to their miserable, moping, slouching around previous to it.

I must have been given the first shock the next day under anaesthesia. Though I remembered nothing whatever of it, I knew that I'd had it because I regained consciousness in still another ward – for incurables. I was told by the nurses I'd have to lie there for a few days to convalesce, as the E. C. T. had sprained my back. Sure enough, when I tried to move there was a sharp jab of pain in the small of my back that discouraged any further attempt to rise. I was told the E. C. T. 's were to resume the following week, however, with Scoline, a drug made from snake venom that relaxes all the muscles of the body. This would prevent any further spraining.

As I lay there helplessly pinned down to the bed by my back I began to look around the room and take it in. This was my first acquaintance with incurables – the lowest of the low in illness. My being there seemed to be fated, as if I personally had to realize at last the essential weakness and fragility of mankind. Here were men who to outward appearance seemed nothing more than suffering vegetables, and for the first time in my life I was touched with pity, real pity for someone else besides myself. Some were crippled and some were senile, many were severely disturbed, letting out odd animal-like calls. The old man next to me held his hands sort of half raised all day clutching at the bedsheet. But his body would be sidling over barely perceptibly. Sooner or later he'd reach the edge and fall out onto the floor. Along would come a male nurse and bundle him back under the covers. Perhaps it was the irrepressible artist in me, perhaps it was to pass the time, but I made drawings of

those incurables and have them with me to this day.

It was here too that I received Margaret's first visit after the attempt. I don't know if the hospital had notified her or whether she had come for our regular Sunday visit and had been directed to the main building. Anyway, I could see she was biting her lip to keep from crying as she asked, "Why did you have to do it, Bill? Why?" I also saw Dr. Yates once more, that same week I think. "So that's why you gave me that painting!" she said. "It was a going away present, wasn't it?" That is all I can remember of my last interview with her. She kept the painting but, like Dr. Cormier, she realized she'd come to a dead-end with my case. I used to see her sometimes when I was convalescing from E. C. T and taking my daily walk down the road. She'd drive by in her little car on the way to the women's villas and would smile and wave to me.

But no one seemed to trust me any more. For a few months I even was kept in a locked ward. We patients were allowed out either singly or in groups but always under escort. The building was four-storey brick and our ward was third floor up. The windows were barred and couldn't be raised more than three inches for fresh air. Twice a week at first, and then once a week, I was given E. C. T. I forget now which were my black days, perhaps Tuesdays and Fridays. I accepted the first treatment readily enough, even with a show of bravado. But, oh my! I just couldn't put up that front for long at all. I was soon stripped of falseness and humbled. Then I began to understand the meaning of the barred windows.

A few E. C. T. patients were obviously brave, or else insensitive, and took the experience in their stride, but most had fear written all over their faces. I recall one get-away attempt: he was caught by several smiling male nurses and led gently by the arms into the "execution" room. This room was actually the dormitory of our ward made over for that purpose on E. C. T. mornings. No breakfast was allowed on those mornings, just a cup of tea. I found myself envying the non-E. C. T. patients even their being allowed breakfast. I also envied the two patients who got insulin shock treatments: they'd sit propped up in their beds, sweat pouring off them, and later never remembered a thing. "Why can't the hospital put me under anaesthesia like the first time?" I wondered. But I was ashamed to actually ask for it.

I was given fourteen treatments in all, and it was like being executed fourteen times over. There's an instinctive dread in a person of being annihilated and so, instead of gradually getting used to the procedure, it is dreaded all the more each time. I noticed that some of the patients

lined up opposite me were moving their lips almost imperceptibly. They were praying. It is said that sorrow remarries us to God and how true that is. Here was an experience horrendous enough to knock the cocky self-sufficiency out of any man. One prays best when one is really and helplessly up against it. That is when I, too, resumed prayer. I've been praying ever since.

In the end I could well appreciate something of what it was like to go to the gas chamber in Nazi Germany, or to the torture chamber during those misguided religious wars of the 16th and 17th centuries. The big difference, of course, was that I knew these people were "on my side." They wore white smocks and moved quickly and efficiently. Each had his duty. Hustled briskly into the room, the first thing a patient notices is a cot just in front of a white screen. The screen was moved one bed forward as soon as the previous patient had been knocked unconscious. Behind that screen, as the next victim knows, lay a whole row of unconscious men coughing and twitching spasmodically. The speed of the operation never allowed me to study the electrical apparatus beside my bed. I suppose it was deliberately so arranged. Quickly I would lie down and loosen my belt. My collar was already undone, and a rubber mouthpiece was given to me to bite on. All this under a series of rapid-fire orders while male nurses stood on both sides, ready to hold my arms and legs so I'd not fall out of the bed when I was convulsing. A needle would go into my arm. Another doctor would say, "Hands up!" I would raise my arms and in an instant the scoline drug would do its terrifying work. Every single muscle in my body seemed to tighten into one big knot. My mouth would drop open as if to gasp in horror, yet even that gasp was cut short by the paralysis.

Within an hour or so I would regain consciousness, and my very first thought was always, "Thank goodness I was knocked out in time." Then almost immediately, I would begin to dread the next E. C. T. still several days away. With each shock treatment, I remembered less and less of the immediate past, and some of the more distant past too. That constitutes its curative effect, I suppose, but also that annihilation of the self which the inner person dreads.

In the intervals between treatments, I sat at the end of a small hall just past the nurses' offices and painted under their watchful eyes. I can't recall now if it was a tiny table I worked on or just the ledge of the window. Through the window loomed the smoke stack and the water tower, always, as I remember it, backed by a heavy grey sky. On the

window ledge was my unlikely subject – a bowl of eggs and tomatoes. I was not, as might be expected, painting some wild psychotic theme but a tight, disciplined, super-realistic *gouache* which I later titled, "Still Life with Eggs and Tomatoes." My sister Winnie now owns it and no one ever guesses it was painted at my lowest ebb. It is visible proof, to me at least, that I was never stark-raving mad. I was emotionally disturbed, my life was a mess, but I wasn't crazy.

I vaguely recall once or twice being taken outdoors by the nurses to watch a hospital staff cricket match; the sky and the grass seemed so raw coloured, and the sunlight so cold as it filtered through my E. C. T daze. But I was still able to discuss rationally the logic of my suicide with a Hungarian male nurse. There was even, believe it or not, a Ukrainian nurse! He had escaped from the Red Army and was now one of the thousands of Ukrainian refugees working in England. He shook his head and scolded me, "How could you try to make such a final break with your parents? My own are still behind the Iron Curtain and I'd give anything to be able to see them." Personally, I hadn't the slightest intention of ever seeing mine again. If I could help it.

Sometime before the last E. C. T. treatment I was examined by a psychiatrist and judged improved enough to be allowed my freedom. Soon I found myself back in the same villa where I had made the attempt. But I didn't get a private room this time and I had to paint in the back lobby with patients and staff passing by. It was there that I got my first communication from the family back home. I don't know how they got wind of my attempt but that's what the letters were about. Mother's, her first ever to me, had a touching passage in it about what a wonder I'd been to her and Father, when they'd first held me and counted my ten toes. Father said in his, "If you had succeeded in killing yourself you'd have killed us too. We could not have borne the shame and grief of it." A year later, in another letter, he revealed his anger. But, in the first one, I suppose he thought it more prudent not to say anything that might have driven me to some further act of desperation.,

I must consider my suicide attempt in some ways fortunate, if only for the E. C. T. 's and the blessed relief they afforded me from the crushing load of depression I'd carried all those years. In my case they really worked. The depersonalization was still there somewhat, and I was physically dazed and somewhat shaky for a few weeks after the treatments, but cheerful nonetheless.

As the effects wore off week by week, I found it interesting that my

childhood memories of some twenty years past returned before the memories of my more recent experiences in England. It is to these early memories that I now wish to turn in the hope that an account of them will afford the reader some insight into my evolution as an artist as well as a Netherne Hospital patient.

CHAPTER THREE
A Prairie Boy's Summer

I was born on March 3rd, 1927, on a farm near the town of Whitford, Alberta. My father, Metro Kurelek, had emigrated to Canada as a young man from the village of Boriwtsi in the Province of Bukovina in Western Ukraine. My mother, Mary, was born in Canada but her parents had also come from Boriwtsi. Bukovina was then part of that powder keg collection of nations – the Austro-Hungarian Empire – which spawned the First World War and, incidentally, ended my father's education in his third grade. He never did return to school. The battlefront between the Russian and the German and Austrian armies passed several times over the village but, somehow, the Kureleks managed to survive without serious injury.

I recall, as a boy sitting in the shadows of the farm kitchen corner, listening to my father tell his hired man stories of the comic confusion and brutality of war. Father was a born story-teller and as hired men came and went, I heard the stories over and over. I can still picture him as an impressionable nine-year-old helping to load soldiers' bodies on a wagon after the battle. They were easy to find in the corn field for they left a trail of blood and trampled corn stalks after being hit. I did a drawing at the time of another of Father's stories showing a greenhorn army recruit with his bowels gushing out. He'd accidentally pulled the pin of a grenade while boastfully explaining its operation to the assembled villagers. Still another story described a Hungarian contingent's hanging of an old woman. She was one of several villagers found with Austrian state furniture which had been "generously" donated by the Russians when they'd occupied the village. Her daughter, seeing her mother still kicking, tried to cut her down. That turned out to be a war crime too, so she was strung up beside her mother. Poor Ukraine had suffered so many

35

centuries of oppression yet, when the war ended, she was once more parcelled out by the big nations. The province of Bukovina became part of Romania.

A peasant's life has always been hard but after the war people had to lie, steal, cheat, even kill, to survive. At dusk a farmer would be returning from the fields with his plow on the back of his wagon. There, right on the village street, a gang of youths would stealthily lift the plow off the wagon, then plow and youths would melt away in the dark. Having seen killing and themselves taken lives in the recent war, rival suitors hardly hesitated to knife each other over a girl at the village square-dance. My father himself took part in smuggling escapades across the now near-by Polish border, exchanging items arbitrarily over-taxed in either country. He was eventually caught by a Polish border patrol and beaten and jailed before he finally managed to escape.

Although Grandfather intended to divide his land among his three sons, Father, being second eldest, wasn't satisfied with his smaller portion. At war's end, an agent from the British Cunard Steamship Line appeared in the village and soon persuaded my father to migrate to Canada. Besides the lure of owning land, Father wanted to escape conscription into the Romanian army. Draftees returning to the village had told of beatings and other humiliations at the hands of the officers. Former gypsies, this was their revenge against the peasantry that had hounded their caravans out of town.

Father left the Old Country with hard feelings against his parents, vowing he'd never see them again. I believe it had to do with Grandfather's refusal to sell my father's portion and give him the wherewithal to begin farming in Canada. By the time he reached the prairies, he had nine dollars in his pocket, a small wooden suitcase and the clothes on his back. An uncle on his mother's side, a storekeeper in Willingdon, had paid his passage over and William Huculak, a prosperous farmer in Whitford, had promised him employment so he could work it off. Father was nineteen and his suitcase was light but he brought with him a heavy load of bitterness and suspicion from the troubled conditions of Central Europe.

My maternal grandfather, however, was one of the original pioneers of the district. When he came over as a boy with his father at the turn of the century, the land was complete wilderness – nothing but bush, wild grass, nomadic Indians, mosquitoes and bears. True, the land had been surveyed and the R. C. M. P. were there to prevent Indian attacks but,

apart from that, once you'd found your parcel of land you were on your own.

A pioneer's first step was to move the whole family in from the railhead at Edmonton because it was important to establish claim by actual occupancy. The first home was a hole dug in the side of one of the rolling Alberta hills topped with poplar logs and sod. The few iron tools were portable ones from the Old Country. Everything else was handmade, usually out of wood. If the family were lucky enough they might have led a cow with them from Edmonton. That trail, some seventy-five miles along the North Saskatchewan River, was usually walked on foot and a pioneer would have considered it a wasted journey if he hadn't carried a sack of flour on his shoulder the whole way home.

In the spring, the man of the family and possibly an older son would go off for the summer to find employment either in the forests or on the railway or in the mines. The woman and children were left to fend for themselves. They had to do a man's work of felling trees and clearing land in order to prove to the Land Claims Office that they were responsible homesteaders. In the fall the menfolk returned, bringing with them oxen or horses and plows bought with their earnings. By the second or third year, they might have become prosperous enough to build their first real house – a straw-thatched, clay-plastered replica of homes they remembered in the Old Country. At my grandmother's, as I recall, it was used as a granary; at our immediate neighbours', the Kirikas, it was still being lived in.

My father was unfortunate enough to appear on the prairies in 1924, by which time the land had long since been developed and occupied. After detraining at Mundare, Father got a lift part of the way but had to walk the last eight miles in the snow and frozen mud of early spring. His shoes were falling apart by the time he reached the Huculak gate. The white farm house looked palatial to him. The rest of the family were away hauling grain or attending school but Mrs. Huculak, a stoutish, strong-willed, strong-armed woman, was home and took charge of him. In the evening, when the grain hauling crew returned, my father met the woman he eventually would wed – the Huculak's eldest daughter, Mary. It is typical of those hard-driving times that, by four a.m. the next morning, my father had already been put to work shovelling a wagon full of grain.

My earliest impressions of Grandfather are of a blunt, loud-voiced

man who drove his own car and was something of a drinker. He even owned a hotel in Willingdon. He rubbed my father the wrong way at once for it seemed to him Grandfather was flaunting his wealth in his face. Back in the Old Country the Huculaks had been the paupers of the village – that's why they'd had to leave. Here, however, Father found to his consternation that the tables were turned. But he decided to stick out the summer until he had worked off his passage. No doubt he then would have left had he known where to go and had he not become interested in Mother.

Mystery surrounds their courtship for me. It seems that the Old Country custom of arranged marriages – including bartering and dowering – had survived Ukrainian immigration. Grandfather pushed the marriage and promised Father a quarter-section of land. He even threw them a giant wedding party which went on for three days. But at the end of it all, there was no going away on honeymoon for this young couple. They just loaded their gifts in a wagon and drove off to their quarter of land. There, in a shack, they spent their first night and were at work the next day.

I was born in that shack nearly two years later. My father had been spending much of his free time in the bush country to the north, cutting and preparing logs for a house on a new farm. He returned on this particular March evening only to discover that Mother's time had come. Back into the winter night he turned his tired horses for a dash to Smokey Lake to fetch an Indian midwife. This lady had no legs but was a renowned herbalist. Too late. By the time he returned with the midwife at dawn I had already been delivered by the neighbouring women. Apparently my grandmother, who was also expecting, had had an intuition that very evening. Out of the blue she had sent my Uncle Peter, a mere teenager, by horse and cutter to see if Mother needed help. Sure enough, she was alone and in labour and dispatched him urgently: "Fetch Mrs. Hawrelak and Mrs. Sanko!" In his haste Uncle Peter made a bee-line across the fields and got lost in the dark. He drove round in circles for about an hour before he spotted a distant lighted window. When he returned with the women he was at once sent to sleep on the floor behind the stove while they set to helping Mother as best they could. Uncle Peter tells me how he remembers being awakened by the sound of a baby crying. That was me – greeting the world.

Of the hard years that followed I have only a kaleidoscopic collection of memories and other people's reports. One account is of a mysterious

stomach ailment that afflicted my father for an entire summer. He had to look after me as best he could while Mother worked in the fields. At the time, she was probably pregnant with John. Appendix operations were in vogue then, so the doctor advised my father to go to hospital in Edmonton and have his out. Weak from loss of blood during the operation and penniless he walked the streets of Edmonton all day, begging acquaintances for train fare to Mundare. Nobody would help so he had to return to the hospital for the night. Next day he did get to Mundare but had to walk the remaining twenty or so miles by foot. Some smart-alec sons of prosperous local farmers drove up from behind in their new Model T Ford. Father thought they were steering to his side of the road to give him a lift. But it was only the better to splash him in a puddle and have a good guffaw as they sped off.

My very, very first memory is from my third year. It's of my sister Winnie in bed with my mother, probably not long after Winnie's birth. For no accountable reason I see dried up batter in this picture as it drips over the side of a mixing bowl. But it is my brother John, born nearly two years after me, who figures largest in my earliest memories. We were constant companions from then until our university days. But we were rivals at the same time. I was early seen to be different–a dreamer–while John was practical and naturally brighter. I was jealous of the affection and praise he seemed to get from my parents which I, being older, thought I had first claim to. Appropriately, my first memory of John is of him hitting me over the head with a vanilla bottle.

When a violent hailstorm caused Father's horses to bolt homeward from their work in the fields, it was John who found the halter they'd lost. I can still see him beaming and handing it to Father and the compliments he received for his smartness. All round us hailstones the size of oranges were melting in the glistening grass. The storm had come as an ominously revolving, fast moving, single cloud approaching from the west. Mother acted quickly and herded us three children into the middle of the farm house. I still have a mental pciture of her stuffing pillows into broken windows as the hailstones crashed in. My father meantime had hidden under his seeder right where he had been caught in the field. The hired man, who couldn't very well hide under it too, made a dash for a burnt-out strawpile. It proved a meagre shelter. He burrowed his head and shoulders into its sooty remnants but his rear end, still exposed, got a spanking.

Equally frightening for us children was another hailstorm a year or two

later. It wasn't the stones this time – they were only the size of rabbit droppings – but the fierce wind which accompanied them. As we stared through the kitchen window with incredulous, horrified eyes we saw this driving hail lift a whole granary and roll it over twice. I had always imagined buildings to be such securely stationary things. Father was caught in the open that day too, only this time it was on the road home from town. He drove the wagon into the ditch, wedging the horses against a fence so they couldn't bolt, and crouched against the safer side of the wagon box. He was beaten red by the pellets on the exposed side of his body anyway.

Besides his brightness, my brother's courage was also praised by Father. I recall Father lifting me up to the straw-covered eaves of the barn to reach into a bird's nest hidden there. But I had no free hands to reach with because I was clinging so tightly to Father's arm. Finally he gave up in disgust and lifted John up there instead. I was also afraid to climb all the way up the ladder that led by an outside door into the attic. My mother kept tubs of chicken and goose feathers up there to make bedding out of. To my chagrin, John showed no hestiation at all.

Perhaps because of his comparative fearlessness he was more accident-prone than I. Today he is a successful engineer and that mechanical propensity even then had him poking his finger out of curiosity into the gears of a whirring seeder – only to get the tip of it chewed to a bloody mess. Another time he walked too close to a newborn calf and the mother cow bunted him head first against a set of metal doubletrees in the grass. I remember blood streaming from his broken scalp as he came bawling toward the house.

My envy increased even more when I began to suffer hallucinations at night. Although he slept with me in the same crib, he remained blithely immune to the terror I was suffering. His immunity was especially galling because my sister too saw the monsters. One was a lynx-sized cat clawing at the underside of our crib. Another was a gigantic grey rubber hose in the shape of a rocker. It had a black sheet draped over one end and kept rocking back and forth on the bench under our window. Most frightening by far, though, was the huge turkey vulture that wanted to get at me and peck my eyes out. But since I kept myself tightly covered over with the blanket, all it could do was walk all over me. I distinctly felt the imprint of its feet as it stomped from one foot to the other.

One morning, when the sun was already lighting up the bedroom, I woke and, glancing out from under the covers, saw John was still asleep.

Then to my horror I noticed that the vulture had dug its beak into John's scalp and was hanging there suspended from it. The reader can imagine how fast I ducked back under the blankets.

How I longed to sleep between my parents like sister Winnie did! They only laughed when I told them of the monsters. Finally, one day when my parents were away and we children had been left with neighbours, we saw our house on fire in the distance. The first thought that came to my mind was to wonder whether the monsters would perish in the blaze. They did. When the new house was built on the old foundation the creatures no longer visited me.

Another spooky thing about that house was something heard not only by me but by all the family. One winter evening we became aware of something crying or screaming under the house. Our house only had two rooms and sat on an earth foundation but there was a root cellar under the kitchen. Father went down there through the trap door several times but couldn't locate its source. I recall being fearful, even with the lamp on, of being left alone in the house. I can still picture the rows of rusted conical rivets on the back side of the kitchen stove where I used to crouch when left alone.

In that same room one summer evening, as it got darker and darker, all three of us children thought we had been abandoned by Mother. We crawled under the benches and table for security and began crying. We so scared ourselves with our own noise that we began bawling all the louder. Mother however was a tough, no-nonsense woman. When our hullabaloo got loud enough to reach her ears, she came charging in, dragged us out from our hiding places and gave us all a good spanking.

This parental attitude, that children were to be punished not only for being bad but also for making mistakes, for being afraid, for being ill, for being careless, for lacking vigilance, took some getting used to. I guess the message got across because the Kureleks tend to hide their personal troubles and failures from each other to this day.

On the other hand, when we were in real trouble, Mother did come to our rescue. On one occasion – magnificently: whenever geese have young they hiss and flap their wings and, lowering their heads to the ground, come charging at intruders. We children used to taunt them just for the fun of it. This once we came a bit too close and the geese chased us. Winnie tripped and the flock pounced on her. John and I, her own brothers, weren't chivalrous enough to think of anything except saving our own skins. But Mother, who had heard our cries, rushed out of the

house snatching up a broom as she went and with a few healthy swipes knocked the geese a-flying.

This tendency of children to be cruel to animals got its come-uppance that time. Most of the time it didn't. In winter we loved to fool the pigs. They thought we were throwing goodies into their pen when it was really their own frozen dung. We marvelled at their teeth going crunch, crunch, crunch, on the frozen "morsels" as they swallowed it. I took a kind of fiendish delight in cats. Aside from pulling tails, I vaguely recall the time I threw one of them on the hot stove. Her feet tripped in a peculiar kind of dance as they sizzled and I was guilt-stricken.

Nobody knows, but it may have been that stove which eventually burned the house down. Mother and Father had left us with the Melnychuks for a few days while they'd gone to the city. Some farm people set fire to their own house to collect insurance and pay off mortgages. But standing next day beside the ruins I didn't believe my parents could have done it. Father looked mighty grim. Mother was openly weeping. A sickly smoked odour prevailed in the air. Our barn and neighbour Kirika's granary had also gone up in the blaze. To my child's mind, the most ominous sight of all was the way the old wood stove now hung down into the root cellar by one leg. The pile of potatoes down there had been cooked and charred by the heat.

A fire destroys more than goods. It also destroys memories and affections. The lovely sepia photos of Mother, beautiful in young womanhood, would never again adorn the walls. Gone too were the religious calendars from which I had acquired anthropomorphic concepts of God and heaven. I gather Mother and Father had believed and even prayed on their knees after their marriage. Now even these vestiges of faith had been, as it were, consumed in the blaze. Never again was I to see an icon grace their livingroom walls—not in Alberta or Manitoba or Ontario.

Speaking of family photos, how odd a child's conception of picture-taking can be! When I heard that the Kureleks and the Melnychuks were going to have a family photo taken outside, I imagined it meant taking down all those pictures from the livingroom walls and arranging them in some kind of impressive display. Instead, the pictures stayed in the house and we people were squeezed into a tight group out in the yard. A small black box was aimed at us and that was all—not even a roll of thunder or a flash of light.

After the fire, we lived in the small log shack that had stood next to the house and had somehow escaped the conflagration. Meanwhile

another house, a replica of the old one but made of lumber instead of logs, was being built on the old foundation. Clay plastering was a common feature of Ukrainian peasant building and one of my memories of life in that squalid old shack is of the greater water stains that used to darken its clay walls whenever it rained. The rest are just fragments, like the details of larger paintings one sees in art books: rows of cabbage stumps protruding from the snow; the smell of sauerkraut which Mother used to make in a big barrel each fall; the grey of overcast skies; the yellow green of urine cutting a ragged canyon beside the front doorstep. In another fragment, Father and I are in a wagon on the way to Grandmother's. He is pointing out to me one of nature's wonders – the tail of a skunk weaving above a wind-blown field of new wheat. Once a pair of trousers with skunk smell on them hung on our farmyard fence for so long the sun had quite bleached them and still we boys held our noses as we passed by on wet days. They had belonged to one of our hired men. Fresh from the Old Country, he too had seen that beautiful black and white striped tail waving at him as he was harrowing the field. Thinking it was a peculiar pussycat, he went over to give it a pat. Blasted full in the face, he was temporarily blinded and almost suffocated in the terrible odour.

Anyone who has read *Zorba The Greek* or Jerzy Kosinski's *The Painted Bird* will understand the insensitive earthiness of the Ukrainian community I grew up in. For instance, Mrs. Kirika, the old lady who lived to the south of us, was getting more and more difficult as a neighbour. What she really needed was sympathy but what she got was something else. One day Father came home after visiting her and described, with obvious relish, how during an argument she'd tried throwing a bucket of cow dung at him. He had put up his hand to protect himself and it had all dumped on her head instead. It was either that day or the next that she went completely berserk. Climbing into her attic she held a crowd of neighbours at bay with an axe. I was there when the local Mountie climbed up and disarmed her. She was taken away to an asylum.

It was the custom to take children to parties even though these went way past the usual bedtime. On this particular occasion, I over-ate and soon fell asleep on a couch in the living room. The next thing I knew it was night and I was drowsily waking to see a circle of faces around me in the reddish lamplight. They were the girls I had played with earlier in the day, now holding their noses and pointing at me with disgust and amusement. I had soiled my trousers in my sleep! My parents were so

43

angry they loaded me on the family wagon and drove home. I felt their disgust even in the way they touched me.

Another social event which I remember stands out in my mind's eye like a woodcut printed mostly in blacks, yellows and oranges. It is of my parents and me arriving by wagon on a chilly spring night for the Ukrainian Easter Vigil. In the churchyard are several large bonfires surrounded by scattered groups of men and boys warming their hands and chatting. The women, however, carrying their Easter baskets, go right in. I stand with Mother on the women's side of the church since I'm not yet considered to be a man. And when I say "stand" I mean exactly that for, as in the Ukraine, pews were unheard of in those days. Once the ceremony began, we had to stand upright six whole hours – all night without sleep.

For a small boy like myself, of course, the services seemed to drag on and on and on. Moreover, the men had to stand with bared head and I, though with the women, was expected to follow the men's rule about caps and hold it in my hand. Every once in a while Mother's sharp whisper would lance through my drowsiness: "Pick your cap off the floor!" I wouldn't believe her but when I did glance down, sure enough, there it was on the floor. At long last, just as the sun rose above the horizon, the big church bells would begin ringing loud and long, joined by the congregation singing in unison, "Christ is risen." When the refrain "He is risen indeed" was repeated I knew the end was at hand. People streamed out into the crisp morning air and lined up to have their baskets of Easter food blessed with holy water. This was followed by an even bigger commotion and gabble of voices and laughter as the horses were untied from hitching rails, the few Model T Fords revved up, and everyone dashed home to a big Easter breakfast.

Easter, like other Ukrainian feast days, was characterized by family visits which we children always looked forward to, especially our stays at Grandmother's. We were excited by the palatial size of the house and the other signs of Grandfather's wealth: the telephone, the car, the large barn filled with horses and cattle. In the meat room, a small pantry off to one side of the kitchen, hung a calendar reproduction of an old naval battle. It fascinated me. I mention this only because it was the first sign of my interest in art. It showed itself again a little later during a visit to my uncle's home in Willingdon. One of the older children we were playing with had drawn a set of house stairs. It was fascinating to see that steps could be depicted by line alone. Moreover, such lines made the steps

appear to be viewed from above as well as from below. When I made this observation to my playmates they dismissed it off hand. Thereafter I kept the wonder of that discovery to myself.

While incidents like these were hard enough to bear and perhaps contributed to my later problems with sociability, things were to get a lot worse with the arrival of the Great Depression and our simultaneous move to Manitoba. One of the earliest childhood pictures I can recall is of a woman who used to visit Mother to unburden herself of her woes. Her husband had left her. Her house had burned down. But to my child's mind, these harsh facts were not nearly as striking as her wearing an extra pair of stockings over her shoes to keep her feet warm. Depression, and the bankruptcy that followed, may have been the overt reason for my father's decision to move from Alberta to Manitoba. But I have a feeling there was more to it. Why were we children warned not to tell anyone we were leaving? Why did none of Mother's family see us off? Why was Mother weeping that time when Father was off in Manitoba looking for a new farm?

We were told we'd have our first ever train ride and at last came the day of our secret departure. I was stunned by my first experience of a train up close. The ground shook as the locomotive came in like a black thundering cloud of hissing steam. But the initial excitement soon wore off to be replaced by tedium. Day after day the train headed ever eastward. There was only one break, an overnight stop in some big city. I remember a small bulldog trotting around in the hotel lobby and people smiling because we children thought the sound of his nails on the floor meant he had horseshoes on.

Journey's end was the C. P. R. station in Winnipeg where Father met us. Once again Mother was crying. Nevertheless, we had two happy days in a small hotel on Main Street. On the evening of the last day we boarded a street car going north to the town of Stonewall. We were met in pitch darkness by my father's cousin, Mr. Budjak, in a wagon. He let us off at the gate of our new farm. While we walked the rest of the way through the bush, Father pointed out the various buildings – what little we could make of them in the dark. To my surprise, we didn't stop at the palatial-sized house. Some people were still renting it. We went on to another house at the far end of the yard.

CHAPTER FOUR
School Days

With the coming of daylight next morning we children got our first clear picture of Father's new kingdom. It seemed like a quarter mile between house and barn. All the buildings – the garage, small chicken coop, big chicken coop, small barn, big barn, milkhouse, pig sty, granary and, lastly, the palatial three-storey farmhouse were strung loosely around a huge open area. It took a good shout to make one's self heard from one building to another. The whole estate had once been operated as a prosperous cheese farm by an immigrant Swiss, Mr. Kern, but he had now retired to Winnipeg – "the feared landlord" who could swoop down from the big city to foreclose if we didn't come across with the mortgage payments. Only low Depression prices gave Father the audacity to make a down payment on such a large farm. It had 600 acres, only forty short of a whole section. Everyone regarded it as one of the larger spreads along the highway.

Already we were fascinated by what we called "the big barn," to distinguish it from the smaller horse barn on the south side of the milkhouse, slipping in and out of its vacant stalls. Mr. Kern must have had fifty to sixty cows at the peak of his cheese farm operation. The upstairs of the barn, the hayloft, was of a breathtaking size and filled with mysterious hay carrying equipment. While investigating the lower part, we got caught literally with our pants down in a favourite pastime of ours – an elimination contest to see who could make the biggest pile. We were squatting in one of the bull pens when a young fellow leading a team of horses walked in and grinned when he saw us hastily pulling up our pants and bloomers. This was Alec Budjak, the eldest son of Father's cousin John, the one who had helped Father find the farm in the first place.

Later that same morning Mother took us on a visit to our nearest neighbours, the Kostyks, whose farm was on the other side of the highway. I now remember nothing of that first visit except the pleasant feeling that they were nice people and we children were going to have a lot of fun playing with their daughters Effie and Patsy.

As arranged, the tenants in the farmhouse moved out soon after we arrived. We children rushed like wildfire from top to bottom, from room to room, exclaiming excitedly to each other at the many objects we found left abandoned by the previous occupants – broken toys, old Valentines, cast-off clothing. Each room seemed to have its own closet and therein most of the treasures were to be discovered. In the basement was an awe-inspiring octopus of a coal and wood-burning furnace. In fact, we Kureleks had never in our lives seen such a thing as a full basement! Another marvel for us was electric wiring. The ends of it protruded from the walls, patiently awaiting the day electric powerlines would come down the highway. The kitchen, always the focal point in a farm house, was so large it even had a hand pump in it so we didn't have to fetch water from the well outside. The sink emptied out behind the house. Mother was delighted but Father was convinced the kitchen was on the wrong side of the house. He was right. A few years later the milkhouse burned down and, if the kitchen had faced the yard, we'd have seen the blaze in time to extinguish it.

But my enthusiasm for Manitoba was to be very short-lived. A few days later began the most traumatic experience of my pre-adult life – starting school. Victoria School could be seen from our milkhouse a mile away. Mother led John and me there by the hand and presented us to the teacher, Miss Irwin. It was a chilly, grey, early spring day – a perfect backdrop to our feelings. I was relieved to see that Effie and Patsy were there but, to my dismay, they avoided us. The reason was language embarrassment. We would immediately start chattering in Ukrainian only to discover there was a kind of unwritten taboo on any language but English in a public school. So it was that, at our very first recess, John and I found ourselves standing alone against the south wall of the school building watching all the other children playing a strange assortment of rough and tumble country games. Some of the older ones would approach us once in a while with a grin and use the one Ukrainian word they seemed to know: "Zemmo? Are you cold?" We could only grin back sheepishly. That made it a one word conversation. Fortunately, this near total communication barrier lasted only a few days for we soon

made the acquaintance of Norman Zozula, who had no qualms about talking Ukrainian – provided the three of us were alone in the school yard. We were happier right away.

The second day of school was even worse. It was windy and for some reason John had to stay home. I got dressed for school, put the school bag over my shoulder and set out. I lost courage before I got past the other end of our yard. Dropping down at a big stone near the small chicken coop I cried my heart out. Presently, the shadow of Mother fell over me. "How come you're not at school?" "Because it's too windy," I sobbed, raising my tear-stained face up to her for sympathy. "Nonsense," she shot back as she lifted me up by the arm. She gave me such a warming on the backside that I almost flew the rest of the mile to school.

Little did I realize our disasters were only beginning. John and I made blunder after blunder. As we sat at our grade one desk below the windows in the north wall I spotted a fly on one of them. *"Mookha! Mookha!"* I exclaimed pointing to it. John even got up to catch it. The teacher stared icily and the classroom roared with laughter as we sank red-faced back into our seats. A few days later came another traumatic experience that, while not squashing my natural inclination to education, nevertheless very much inhibited my enthusiasm for oral expression. Miss Irwin had us first graders up at the front of the room in a row while she showed us pictures of various animals to identify by name. When a picture of a cow clipped off a Cow Brand Baking Soda box was presented, I could restrain my excitement no longer – *"Ya, Khochooh toh robeteh* – I want to do that!" I exclaimed. "Beg pardon?" The teacher was staring at me. Then it hit me: I'd used the wrong language. I clammed up immediately and wished with all my heart that it was possible to sink beneath the floor. This calling up of pupils to the front was standard practice for subjects like reading. A few of the younger pupils would suffer such nervousness they'd wet their pants. There'd be a general tittering in the room as a yellow rivulet meandered from under the unfortunate's shoes and trickled towards one of the front desks. Thank goodness I didn't have that handicap to add to my misery.

Within a few days we found we'd been singled out for bullying by the older boys: Alan Dolensky, Alec Scott, Mills Lyon and Willie Hill. Somehow Fred Tomyk, the son of another of our neighbours, and Bill Myron managed to stay neutral. Fred Tomyk, in fact, carried me across the flood in front of the school gate in his big white rubbers one morning and I remember looking up into his smiling face with complete, utter gratitude.

To everyone else the flooding presented yet another opportunity for cruel sport at the expense of any kids who had no big brother to protect them. The ditch in front of the school would freeze over each night in early spring, forming a thin crust of ice. With barely concealed expressions of delight these fellows would half-persuade, half-force John and me and other little greenhorns out on to that ice to test it. Sooner or later we'd all break through and have to be taken, soaking wet and cold, into the schoolroom where the teacher had to undress us and dry off our underwear behind the stove. The bullies would glance up at us from their studies from time to time with quite open, gloating grins. I'm not sure if the teacher realized who was really to blame for all her trouble. Our companions in humiliation were usually the two Williamson boys, Edward and Henry. They were a very poor family whom my father always used to point out to us as an example of shiftlessness.

A new sport seemed to be devised by the big boys at our expense every few days. I can still picture one which happened that sad spring: John and I are walking home with the Williamson boys. In spite of our small stock of English words, we are managing to carry on an amiable conversation. Just then a sleighload of older boys drove past us on the snowy shoulder of the road, deliberately, slowly, saying something to Edward and Henry in English which John and I couldn't understand. We found out soon enough. Without warning, Edward and Henry set down their lunch cans and attacked us with fisticuffs. Their attack was an obviously half-hearted attempt to get into the good graces of the bullies and we managed to hold our own easily. That's when Willie Hill's young brother Bob gets sicked on us as well. Appropriately dressed in black winter cap and black sweater, he leapt off the sleigh and came charging at us like a bull. The next thing I know, John and I are running down the road crying, the sleigh is pulling away and the bullies are laughing.

Naturally, next day, John and I were afraid to come home by the highway. I persuade my brother, who half-heartedly agrees, to cut across our farm. This scheme might have worked at any other time of year except that particular week because, apart from the odd patch of snow, the plowed field was a sea of mud. We are soon bespattered and, worse, we sink into the mud so deep it sucks our low rubbers right off our feet. John is crying and cursing me for getting us into this mess. Meanwhile on the highway, out of the corner of my eye, I can see the sleighload of older boys driving by and guffawing with glee.

To Mother and Father, our troubles look like a neighbourhood con-

spiracy because there is jealousy of Father's large farm. He is already being called *pahn* (lord of the manor) in derision behind his back. These people must be influencing their children to pick on the young Kureleks. Mother comes once more with us to school, this time to explain our unhappy situation to the teacher. As soon as Mother goes, the teacher announces to the assembled school that all bullying of the Kurelek children must forthwith cease. The bullies are staring coldly at us. That recess, they leave us completely alone and refuse to speak to us. Norman, Effie, Patsy shun us too.

John and I still have each other of course. But not for long. The teacher decides John is too young to continue the rest of that term. I am left all by my lonesome, sitting among the dandelions in the school yard while the others play in the distance. I pretend I am enjoying my solitude, that I don't really care for the games of the others because I'm absorbed in making something out of dandelion stems. But it's not true. I am very, very unhappy, suffering to the depths of what I now have to admit was a hyper-sensitive personality all along.

Alec Scott's brand of bullying was especially memorable: All the boys were playing in the school barn during recess because it was raining outside. Alec comes up to me. I pretend not to notice him because I already know what he is like. But it's no use. I can tell by the glint in his eyes that I, and no other, am to be the victim. He places a chip on his shoulder. "Knock that chip off or I'll hit you," he demands. I'd already learned that knocking a chip off a shoulder is an open invitation to a fight. So I'm going to "get it" no matter what I do. I refuse to knock it off so he slugs me. I back away blinking tears. For me as a farm boy, even then, life came through in the form of animal imagery. What choice had I but to back away like a yelping pup before a ponderous bull? But it was even worse than that, for animals know nothing of humiliation. It gives physical pain a crueller twist. I discovered there is a heartless mob streak in human nature that sees a fight, any fight, no matter how unequal, as an amusement. Many a fight I saw in that school yard when the pupils would encircle a pair of combatants and watch the nose, the lips, the face of the underdog smashed and bloodied by flailing fists. The loser was always left on the ground sobbing in raging helplessness. Not once did I see anyone break the social code and comfort the vanquished in his humiliation.

At last those wretched first four months were over! School was out for the summer holidays. "Maybe next year school will be better," I told

myself. Sure enough, in the fall, I found the battlefront changed. Alan Dolensky and Mills Lyon were gone. My brother John had rejoined me. But, alas, for each of the old enemies that had retired, new ones appeared in new stances of hostility. The secret, helpless rage within was not to be alleviated but deepened by the new humiliations yet in store.

Effie and Patsy, who had played amiably enough with us during the summer, were still cold to us at school. Language was no longer the barrier. There was a new one now. I can still see myself in the Kostyks' summer kitchen innocently revealing to Mrs. Kostyk how her girls had been snubbing John and me at school. All the while I'm getting sharp kicks under the table meaning, "Stop it, stop it. Stop tattling on us, you scab." The problem was that our enemies at school had gotten wind of our friendliness at home and a new game had developed at our expense. We were being teased about being "boy friends" and "girl friends." The Koystyk girls are embarrassed and work hard while at school to dispel the image. And Norman Zozula, who seemed such a promising playmate at the very beginning, has now become as aloof as if he actually despised us. We never do regain his friendship. How we'd love to be invited to his place again where he once showed us his playhouse. It is a fascinating little shack in the bush, just chockful of all kinds of bric-a-brac and homemade gadgets. At school he has now taken on a new "sunny-boy" role of popularity with the older pupils. He is handsome, intelligent, strong. Before his "sunshine" I cringe inside myself with inferiority feelings.

If they had been mere imaginary feelings perhaps I'd not have been scarred so deeply. The trouble was that my inferiority was proven with frightening swiftness to be very real anytime I dared stand up to my tormentors. Norman was joined by his opposite number, "sunny-girl" Victoria Dolensky, the young sister of none other than the chief bully of the previous year. To this day I cannot comprehend the power she held over me. I used to cringe even when she merely glared in my direction. After a while it seemed to me Norman and Victoria were working as a team to subjugate me. It's the following spring and once again there's water and slush all over the school yard. A fight starts up between my brother and Norman. Norman simply gives John a shove and John gets up off the ground near crying with his hind quarters dripping wet. I pretend not to have noticed because then my parents would ask, "Why didn't you defend your brother?" Victoria is laughing with glee as she points out John's dripping posterior to everyone and praises Norman for his

strength. Once more Norman is the hero and I the coward.

In my inner fantasy life I spent a lot of time throttling Norman and demanding he apologize. But I only hurt myself with this interior seething. In reality I dared not show my anger. My enemies were just waiting for a chance to enjoy slapping me down. Actually, it would have been senseless to attack Norman. He had an older sister and friends who would have stood up for him right away if he had ever seemed to be losing a battle. But he needed no such help. He was stronger, quicker, more wiry than either John or me.

We found this out to our sorrow when we tried once more to stand up to our bullies. It was winter and for some reason John was foolhardy enough during recess to toss a snowball in Norman's direction. Norman was with Alec Scott. Alec of course jumped at the chance for a fight. He whipped back a hard-packed dirty snowball and, this time, I did come to John's defence. But if we were no match for Norman, to have tackled Alec as well was madness. The exchange of snowballs couldn't have lasted more than ten minutes till recess was over but John and I were naturally scrawny and over-dressed in heavy winter clothing. Very shortly we were sweating heavily and completely exhausted trading shot for shot. To our adversaries it was a lark. John and I could hardly reach them, let alone make a direct hit. They stayed so cool and in control of the situation that whenever John did make a direct hit they simply walked over and washed his face in the snow.

Recess was over. Everyone had gone in, leaving us exhausted. The teacher asked us to explain why we were late but we were so racked with sobs we couldn't speak to defend ourselves. It would be six years before John and I got up the courage to make another desperate bid against our tormentors. Defending oneself was so utterly, utterly useless that there was no way out except to wait.

However, there was some relief from the previous school year. The ostracism imposed by the bullies could no longer be fully enforced. New pupils appeared who did not consider themselves bound by last year's events. One of these was Johnny Giesbrecht, the son of a Mennonite farmer-preacher. John and I knew enough English by then to be able to converse with him and he was scrawny like us as well. He became our favourite playmate for a while and one day we were invited to his place after school. This was in the opposite direction to our farm so John and I returned home considerably later than usual. I had had an uneasy feeling all along that we shouldn't be there. John assured me Mother had told

me our taking off that day was alright. But I knew she usually expected us to bring the cows in for milking on our way home. Sure enough, the good time we had had at Johnny's was painfully equalled by the good spanking we got on our return. No protestations of innocence from John or accusations against him from me could pull the wool over my mother's eyes.

The friendship between John Giesbrecht and me was far from brimming over with love. A pronounced scholastic rivalry developed between us and we watched each other like hawks for any opening in the other's defences. I suppose in my own way I wasn't any kinder to him in his defeats than others were to me in tests of physical strength. I went to the top of the class while still in grade one and held on to that position till grade nine, which was the last year in public school. My average usually hovered at ninety or over. And I drew Johnny's attention to this whenever he'd top me in a minor test. That was usually in arithmetic, and these little upsets rankled me. Touchy as I was, and clinging desperately to any possible source of self-respect, I was even less prepared for the blow that hit me at Easter examinations in grade four. Johnny came out with top class average. I can still see myself with several other pupils gathered round the teacher's desk while she totals up the marks and averages. Johnny is beside himself with glee. Victoria Dolensky is taunting me. "What happened, William?" I am tongue-tied with disbelief. That night I swear an oath on my private altar of scholastic superiority: "Never, never again this humiliation!" I did pull back into first place in June, but Johnny and I were to wrestle for laurels no more because the Giesbrecht family moved away.

This was a blow, for our rivalry had begun to stimulate my art work as well. I still remember how it first came up. It was a grey fall day and the two of us were standing against the school wall when one of us, I forget which, took it into his head to taunt the other: "I bet I can draw a better train than you." "I bet you can't!" So in we went, even though recess wasn't over, and each drew his respective train. I don't recall now whose train was in fact better. Naturally I thought mine was. But that was beside the point really, for in an intense rivalry like ours, no contest not actually umpired by a third party could possibly have a decisive victory. Even if one drawing had in fact been obviously superior, the loser would still have gone down shouting, "I win! I win!" The important thing that did come out of the contest, as far as my own future was concerned, was my recognition that I could draw. I then began to notice that others in

54

the school, however grudgingly, began to admit that I did excel in at least this one thing. Considering my many early failures and feelings of inadequacy, it hardly needs a Sigmund Freud to understand why I later developed an almost obsessive creative drive.

Meanwhile, the pressure to learn English was so strong that I found myself being pushed to the opposite extreme – I began to lose my Ukrainian. We Kurelek children still understood it as well as ever – no problem there – but the pronunciation began to give us trouble. Our parents began to laugh at our growing clumsiness with the mother tongue imagining, I suppose, that this would shame us into proper pronunciation. In fact it had the opposite effect. When we resorted to communicating in English, Mother's common taunt was, "Scho Feh Kazlesh? What are you saying?" Father was quite openly anti-English, ridiculing the absurdity of a language that required spelling. The end result was that we tended to avoid talking to our parents altogether.

But I loved learning English. Our teacher used a method called "Tickets." We had to copy out sentences using letters on little pieces of coloured cardboard. I don't recall how good I was at Tickets, but I do remember loving those bright colours. I also loved the smell of plasticine. No doubt this accounts for the pleasant associations school desks still have for me. So much of a child's early life is spent on that two foot square of hardwood. I managed to salvage one of my own a few years ago and all its scratches and carvings and stains brought back a flood of memories. Weather had washed and bleached away its other souvenir markings, nose-bleeds, ink splashes, even foot prints, while the desk stood derelict in the grass behind the school. Yes, shocking as it may sound, pupils hopped on top of the desks to run from one to the other. This usually happened during the paper-dart and elastic wars that erupted when the teacher hadn't arrived in the morning or had stepped out to the toilet. The ink would jump out of the ink wells and the occupant would scramble to catch the leak before it ran down amongst his books inside the desk. Of course, the Kureleks took only a timid part in such rowdiness. It was hard enough to get praise from my parents for good marks. Had they heard we were discipline problems, they would have taken that as personal insubordination to themselves.

After Father had worked and harvested the land that first summer, he returned to Alberta for a few weeks in the fall. I assume now it was to dispose of what remained of his property back there. He had left instructions with Mr. Budjak and a hired man to finish hauling the hay into the

loft of the big barn. One night, while Father was still away, the whole thing went up in flames. I shall never forget the awesomeness of that sight. As the fire ate away the exterior shell of boards and shingles, it revealed blackened rafters and beams and the barn took on the aspect of a gaunt animal with its rib cage exposed. The great mass of burning hay inside became the internal organs, blackened on the outside, but inside heaving and throwing out sparks of intense reds, oranges and yellows. Above it all towered an upward draught of hot air that carried red hot shingles ever so high into the sky. There must have been a northerly breeze because the following day the school yard was littered with their greyed remnants. Finally, when the fire had eaten through the floor of the hayloft, the whole mass of still unburned hay crashed into the stalls below.

A circle of neighbours watched the spectacle from a safe distance. We children stood amongst them vaguely aware of all the waste both in man hours and in feed, but mostly beside ourselves with excitement. I must have expressed my elation in some way for I recall Mother boxing my ears right there and then. Perhaps she was worried my behaviour might arouse suspicion. Once again, as with the Alberta fire, it might be said that the fire was deliberately set to collect fire insurance. As a matter of fact, the insurance company took no chances and when Father returned from Alberta a few days later, they set about thoroughly investigating his movements. Obviously, he himself couldn't have been in two places at once and no collusion was uncovered. A plausible story accepted by most was that one of the workers taking in the last load of hay had been smoking. Father was too cagey an old country peasant to have conspired with Mr. Budjak or the hired man. He'd never have slept secure knowing that he could at any time be betrayed. But there is no escaping the fact that the fire was a great blessing. It brought in such a fat sum in insurance money that Father was able to pay off most of the mortgage to Mr. Kern.

CHAPTER FIVE
The Family

A few years later, before it too burned down, the milkhouse was used as a temporary home by uncle George and his family. Father had brought them out of Romania just in the nick of time – the rival forces of World War Two were aligning themselves for combat in Eastern Europe. Once more the occasion demanded a group photograph. We drove all the way to a Winnipeg studio, but the photo turned out badly and had to be retouched, an omen of the bad times yet to come. I recall being repeatedly scolded by my parents to keep my chin up and smile.

The two older Kureleks were both headstrong and touchy and quarrelling soon began over whether or not Father had promised to sign over a part of the farm to uncle George. This all took place in our dining room and Mother kept butting in trying to stop it.

Sometimes, however, elements of a what might be called divine justice intervened in the feuding. One time my one-year-old cousin, Metro, pulled a pot of boiling liquid on himself. My parents were disgusted: "We'd never let a stupid thing like that happen in our home!" A few days later my sister Nancy, the same age as Metro, tried lifting a log of wood out of our open oven. It dropped, pinning the back of her hand against the hot stove.

Poor Nancy! Another incident also involved her. Father had brought home a loaded shotgun and placed it in the kitchen corner, warning us children not to come near it. That evening, while my parents were in the barn milking, I left her alone in the upstairs hallway, taking a chance she'd not toddle into the kitchen while I sneaked into the basement to make myself a jelly sandwich. There was a terrific explosion. "Oh my gosh, Nancy!" flashed through my mind as I dropped the sandwich and charged up the stairs. But no, there she was, a little angel, waiting for me

at the cellar door. Intensely relieved, I felt free to investigate. My uncle was sitting in the kitchen in a state of shock with the shotgun in his hands pointed at the floor.

Matters came to a head when Mother noticed that the eggs which the chickens used to lay under the horses' mangers were no longer to be found. Father decided Aunty must be taking them, so he played detective. He announced one day, within Aunty's hearing, that he was going to Winnipeg next morning. I happened to be near the barn when Aunty came out carrying a covered pail. She was headed toward the milkhouse when, suddenly, the north side loft door of the barn swung open and Father, who I too thought was in Winnipeg, jumped to the ground, ran to Aunty and demanded to see the contents of her pail. There was no doubt in our family's mind she'd been caught red-handed. Uncle George and his family moved away to British Columbia and the two brothers are on no-speaking terms to this day.

Not only uncle George but, one by one, most of our Ukrainian neighbours broke off relations with our family. It really hurt when my parents told us not to play with the Kostyk girls. I missed the Tomyks, too, and the Budjaks. But I got really worried when Father warned me against playing with Steve. Steve was an only child and this got him all kinds of goodies from his doting parents – marbles, comic books, guns, you name it. He was a natural leader at school, all the more so since the farm which surrounded it on three sides was "his" farm. I never ceased being amazed at his scouting ability. If, for example, he was the leader of the cowboys, the opposite side, the Indian war party, was practically doomed to annihilation. Even if the Indians managed to massacre all of his cowboy gang, he himself would appear out of nowhere – from up a tree perhaps – and shoot dead all the scalphunters caught out in the open: "Bang William, bang John, bang Bob, bang Robert, bang Gerhardt, bang, bang, you're dead!"

But Father thought Steve was a troublemaker. Not that he was mean or a schemer, just that he was dangerous. For example, there was the time he cut Charlie Muller's leg with a scythe. Harwood, Mr. Dure's epileptic thirty-two year old son, was cutting grass with a scythe in a field next to the school. Steve hopped the fence with a bunch of our boys and borrowed the scythe from Harwood to try it out himself. This was precisely the kind of interest in everything that my father wished I had. But after only two swatches the scythe hooked Charlie's leg back of the ankle and cut it to the bone. Charlie walked back to the school

bleeding profusely. When the teacher didn't believe the seriousness of the wound, Charlie took off his running shoe and poured out the blood. She fainted and suddenly we had two casualties on our hands.

My turn for injury came soon enough. It was threshing time on our farm and Steve, curious as ever, came over and right there and then invented the game of us Kurelek boys running round the big granary in the opposite direction from him. The noise of the thresher and the rain of chaff concealed our approach from each other and Steve and I collided with an awful impact at one corner. His physical resilience saved him, but I lay on the ground stunned for a few minutes. Worse, when I did rise, I found I was bleeding at the crotch. Mother called the doctor fearing I'd been gelded for life. After examination he announced to everyone's relief, including Steve's, that it was nothing serious. Later, out of Steve's hearing, Father glowered, "You see, I told you, you have to beware of that guy!"

The trouble was that all of us were way behind Steve in agility and daring. My infamous leap from the hay loft was a case in point. Several of us were playing in our barn loft one summer's day when, with casual bravado, Steve leapt out the loft door to the ground outside, fifteen feet below, calling us to follow him to a rendezvous on the other side of the barn. I suppressed a gasp while one by one like paratroopers the others, including John, followed him. Fearful of being called a sissy I jumped too, last of all. By the time I hit the ground the others had already vanished around the corner of the barn, so I had my painful surprise all to myself. The landing was bad enough but the error I made was not to centre my chin between my legs. Down it came, wham! on one of my knee caps. I can tell you I saw stars a-plenty even on that bright sunshiney side of the barn.

Aside from cutting grass and doing odd jobs, Harwood Dure's epileptic seizures kept him a dependent all his life. Once a year our teacher would let him entertain the class by drawing cartoons on the blackboard and embellishing them with fanciful tales as he went along. I looked forward to his hilarious work-free visits but his ability always had me worried about my own talent. My own work seemed so laboured by comparison. It wasn't too happy in theme either.

Recently I discovered some of my early drawings in my parents' attic. When I showed them to my wife they struck her as being frightfully violent: people's heads being ripped off by cannon balls, bullet-like baseballs throwing terrified players off balance, heavy arrows crashing

59

through a knight's shield to stab him in the eye. My desk housed a mass of such works at all times. I did them every chance I got, even on the sly inside the desk during class hours. At recess, and in art periods on Friday afternoons, I began to get the recognition I so badly needed. Once, I recall, the press of students was so tight some even got up on top of their desks in order to see me executing a particular drawing.

In that once a week art period the pupils would go through a yearly cycle of drawing and colouring and cutting out decorations for the various holidays. I was conceited enough about my talent to pooh-pooh any real competition from the others. Instead I competed with myself to see if I'd made a better Santa Claus, or shamrock, or Valentine than the previous year.

I was becoming intellectually cocky as well. I could see, for example, that I knew more ancient history than the teacher. As for science, well, she was hopeless. "Suppose," she said one day, "men were to dig down to the centre of the earth and all the gravity leaked out. Wouldn't we all fall off the earth?" I grinned and gloated to myself, "That's silly!" About that time I tried explaining the eclipse of the moon to my father. He insisted on his home-made theory that the moon was like a flashlight that turned toward or away from us. That was when I realized I had already passed him in learning.

But nothing could surpass his ability to antagonize our neighbours. The feuding got so bad that some of them resorted to underhand ways of getting even. Once, for example, a wagon load of grain was stolen from one of our outlying granaries. Father followed the tracks as far as he could but lost them on the hard surface of the highway. To make matters worse, the tracks looked like they had been made by our own wagon which had been borrowed only a few days previously.

Then there was the time my parents were given a bottle of home brew. It was illegal and anyway my parents didn't drink it. But somehow they didn't think it nice to refuse. That very afternoon we children drew our parents' attention to a car pulling through the gates at the top of our long driveway. We could see it picking up speed, belting down the drive at a speed visitors never used. My parents galvanized into action. Mother dove into the pantry and snatching up the illegal bottle, deposited it in her bosom and dashed down the hall to the back door. Two Mounties piled out of the car as it ground to a halt in a cloud of dust beside the house. One came in the front and the second headed for the back just as Mother emerged. I still have a mental picture of him trying to head her

off with out-stretched arms as she headed relentlessly toward a white-washed stone in the grass. Mother was a crack shot with a .22 rifle and her aim served her well as she whipped out the bottle and heaved it at the stone. "What'd you have in that bottle?" the frustrated Mountie demanded. "I'm expecting a baby and it was a special medicine," came her breathless story while the other cop skidded to his knees at the stone trying in vain to wipe up enough evidence for a conviction with his handkerchief.

Sometimes these feuds began with a wrong word spoken in the wrong place. We got along well enough with the Lewaks and the Wowchuks until, one winter's day, my mother paid a visit to the house they shared. That evening, after she'd gone, one of the women there became seriously ill and blurted out, "Mrs. Kurelek is a witch!" Eventually the remark reached Mother's ears. "Well!" she said, "You'll never see me in *that* house again!"

Because it was a dairying district there were always herds of cows moving down our country roads. Cows are pesky creatures and, if not driven smartly along, poke their heads through fences to get at the farm crops just beyond their reach. If they press hard enough the wire or the posts snap and, before you know it, the whole herd has invaded the field. Our farm was particularly vulnerable because the municipal road dividing it in half gave us six fences that might be broken. Finally, Father got fed up chasing strange cows off his property and canvassed for a municipal pound. He managed to get just enough signatures to push it through. The first cows that presented themselves for a test case were the Dolenskys'. Just as we were driving them off, Alan and his stepfather, old man Ryka, appeared. The old man ran in front of the herd, shouting and waving his hands to halt their progress, while we pressed them on from behind. For a moment it looked like there would be an ugly confrontation, but Alan decided against it. Giving us only a cold, hateful stare he said, "Let them go, Father. We'll even the score another day."

"Mark well what Alan said," Father warned us as we moved on to the pound with the cows. "Remember those exact words because you may have to be a witness in a court case." .

Possibly to catch my father off guard, Alan bided his time. That fall we were threshing late into the evening on the last field and the final load was up to the feeder. The hired man, a favourite of my father's, was pitching in the sheaves when he hesitated and began examining one of them closely. Father, I, and in fact everyone standing nearby to clean up

when the machine was stopped, wondered what he was getting at. Only when he pulled out a heavy iron bar which had been tied inside did we understand. Father figured out the villainy at once. Two weeks earlier the Dolensky boys had been cutting corn for the Tomyks just across the fence from that very field. Father telephoned his strong suspicions to the police, and we proceeded slowly, carefully, to do the rest of the field. One of us sat on the tractor with his foot ready at the clutch. Father stood on top watching every sheaf as it went in. Eventually we discovered one more iron bar. It smashed a few teeth in the cylinder before we could stop it but that was nothing compared to the heavy loss we'd have suffered if we'd not been forewarned. The police paid a visit to the Dolensky place. But they denied knowledge of the bars and since there was not enough evidence for a court case, Father had to forget about it.

Hallowe'en was a nightmare for him because he couldn't take a practical joke. The older boys would move a farmer's privy back a few feet, for example, and any one visiting it in the dark would fall into the gooey, smelly contents of its pit. Someone else might find his gate missing the next morning or that his buggy had been dismantled in the dark and reassembled up on the barn roof. Some prankster managed to get past our dog and removed the spark plug from our water pumping machine. Father was seething with anger because he had no way of knowing if the prankster hadn't also thrown something into the piston chamber to cause damage when the motor was started. He kept a loaded shotgun and powerful flashlight at the ready every Hallowe'en thereafter. Many's the time I recall him charging into the night shooting at real or imagined prowlers. In winter he could relax because no intruder would risk his footsteps being found and followed in the snow. I remember one Hallowe'en when John and I decided to go trick-or-treating. I went as Death. I was quite proud of my outfit which had a skull I'd drawn on cardboard sewn into the cowl of a white sheet. The costume was great for covering up my nervousness but I hadn't allowed for ventilation and found myself getting quite uncomfortable with perspiration if we tarried at someone's house. I can tell you I was more than a little nervous by the time we got as far as the Dolenskys'. We got a handout in spite of the family feud but we were also exposed to Alan's cruel sense of humour. "Hey, what's under that hood? He looked under my cowl and, in mock self-defence, landed a good punch smack into the middle of my mask.

Mother was usually serious but I do recall one balmy prairie night

when she surprised us by suggesting an unusual nature game. We took off all our clothes and romped in the moonlight in primitive naked delight at the caress of the air on our bodies and cool soft grass underfoot. She enjoyed our pixie dancing from the veranda until I chanced to cut my foot and the fun was over. On the other hand we also knew that she was strong on shame and modesty. When a bull or stallion was brought into the barnyard to impregnate our livestock she would shoo us away. That was how John and I knew we could tattle successfully on Jean Budjak after she'd done a naked pixie dance for us in a forest clearing one summer day.

My mother's shushing the subject of farmyard sex was really a lost cause as we couldn't help but see it all around us. Our dog, for example, would sometimes "ride" us when we'd roll on the ground. I must have felt a close kinship with animals because I used to follow our dog into the bush after he'd been beaten by Father and try to console him there. Father's farm and personal failures used to make him morose and he'd take his rage out on the animals. We had a black mare by the name of Dolly and the beatings she got broke my heart. She finally died of overwork. Yet I have to admit that had Father not been able to vent his pent-up anger on the animals, I myself would have got much worse than tongue-lashings.

My closeness to nature in turn drew me closest of all to a new boy at school. Joe Gay arrived from Poland with his parents in the Thirties and at first he couldn't speak a word of English. Remembering our own language ordeal, John and I befriended him early and he, perhaps in gratitude, became our constant companion whenever we were freed from work. We all got bicycles about then and every Sunday we'd go nature exploring out on the bog or in the local limestone quarry. He showed us a sandpit where thousands of cliff swallows had sculpted dwellings for themselves and scolded us whenever we tried to investigate their nests. And there was a haunted house half a mile from the Gay farm which we pedalled to on our trusty steeds.

And Joe was tough. I recall the time we were tossing darts in school. These were made of willow wands or match sticks fitted with paper fins and pen nibs for heads. The teacher had her head down in a book and didn't see that someone had tossed one of these ceilingward. It came down and stuck in Joe's head. Not a sound came out of him. He just winced and pulled it out and stowed it away.

Eventually Joe found us Kurelek boys too tame and weak. Many was

the secret heartache I had on seeing him move over to the big boys' company. I just didn't have the stamina in pedalling my bike to keep up with the other boys the way Joe did.

My parents knew this but they seemed to lay the blame on me by making remarks like, "People are talking that you're a sickly child." The gossips were in fact half right. Some half dozen years later – a crucial span of years for a growing boy – we discovered that my thyroid gland was underactive. I dreaded marathon errands my parents would send me on such as the five mile bicycle trip to Stonewall. It wasn't so bad with the wind, but against – it was agony. My reflexes were poor too. Coming up behind a car that had come to a halt at a stop sign in town, I banged into it before I could apply my brakes. I wasn't physically hurt, but emotionally it was yet another wound.

I'm not sure to what extent my physical lethargy was tied in with a kind of mental myopia I was suffering from. I did have intelligence – my standing at school proved that – but I seemed to be stupid anyway because of my tendency to be forgetful and daydream. Just to show how bad it was, there was the time mother sent me to the Stonewall Post Office to mail an important letter. I returned, having pedalled the total of ten miles, only to discover to my consternation that I'd forgotten to mail it. I was so scared of Father's reaction on hearing about it when he returned from the fields that I hid behind the woodpile for the rest of the afternoon. It was already dark by the time I felt it safe to come in for supper. Another example is the chicken coop door incident. We were returning from the barn in the evening when Mother questioned me: "Did you close the chicken coop door like I told you to?"

"No," I had to reply, already upset, "I opened it."

"What!" Mother exclaims. "What's on that mind of yours anyway?"

Father, the philosopher, adds his derisive contempt to Mother's expression of shock: "There, you see, deaf and stupid as usual. Just like the heifer staring at a new gate, only worse because a heifer isn't expected to know better."

Obviously they hoped to shame me into efficiency. Instead, I simply hung my head when scolded. I got so used to hanging my head that my parents took to criticising this trait as well.

Perhaps my upbringing would have been healthier had I been physically chastised instead of being given tongue-lashings. But spankings were so few I can actually count on one hand the number I received from Father. The first was the time I gave the Smith girls a complete

64

guided tour of all our farm buildings one Sunday afternoon. Father said nothing whatever to me while this was in progress, but as soon as the visitors were well out of sight down the highway he took down the razor strap and grabbed me by the arm. "Who gave you permission to give that tour? Who? Who? Who?" With each "Who" I got thumped across my bottom. After that I always regarded the strap with apprehension as I passed it hanging near the kitchen door. The next time I got it I was really disobedient. Bill Dutka, our hired man, had asked me to go home and bring a jug of water to where he and Father were building a haystack at the end our farm. I walked about half the way to the house and then sat down in the field to play in the mud cracks. I arrived at the house shortly before the stack builders came home for lunch. And lunch time was when I got the second and last spanking.

Actually, Mother punished us children much more often than Father. But I was more in terror of him than her, probably in anticipation of what he might do if his rage ever reached the striking out stage. This was reinforced by his ridiculing of Mother's disciplinary efforts. The only time I recall him actually striking me without premeditation was the time I helped him haul a hive of bees. He led the horse pulling the stone boat and warned me to hold on tight to the hive so the bees couldn't get out. It was a jerky ride, however, and soon cracks began to appear in the hive. At first I thought to avoid his ire by readjusting the hive myself. But after I'd got ten stings on my hands I saw it was hopeless and let him know I was having trouble. He ran up to me, booted me in the backside, and dismissed me from the job.

John was luckier than I in being talented mechanically. This aptitude came in very handy on the farm in Manitoba. I have already described the losing contest with John for my father's respect and affection in Alberta. This continued in Manitoba. It was 1939 and war news was coming through on the radio. A big passenger ship had been sunk. "If they'd make a lot of small ships instead of one big one, not so many people would drown," John observed. Father beamed with pleasure at his son's brilliance. I, who happened to be thinking the same thing, piped in, "I thought of that too." The two of them turned on me. "Well, why didn't you say it then?"

Because of our perpetual rivalry we had several disgraceful fights, one of which I regret to this day. It was about who owned a certain toy train. I beat him down and left him crying in the snow on our way home from school. Except for one embarrassing occasion when John wrestled me

65

down in a kitchen corner, much to my parents' amusement, I always won the fights between us simply because I was nearly two years older. I was still afraid of him however when he resorted to really dangerous things like throwing iron bars and rocks at me.

Partly because of rivalry with John I cultivated Winnie's friendship. At times it seemed I almost had a crush on her because of her good looks. In the earlier Manitoba years I even recall playing at dolls with her. I was ridiculed for being effeminate. Then there would come times when I just felt estranged from everyone. I began to experience very powerful persecution fantasies. I'm puzzled to this day that in memory I sometimes see no separation between fact and fantasy. One of my recurrent fantasies was of my family being "in cahoots" with my school enemies who were plotting to torture and execute me. The execution would take place in the preserves room in our basement where there was a meat chopping machine. Victims threw themselves into it with masochistic ecstasy.

I recall another time, at the tail end of winter, when I had caught a rare disease called trench mouth. My mouth walls were coming away in ragged gobs inside. My parents were hoping if would go away by itself as doctors' visits cost money. My illness dragged on a long time before they finally had to take me into town for a medicine prescription that cleared it up. During that illness I used to see Yahoo-like hairy creatures crawling out of and over the melting snowdrifts on the way to school. And one summer's morning very early, as I made my way to the outdoor privy, a most awful sensation overwhelmed me. It was as if I were choking on big spikey balls. I sat on the path trying to reach in and pull them out for quite some time before the feeling left me. Of course many of these images eventually became symbols in my more surrealistic works.

Some of my sacrificial masochistic imagery may also have derived from a children's radio serial called "Talking Drums." I well remember the day we got our first radio. Father got it primarily so he could listen to grain price quotations. He rigged up the aerial late in the evening and I was quite sleepy when I heard my first ever radio program. It sounded as if there was the breaking of surf on a beach in between each song or announcement. I found out later that it was applause in a concert hall. We children were mesmerized by the cereal-sponsored radio plays like The Lone Ranger and The Shadow. But Talking Drums held a special fascination for me because of the hypnotism scene in which Tara compels the hero to submit to her will against his better judgement. It inspired

in me a wonderful dream of a beautiful empress in a far away tropical country. Two white hunters shoot her pet peacock and are brought defiant before her. She is above using force as punishment however. She sings a song. The magic of it breaks them into complete subservience at her feet. The story and the elusive magic of the tune stayed with me for years.

My imagination was also fed by comic books and pulp Westerns which I read, appropriately enough, while pasturing cows. Pasturing was an all day job which we children had to do in the years before Father got an electric fence. It was all right as long as the cows were satisfied with what the pasture had to offer, for I could then read in peace. But more often than not some far away field would beckon and the cows would insist on crossing the forbidden line. Sometimes I'd aim at the worst troublemakers with my slingshot. Once or twice, when my shot made a particularly accurate strike in the middle of a forehead, the cow would shake her head as if stunned. I fell into a panic. Had I permanently injured her? What would my parents say?

Another chore was berry picking. Saskatoons, pin cherries, choke cherries, and cranberries were plentiful and had to be picked in season to be preserved, dried, or made into jams and jellies. Others in our neighbourhood or from the city thought they were entitled to pick in our bush too. So Father told me to make a NO BERRY PICKING sign to be nailed up on a tree on one corner of our farm. He expected me to do a good one since I was obviously artistically inclined. I was excited by the project and tried to make it professional—like the JOE'S LUNCH sign I had found in the grass by the chicken coop. My effort flopped and Father in disgust took the job away from me and put up a crude one of his own making. I noted with a wee wicked sense of satisfaction that Father's sign didn't work either: Mother still had to chase trespassing pickers off our property.

Although we children had no leisure or play relationship with Mother and Father, we were still lucky to have a work relationship. This is one advantage farm children have, or had in those days anyway. Thus I looked forward to the annual family job of transferring the chickens from several coops into one for the winter. There were a lot of chickens and they all had to be moved after dark when they had fallen asleep. We would leave our lantern outside the coop, step in and lift them off the roost and carry them head down by the legs, squawking but unresisting, to their new quarters. One winter, a legion of rats living under the chicken coop started feeding out of the grain troughs at night. That

called for another family effort. During the day we blocked up every hole in the floor except one. Over that one hole we suspended a steel plate attached to a string which could be operated from outside the coop. After dark, when the chickens were already on their roosts, we approached the building quietly and let down the steel trap. Then in we all rushed with our two dogs and a bright lantern and clubs: it was a massacre!

But some aspects of animal behaviour had us baffled. One of these was egg-eating. Once a chicken got the idea that eggs were tasty it would simply lay an egg and then turn around and eat it. We tried all kinds of tricks to break them of it: Blowing an egg out and refilling it with hot red pepper; sitting them on gunny sacking with a hole in the middle down which the eggs would disappear as soon as they were laid. Nothing seemed foolproof.

Another habit was cannibalism. If a chicken happened to get blood on itself the others would peck at it until its own blood began to flow. They would then keep pecking at the raw wound until they'd pecked it to death. But the trouble didn't end there. Some of the cannibals would now be spattered with blood and these were pecked in turn so that process would begin all over again.

Growing up with farm animals I began to see animal imagery in human behaviour and eventually this furnished the basis for much of the symbolism in my message paintings. The cannibal chickens, for example, struck me as analogous to the human trait of picking on a weakling. I observed that animals will fight for a place at a trough or over a mate just the way humans do, but they are dumb and cannot hurt their kind with malicious ideas conveyed with words. The feuding among the adults of the district was reflected in the behaviour of their children at school. Groups would form, usually among the girls, and usually with Victoria Dolensky as the leader of one of them. They'd spread mean stories and call each other names or not speak to each other for days and weeks at a time. Then there'd be a thaw followed by a new alignment of forces for a new war — very much as national states have behaved throughout history. I rejoiced the day Victoria proudly announced that she'd be attending school in Winnipeg the following year, only to see her role taken over by Eileen Samson.

The Samson sisters, along with the Smith girls, began calling us Kureleks names. The sport in it was to make us a laughing stock. The day came when Eileen, the oldest Samson girl, provoked my friend Joe Gay

by calling him "a damn Pollack." In the fight that followed, which the teacher broke up incidentally, I found a certain secret solace. It was now obvious that the war on us was drawn along racial lines and Joe had shown one could fight back. A few days later the name calling got so thick I decided to ACT.

It was a desperation course not only because the "enemy girls" outnumbered John and me four to two but also because the Samsons' older brother, Howard, was present as well. I hid a jagged piece of wood up my sleeve and as Letha Samson was cursing me I lunged at her and began jabbing at her with the piece of wood. Eileen Samson and Marguerite Smith then came at me with their nails and pieces of wood, and John came to my defence. There was a short, desperate fight. No more joined in the melee and so John and I were able to overpower Eileen, the strongest girl of the lot. She sank to the ground shielding her head in her arms and the fight was over. The other half dozen "enemy" had fled into the school house screaming, "He's using a knife on her!"

There followed an emotional court scene before an angry teacher, Miss West. The enemy tried to tell their story in their own way but they didn't get far before they broke down into sobs. When John tried to tell our side of the case, he too broke down. Only I, to my great surprise, probably because such a weight had been lifted off me, was able to stand up to defend myself.

Just as a short, violent thunderstorm clears the air after a long, oppressively hot summer's day, so the actual coming to blows cleared the atmosphere at school for months and even years to come.

69

CHAPTER SIX
Hard Times

My father's dislike of his eldest son came down on me with all its weight in 1939. Two events conspired to bring it on – the outbreak of war and a grasshopper plague. Almost overnight every able-bodied single man was drafted into the army or went to work for the war effort in city factories. Father's hired help disappeared. If he did happen to find someone at the employment office in Winnipeg he'd bring him home only to discover that he was a social reject in some way. John and I, small and scrawny as we were, had to step into a man's shoes. I was twelve, John only ten years old, but Father impatiently dismissed the age factor: "When I was nine in the old country, I had to plow all day by myself and I couldn't even see the furrow properly because the plow was taller than me."

The grasshopper plague had actually come in 1938 but the consequences of it only caught up with me the following year. I remember it was a summer morning when Father noticed a peculiar yellow cloud approaching from the east, over the bogland. The crops stood green, not too tall, but promising nevertheless. By evening the cloud had arrived. It was grasshoppers, billions of them, a flying, munching, crawling blanket that settled on the crops, the grass, even the leaves of the trees. Halted by the bush along the highway and the limestone escarpment just to the west, they piled up on our farm until we children were able to scoop them up in buckets as feed for the chickens.

The very next day Mr. Kern, our mortgager, drove out to see the extent of the damage. He was speechless at first. Then, raising his hat as a sign of defeat, he made the swift decision: "Never mind the mortgage payments this year. Cut down the crops quickly. It'll make green feed for your cattle if the hoppers don't get it all." Thus it was that our total yield of actual threshed grain for that year was a pitiful thirteen bushels! The

hoppers ate whatever was left and died of starvation. But before they died the females laid their eggs. Everywhere we could see thousands of wicked abdomens thrust into the parched ground depositing trouble for the following summer.

Father in that darkest hour seemed stronger, more serenely fatalistic, than I'd expected him to be. I recall him drawing the family together after one supper that fall and consoling us: "Never mind, we'll try one more year here and if that also fails then I know of another farm east of here that we can make a fresh start on." As if the grasshoppers hadn't been enough, we suffered a minor drought that year as well. The potatoes we dug that fall resembled outsized marbles, conveniently bite-sized when they were baked in their skins and dipped in the grease of an old cow we had slaughtered. It was a monotonous diet but we survived the winter.

I misread Father's true reaction to the disaster however. His initial show of bravery soon wore off. He was actually more bitter, desperate, morose, and ruthless when his back was against the wall. I couldn't accept this at the time but, some years later, I got a little insight into his reaction when my turn came to experience serious failure. Father drove himself and us mercilessly. The war suddenly brought miraculously good prices for farm produce and he saw this as a way not only to snatch the family farm from the jaws of disaster but also to make it the prosperous private kingdom he'd always dreamt of building.

Once in a while Mother would try to elicit our sympathy for Father. I still recall her saying, while Father was off in the distance on the binder cursing the horses, "You mustn't be annoyed with him. He's trying so hard and things aren't working out." What bothered me was that he was so impatient with us not because we were lazy—we weren't—but because we were inexperienced. Perfection, immediate perfection, was simply what he expected. I'd never operated a tractor in my life and knew nothing whatever of its mechanics. Yet suddenly, in the summer of 1939, I was placed on that black monster, the McCormick Deering, and expected to start it, drive it in a straight line, make proper turns at the corners of the field, even service it—all in one day.

Father had rigged up two binders to be pulled in tandem behind the McCormick Deering. Father sat on the first binder, John on the second, and I on the tractor. The binders were really designed for horses but we couldn't afford anything better. Old and decrepit, they broke down often, especially Father's, and I found myself having to jam on the brakes

again and again whenever Father yelled "Whoa!" This loud, angry voice behind my back unnerved me. After a while I could no longer distinguish between whether Father was angry at me or the binder for breaking down. Father's binder began to throw out untied sheaves and I didn't hear his first call to stop. "WHOA!" he bellowed. In panic I jammed on the clutch and brake. "Go on, what'd you stop for?" he asked sarcastically when the clattering din of the binders had stopped. I was so muddled I took him literally. Whereupon he bellowed all the louder. I stopped again. His glare was now so fierce I'd have sworn he was ready to murder me. This terror of some as yet unknown physical punishment from him hung like the sword of Damocles over me.

To offset all the time lost on breakdowns we cut well into the night. As long as the dew had not yet fallen to shrink the canvas conveyors it was possible to keep cutting. At the end of these long days John and I would fall into bed so dead tired we didn't even bother washing up or changing our clothes. Yet the next morning we were expected to get up at six a.m. and fetch the cows for milking. This chore wasn't strenuous in itself, but it meant dragging oneself out of bed and on to one's feet when every nerve screamed for more rest.

Nothing escaped his eagle eye. He was down on us continually when we were building haystacks to keep packing the centre of it higher than the sides at all times. Otherwise rain finds depressions and seeps in. "You see that mouldy, black and green patch. Cows won't eat that, and that's your work!"

At times I had the uncanny feeling that I was actually sabotaging farm operations. As if some secret part of me wanted to harm both me and Father. The time I froze the water pipeline to the barn was a case in point. I must explain that we used to have to drive the cows to the water trough at the pump house each day. It was an ordeal to man and beast. First one of us would have to thaw out the pump with a kettle of boiling water from the house and then proceed to pump energetically. Another one or two of us would drive the cows outside. They'd hunch up in reaction to the shocking cold after being cooped up in the dank but cozy stable. The weakest would get the last drink and we gave her just enough. Otherwise the leftover water would freeze solid and have to be chopped out next day. The trough was half-filled with ice at the sides as it was. A pipeline running high in the air from the pump house to the barn, such as a few of our neighbours already had, was the answer. Inside the barn were reservoir tanks and wooden troughs running in front

of all the cows just above their mangers. This system, once we got it installed, was a real blessing. But it had its risks too. On no account was water to be left in the pipes outside or it would freeze solid. Well, on two occasions, I closed the tap above the reservoir tanks so that the pipelines couldn't drain. Since I was the culprit, I was the one who had to climb the ladder into the freezing wind and snow and with a blow torch thaw it out inch by inch. Even more painful were my guilt feelings on watching an angry father and brother climbing into that same frigid wind. They finally had to help me to get the job done before nightfall to satisfy the bawling cattle.

One of many such incidents happened when Father sent me to check if the tractor crankcase had enough oil. You then closed the cock by screwing it outward, not inward as you'd expect. This time, however, I forgot which way was off. In fear of a possible scolding, and losing my nerve and reason completely, I plumped for the obvious and turned the cock inwards to shut it off. To my horror, the oil began to leak all the more. I was in trouble. I was going to get a tongue-lashing now regardless of whether I let it run dry or asked him to turn it off because I was confused. Petrified, I just stood there doing nothing. He was furious at the loss of oil he eventually discovered and once again dismissed me from the job with a swift kick in the backside. In my intense misery, I was developing a kind of concentration camp mentality called "depersonalization." In it, a person need not feel hurt, or not hurt nearly as much, because he is not a person.

This depersonalization seemed to induce sleepiness too. Mother would observe from time to time that I was walking around breathing heavily "like someone sleeping." The noise of farm machinery added to the drowsiness because of its monotony and when I became sleepy things fell apart under my eyes without my noticing. "Got to watch that bolt, got to what that bolt," I would keep repeating to myself to focus my attention on a particularly troublesome part of the mower, for example. But the tension of constant alert exhausted me all the more. Then, of course, other parts of the machine might also break down, some part I was not familiar with. When I got back to the house at meal time, I found it wasn't enough to report to Father that something was going wrong. I was expected to name or describe the broken piece so he could bring it along with him and save an extra trip to the end of the farm.

He accepted no excuses for an inadequate report, no matter how valid. This was got across to me with traumatic force the time the horses

ran away with the sweep. The sweep is a huge haying machine. It resembles a giant comb set on two wheels and is pulled by two horses, one at each end. Moving down a windrow of hay or clover it pushes it together till a big enough mountain has accumulated to be delivered to the stack in the middle of the field. That particular morning, as was his custom, Father outlined the family's workday at the breakfast table. John and I were to proceed to the farthest field and start building a clover stack while he did some urgent machinery repairs in the tool shed at home. I'd had a few days' experience at stack building under Father's supervision and dreaded the responsibility. But it was still preferable to "the other job." Neither of us had ever done "the other job" which is called "sweeping." John was only eleven, and the weaker of us two, so I should have volunteered to tackle it. But I had a premonition something was going to happen so I chickened out. Poor John had to take the reins and perch on the foot stand of the sweep.

For about an hour we both somehow managed. But as the sun rose higher and got hotter, the flies came out and began to pester the horses. John added to their nervousness by impatiently yelling at them and weakly waving the whip. They decided to make a break for it. Before my horrified eyes, the sweep picked up speed until the teeth dug into the ground. There was a shattering sound as the sweep broke apart at the hitches and upended itself, catapulting John forward into its path. Then the horses finished the machine off by dragging it, minus the wheels, as far as they could possibly go, which was the fence. To my intense relief, John staggered to his feet. The clover pile being pushed by the sweep, into which he had fallen, had saved him. But he was scratched from head to foot and his clothes were in shreds. He was sobbing by the time I came up to him, and then I began to cry too. That was how the two of us reached home, feeling very, very sorry for ourselves. Surely this time Father would see that we couldn't be expected to do men's work. But the world was an even harder place than we'd grown to expect. Father flew into a rage not only because we'd wrecked the sweep – we half-expected that – but because we hadn't stopped our "silly bawling" and examined the sweep to see what repairs were needed!

An astute farmer always tries to figure out why the previous owner has sold a particular horse but, when a pair of greys were offered at an unusually low price, Father couldn't resist the bargain. With the money saved he even bought a nice new harness to go with them. Nevertheless, even though they looked in perfect health, he had an uneasy feeling

something was wrong with them. We found out what a few days later.

I was hitching them up to the wagon box and was only half-finished when the greys started to move. "Whoa!" I said. They paid no attention. I jumped forward and grabbed the nearest one by the halter and bit. The bit pulls down on a horse's gums and ordinarily this is enough to stop any horse. But not this pair. Faster and faster they trotted until I became aware that my feet were hardly touching the ground. I stumbled in the dirt and the wagon wheels clattered by just inches from my right ear.

When I dared open my eyes, the runaway wagon had just reached the water pipeline leading to the barn. The greys caught the pipeline support pole neatly between the two of them and the hurtling wagon snapped it off at the ground, sending it flying through the air like a mere matchstick. The awful drama ended with a crash that echoed throughout the farm yard as the horses plunged into the barn to reach what they considered safe haven – namely their stall. The wagon, of course, couldn't make it through the half open door. Something had to give, and that something was Father's beautiful new harness.

Father had seen the whole thing from a distance and hurried over to survey the damage. He was obviously fuming but said not a word. The next morning he sent me to the barn to fix the broken harness. About half an hour later, he himself appeared and stood over me for some time, watching my bungling efforts and still saying nothing. Finally he spoke. But not to me. It was more like a soliloquy: "I bought myself this new harness, and took such pride in it. But then I had to give it to this dog dirt to ruin it for me." And turning on his heels, he strode out.

It seemed I was now bungling something or other every week, if not daily. And I was painfully aware that, with each slip I made, I was moving further and further from any possibility of closeness to my father. It was like getting deeper and deeper into financial debt until one despairs of ever being free. Knowing his dislike for me made it impossible to approach him through conversation. I found myself on the verge of breaking into sobs whenever I was alone with him. It seemed I had to keep my mouth shut simply so as not to let those sobs out. One incident occurred when Father stepped out of the barn and latched the door. I had arrived at the same door just at that moment and had to enter the barn on an errand for Mother. So intense was my fear of him that I could not even venture the words, "Please don't close the latch – I'm going in." I just stood dumbly to one side until he'd turned his back and then I unlatched the door and entered. He obviously reported this to Mother

because later that day she said, "Why don't you talk to your father? You know he has your welfare at heart."

But it was obvious to me that, except for my good standing at school, I was in no way fulfilling his concept of what a son should be. No matter what the circumstances, what I said disappointed him. "Stupid" was the most common adjective I was branded with. "Deaf," "dumb," "blind" were close second-favourites, heaped on my head as it hung in shame. It got so bad that the mere sound of my voice roused his contempt for my intelligence. When John, he and I were fencing one day at the bog end of the farm, we ran short of wire—just a few feet short. He sent me to the other end of the fence, a good quarter-mile walk, to fetch the piece we needed. Just so he wouldn't scold me if I brought too short a piece, I decided to bring a whole roll. It was quite heavy. He smiled sardonically at me when I arrived: "You know, William, I feel sorry for you, not because you lugged that load all that way for nothing, but because you're so stupid."

CHAPTER SEVEN
Leaving Home

Father had planned and dreamed for years to make something of his children by means of higher education. But his announcement of those plans when we finished our ninth grade came like a thunder clap out of the blue. We weren't going to Stonewall High School, but to Winnipeg, the big city itself!

That whole summer preceding the move I daydreamed of school in the city. On the corn cultivator I'd have my head down, my eyes glued to the corn passing below, but my thoughts were far away over the southern horizon, beyond Stoney Mountain.

Mr. Chokan, a prosperous grocery storekeeper in Winnipeg's north end found lodgings for us. John and I were introduced to Mrs. Lysak, the landlady. Her house on Parr Street could almost be seen from the Chokan store. We were shown a small hygienic white room up in the attic of Mrs. Lysak's house. I say "her" house, because it was she who wore the pants in the family. Mr. Lysak was a worried little man whom we seldom saw.

Fitting into our new-found quarters was not nearly as traumatic an experience as our crashing entrance into Isaac Newton High School. Apparently, Father had needed our help with the threshing and the principal had agreed that we could skip the first week of school without seriously affecting our studies. The result was that we were dumped into a system already in full swing.

It was a grey day with yellowed leaves being torn off trees by squalls of rain. The three-storey building looked enormous to us as we followed Father to the door of Room Twelve, our home room. Mr. Katz, a wavy-haired, bespectacled man with broad besuited shoulders, showed us into the room. Not only were we one week late to begin with, we were

late for that particular morning as well. Classes had already commenced. The students stared at us. Our eyes popped at the size of some of the fellows and the variety in their dress. Self-consciously, we sat ourselves in some back desks. Both John and I were carrying a big brown parcel of books – all our books. But no sooner had we sat down than the whole class got up to go. "Hey, that can't be right," I gulped. "Is this our room or isn't it?" Each student was leaving with a loose leaf notebook and one or two text books under his arm. "Can't we leave our books here?" I begged. "No," someone said. "Another class is coming in." So up we had to get, with our big brown paper bags already beginning to fall apart in our arms, and follow the rest.

John and I were in a panic. The hallways were a seething mass of students changing classes. Somehow, we had to keep up with "our boys." But we lost them anyway. A bell rang and suddenly the halls were empty again. We tiptoed from room to room, along the creaky floors, peering in through the glass of the doors. Finally we spotted a familiar face and, once again, barged in amid general stares and titters of amusement.

It was Mr. Armstrong's history class. We sat that out in bewilderment for it was now obvious that we were behind in our school work too. What was the next shock to be? Desperately, we tried memorizing faces, shapes of heads, sweaters, any distinctive feature whatever, in order to identify them in the halls. No luck. In the next period the room broke up into Latin, French, German, and several business courses. Not only that, there were now two floors to choose from. John is almost in tears. But to my surprise, I find that, just as I did after the fight with Eileen Samson at Victoria School, I have a little extra reservoir of strength. I am convinced that things can hardly get worse. We sit ourselves down in the typing room. Slowly, as we sit there listening to the teacher giving the basic finger exercises, the realization dawns on us that our timetable said we were supposed to be in German class. We tangle up the keys of the typewriter impossibly and are just getting up to seek out the room when the bell rings. . .

I was right. It didn't get worse. After that we were slowly but surely on the way up. The city school – big, impersonal, indifferent as it was – was also not as cruel as Victoria School had been. True, nobody stepped forward in that first baffling week to guide us or help us with our problems, but neither did they take advantage of our troubles to ridicule or tease us. At our lodgings, on the other hand, things went steadily downhill. At first everyone was deceptively nice. Mrs. Lysak adopted the role of a

good but stern second parent, and we were shyly polite in return. In fact, we were so afraid to offend her that it took a few days before we relaxed enough to breathe normally. When we did take our first deep breath, however, we discovered that the air was stale. Mrs. Lysak was a tightwad. She wouldn't even let us open the little air vents in our windows because she was saving on furnace heat. Instead she would open the downstairs door so that the kitchen warmth with all its cooking smells would rise up the stairwell to heat the two rented rooms.

These kitchen odours were so sickening that we had to emerge from our cramped attic to clear our heads by kicking a football around in the snow on Parr Street. Winnipeg streets were not cleared in those days. The snow was simply packed and the sewers projected above that. But a good whiff of the evil stench from one of those would decide us that Mrs. Lysak's cooking odours were preferable. No sooner would she hear us coming than we'd be met with admonitions to take our shoes off at the door as the house was immaculate. We began to feel so claustrophobically trapped in every direction that we had to let steam off, somehow, somewhere. So we wrestled in bed. And one evening one of us actually fell out of it onto the floor. The thud registered on Mrs. Lysak's Richter Scale as having earthquake proportions and there was a big to-do about it the next morning.

The food at first was varied and plentiful. But, just as we feared on observing her heat saving efforts, our diet dwindled until we were on a ration of soup, sandwiches and fish. Despite our physical inactivity, our stomachs were still farm-sized and we had to complain to our parents that we were actually hungry. When we found worm carcasses floating in the rice soup I got up enough courage to complain. By the time Christmas rolled round we'd all had enough of each other and, to everyone's relief, we moved.

Every second weekend while we studied in Winnipeg, John and I would board the Grey Goose bus for the farm where we were still expected to help as much as possible. And once in a while, washing off as much of the honest dairyfarm smell from themselves as they could, Mother and Father would visit us in town. They watched anxiously for our first report card. Fortunately, we did well—so well, in fact, that I came second in the class. My average was a disappointment to me personally—seventy-six compared to the nineties of my public school days but, in Room Twelve, such a surprising performance from us two little farmers caused consternation, even a little jealousy. We could sense it.

Yet they were better sports and more civilized than country school children and didn't ostracize us for it. One or two of the more astute pointed out that our heavy study schedule had put us on top and I guess they were right. Being strangers and on a tight budget there wasn't much else we could do except study.

The one city kid who gave me a rough time was Steve Sokol. This happened in our second term of grade ten after we'd moved to our next boarding house on Pritchard Avenue. John and I had joined the nearby "Bull Dogs," a Y. M. C. A. clubouse and rink so that once again we could get some fresh air in between studies. After a few evenings there, the regular members usually got some idea of each other's athletic abilities and strengths. On this particular occasion, two of the older boys, Steve Sokol being one of them, began to choose teams for a hockey game. Most of the other boys were still in public school so I assumed, despite my obvious inferiority as a player, that I would be chosen fairly early. By the time, however, that even the littlest fellows had been chosen I was feeling quite uncomfortable with shame. Steve seemed not to notice me, but just as he was about to skate off, he said aloud pointing at me, "Well, I might as well take that big hunk of worthless shit over there." There was an explosion of laughter on all sides and I floundered and sank in a sea of anguish. "How long? How long," I asked myself, "will I be kicked around like this?" I could hear my father's stern words of warning as he sent us off to Winnipeg: "Now, when you enter that high school, you start right off giving the students the impression that you are popular and can fend for yourself. If you fail at the beginning no one will respect you after that."

I was growing up whether I liked it or not and life had no mercy in presenting hard decisions to be made and inescapable situations to be faced. One of these was choosing a career. Father wanted me to be a doctor. He maintained I had talent for it because, in his words, I could "do delicate things with my hands." Somehow he discovered shortly after we began high school that to become a doctor Latin was a must. I would have to drop German and switch to Latin without delay. Even then it wouldn't be that simple for I'd also missed two years of grade school Latin. But such a major rupture in my school curriculum was justified only if I made a firm commitment to either pharmacy or medicine.

I learned of his decision one weekend when I was working on the farm. Bright sunshine was streaming in through the open door. I wasn't

allowed out until I'd had a talk with Father. He was cat-napping on the bench behind the table as was his custom after the noonday meal. He fixed me with his fiercest gaze and insisted that since he was sending me to high school he had the right, then and there, to know what I intended to be. Actually, I didn't have a clear picture of what I wanted myself. In my heart I'd have liked it to be something associated with art. But doctoring? No, a hundred times no! The thought of associating intimately, aggressively with people as a doctor had to do, to touch their bodies, to cut them open . . . well, I just couldn't face the idea of it. At the same time I couldn't tell him that in so many words without risking his anger. Finally, just to get out of the house, I mumbled I would. For one pathetic week then, I did try catching up on three years of Latin. But it was obvious to all, including myself, that it was hopeless. Humbly I returned to the German class for the remainder of the year. That Christmas I rose to the top of the class.

Two other important events of my youth took place that first term in Winnipeg. I became a Ukrainian nationalist and I had my first experience of puppy love. It all started at Ukrainian night school. Mrs. Lysak, at my parents' request, had taken John and me to enroll in it at the local Ukrainian Greek Orthodox Cathedral. When I first entered the hall and saw the pupils I was taken aback at the small size of them. As a mere beginner I knew I'd have to sit among the very smallest of them, the first graders. Soon there entered a little man in black, slightly bow-legged and balding, Father Mateyko. Everyone stood up with the words "Glory to Jesus Christ." He returned the greeting. Then we recited the Lord's Prayer in Ukrainian. I mumbled, pretending to say it too. If I'd been able to read Ukrainian I could have followed it easily on the big scroll at the front of the classroom. When the formalities were over I turned around and saw that a few older students had arrived so I didn't feel so embarrassingly out of place.

One of the big girls, Betty Olynyk, caught my fancy at first sight. I recall thinking to myself, "Now if only that other girl with her, Natalie, and her sister Olga weren't taking up Betty's attention." This kind of interest in the opposite sex in myself rather surprised me. Anyway, I had to sit near the front with the grade ones, my feet barely fitting under the desk, and didn't dare glance back too often toward Betty. Father Mateyko found I'd been trying to study Ukrainian on my own back at the farm and put me in grade two. Everyone was welcome to make all the grades they wished in those two evenings a week. It was obvious,

though, that work was the furthest thing from the minds of most of the pupils and that Father was having a big discipline problem. He could have borne down hard on those talking during class but he realized his strictness would probably be reported at home as harshness. This in turn might persuade the parents to let their children drop Ukrainian, which was what they wanted and Father didn't. I really felt sorry for him.

Then I began to notice that a new feeling was supplanting the pity. It was hero worship. Perhaps because of the terror I felt toward my own father I wasn't able to identify with him as hero. So I went completely overboard in admiration for this substitute father. I was really gushy in my later memoirs, as in this sample: "I have never met, and never hope to meet a finer man, one whom I can revere and look up to, whose teachings are so inspirational, who had such wonderful leadership qualities . . ." And much more of the like.

The most obvious thing about him was his Ukrainian patriotism. As he told us the history of the Ukraine, described her natural riches, her cultural beauty, I realized his zeal was passing from him to me. Now I was on fire too. I was really moved by the tragedies of Pid Kova, Mozeppa, Shevchenki and the Free Ukrainian Republic. Father Mateyko was also a noted Ukrainian choir conductor and, in listening to the concerts he put on, I began to hear again the haunting beauty of the Ukrainian folk songs my father used to sing in the years before the Great Depression.

At Christmas I took part in a St. Nicholas pageant. I played the part of Satan, and Betty Olynyk the chief Angel. At the climax Betty and I had to cross sword and pitchfork. Added to the stage fright I'd inherited from Victoria School I now had this totally new perplexing emotion of puppy love to cope with: that which I loved most I feared most. How I managed to put on a creditable performance amazes me – probably Father Mateyko's praise and respect for me did it. I was really lapping it up and gaining a small measure of self-esteem at last. With his coaxing I had also begun attending church. I went partly to please him and partly to catch more glimpses of Betty. I even set to learning Orthodox Church prayers and tried to mean the words I was reciting. In my heart of hearts, however, I had to admit it was Father Mateyko I was worshipping.

After Christmas, as I said, we moved over to Pritchard Avenue. Mrs. Holyk was a much less sophisticated woman than Mrs. Lysak and more at ease with our countryish manners. On the other hand, like Mrs. Lysak, she too was a dusting and waxing fanatic and had her husband under

her heel. And she turned that heel with a vengeance. What was it, I wondered, about these Winnipeg women? Why the reversal of roles? She would scold him and call him a dog right in our presence. Observing all our boarding difficulties, Father determined to buy a house in Winnipeg the next year. We would stay in it and save on food, most of which could be brought in from the farm. In fact, boarding out offended his shrewd peasant sense of husbandry. "You eat up the money and it disappears down the toilet with nothing left to show for it," was his crude way of putting it.

John and I were let out of school ahead of the others that May as our averages were good and our help was badly needed on the farm. It was another miserable summer of silent suffering for me. I had grown slightly rusty from the enforced idleness of studying and Father criticized my blunders all the more. I hardly spoke to him days on end. Finally he said, "William, you seem to me to be always very unhappy. If you don't like me or my dictates you are free to leave home."

One might think that I'd have jumped at the chance. But I was too demoralized to go for any such dramatic exit and only took note of his words in somewhat the same way as, years before, he himself had told me to note Alan Dolensky's words so they could be used against him. I preferred to just slip away. At the back of my mind I'd already decided to bluff my way through two more years of home life, at least until I'd graduated from high school.

But breaking with home wasn't going to be that easy, as I discovered to my surprise when I returned to Winnipeg to catch up on my Latin at summer school. One sad Sunday, while everyone else was at a party, I packed a suitcase and boarded the bus for Winnipeg by my lonesome. I felt like calling it quits to the whole Latin venture if only Father would have stood for it. Some kind of emotional struggle was raging deep inside me which I was barely aware of, probably something to do with excessive dependency. The turmoil was so profound that it came out physically: Even though it was a bright summer's day, I could see everything getting quite dark from time to time. I made it to Winnipeg but my suffering was not over by any means. That first night in The Nugget, a tiny old hotel near the railway station, brought on the worst depression, the most utter loneliness I'd ever experienced. I managed about two hours sleep that night.

The following day, sleepy-eyed but glad morning had arrived at last, I walked the eight blocks or so to the summer school where I would be

taking three years of Latin in six weeks. But the teachers gave me generous doses of praise and I had ten free hours each day in which to study, apart from the weekends when I had to go back to the farm to work, so it all ended with me passing the examinations handsomely.

That fall, John and I returned to Winnipeg to begin grade eleven. Father had bought a little old house at 834 Burrows Avenue, about three blocks from Isaac Newton and just across the street from Ukrainian night school. We had a two-burner hot plate, two tables and chairs, a few pots and dishes, a supply of coal in the cellar and a little spending money each week for basic essentials. At first we divided our housekeeping tasks equally. But very shortly it became obvious that this kind of enforced closeness wasn't going to work. We began to find more and more fault with each other and then to quarrel. I did it mostly with cold silence and he with violence. He couldn't keep quiet while I was trying to concentrate on my studies and I was stubborn about doing my share of the housework. Once he became so incensed at my silence during dinner that he began to flick spoonfuls of soup into my face. A little later, when it was my turn to cook, I forced him to eat mouldy rennet cheese.

Because of the hostility between us, it was a good thing that John and I were now separated from each other at school. He was put in Room Twenty and I in Room Five. Unfortunately, Room Five contained the "cream of the crop." I say "unfortunately" because the only self-respect I'd been able to glean anywhere up to that time was in my being able to out-shine the others in art work or scholarship. I saw I couldn't possibly out-shine these stars so I just caved in completely. My unhappiness must have been written all over my face and even my posture. I recall climbing up the stairs in between classes, trying to avoid a group of Room Five girls because I felt so inferior with them looking at me, when one of them, Vera, a short pretty student in a school tunic, called after me, "Cheer up, Bill. What are you feeling so sad about?"

Although I was demoralized because of the impossible competition, I was still work-obsessed enough to rise to seventh place by Christmas. Then I cracked. I just couldn't do more. Sure, I sat at my desk all the hours I set myself for homework but, perhaps because of the extra studying that summer, I'd lost my freshness and concentration. I would launch ambitious study and review programs but never complete them. I shirked algebra which I hated. I even went half gladly to the farm on Easter holidays – if you can believe that! And so exam time came – and I FAILED! My whole world seemed to collapse.

Grimly I wrote the finals in June and made it comfortably under the line. But the Easter humiliation had changed me and "comfortably" would never be good enough again. So intense was my desire for respect and acceptance, I vowed I'd kill myself with study next year. I launched my new do or die approach by throwing myself fanatically into farm work. This was not to please my father – I had no hope of that – but to dust off as many academic cobwebs as possible in preparation for the big push forward in grade twelve. Rather to my surprise there were some vague signs that Father was pleased with my industry, even though it was still obvious that he hated my nature.

That fall Winnie joined us at the house. This was a blessing for she acted as a buffer between John and me and she could do the cooking. Also the Melnyks, friends of Father from the old country, joined us in the house. Mrs. Melnyk was garrulous and Mr. Melnyk drank heavily so they were continually quarrelling. I avoided them as much as possible and locked myself in my room, studying fiercely. My motto was Churchillian: "Nothing matters now but victory."

In literature class we were studying the more modern poets. Browning's philosophy I pounced upon as the very thing for me: "A man's reach should exceed his grasp or what's a heaven for?" This kind of fanatic idealism put even more distance between John and me. Everyone found it hard to believe we were brothers even though we were once more in the same room. John even got the nickname "Squirrel" because of his lightheartedness. I made fourth place in October and in Ukrainian school received top honours. One evening, as I got up from a heavy study schedule to go to the washroom, I suddenly collapsed. I'd been having a headache all day. I passed out completely. Mrs. Melnyk and Winnie were quite frightened and Mr. Melnyk even called two doctors. One of them came and diagnosed a weak heart. He prescribed pills and a rest. But I'd no intention of following the rest program for had I not vowed to succeed in grade twelve even if it killed me? I kept right on studying in bed.

Meanwhile, however, something very unexpected happened: I fell in love, really and truly this time. John and I were returning home about 1:30 p.m. when a streetcar rumbled by and stopped at the corner. John said, "Say, look, there's Natalie Belenky." I looked, and instantaneously felt a most delightful sensation flow up through my body. She was sitting in the back window apparently lost in thought. I had to tear my gaze away from her for fear John might realize what had happened to me and

said off-handly, "Yeah, I see her." At first I cautioned myself it was proba-
bly just another Betty Olynyk infatuation and made no move toward her.
But I used the angel image I had of her for all it was worth. She was the
fuel that powered my ever more fanatical studying. She had me despis-
ing vulgarity in people like the Melnyks. She inspired me to speak Ukrain-
ian at home. She helped me to overcome my sexual temptations.

After a while I had to admit this was more than mere infatuation. I'd
read and heard about being "in love" and "falling in love" but this was
the real thing. A concert of Father Mateyko's choir was turned into sheer
heaven as I sat in the audence at a vantage point from which I could
drink in the sight of her. One winter evening, not having seen her for a
few days, I just upped from my studies and walked over to her part of
town. I didn't know which house she lived in, just her street, but I walked
up and down it all evening hoping to catch sight of her in some lighted
window.

I remember so well the closest I ever got to her, a mere inch or two.
This was in a group pose for a Sunday School photograph. I was directly
behind and above her in the line standing on a bench. Once again there
was that cursed axiom: "What I most loved I most feared." I was
petrified lest I say or do something that would draw her attention to me
and at the same time that's precisely what I most wanted. What was it?
What had happened to me to give me such a wretched complex? Was
it tied in with my bad childhood experiences with girls? Effie, Patsy, Vic-
toria, Lily, Rosie, Eileen? I would go into her father's Ukrainian book and
music store on a Saturday morning and buy some items just so that I
could have a glimpse of her. From the last time I visited her father's store,
I carried away a clear mental picture of her to treasure in my memory like
a rare cameo portrait. She was at a typewriter at the end of the counter
and I don't think she even noticed my coming in.

All the time I knew her I didn't in the least feel the desire to think of
her sexually. She was to me, as I once depicted her in a halo image draw-
ing, an angel—nothing less. I now know I was, in fact, experiencing an
exalted, spiritualized kind of love called "agape" by psychologists. In it
the young man worships the maid as a goddess so pure it would be
sacrilege to desire her body. He usually does no more than daydream
and write hundreds of verses. A few such have become classics of love
poetry. I myself didn't actually write verses about Natalie but, with her in
mind, I was suddenly quite taken by poetry. Like Robert Browning, I
looked forward to meeting Natalie in heaven some day where one's love

would be totally fulfilled and never-ending. I have never since had that experience, so wonderful and yet so painful – painful, that is, on those occasions when I realized my wretched shyness precluded my either approaching her or impressing her.

By Christmas, my fanatical book work had pulled me into third place. And now it was John's turn to fail and presumably to suffer my shame of the previous year. But he didn't take it to heart as I had and eventually he failed the whole year. My attitude to Winnie, now that she lived with us, was curiously ambivalent. I was proud she was my sister. She was a good looker and athletic. And, though I didn't realize it till I went to University, she was also the brainy one of our family. Yet, because of the idealistic stage I was going through at the time, I was disillusioned with her seeming hard-heartedness and materialism. My Ukrainian nationalism, for example: that I was so on fire meant nothing to her.

I attended one of my first dances with her and John in the high school auditorium. I tried three dances, two of them with Winnie. Perhaps if I had known *how* to dance, it might have helped, but I doubt it. The problem was much more fundamental, and everyone, especially my parents, compounded it by saying, in a dozen different ways, "You're a failure." Mr. Floyd, the principal, did it at that dance with a friendly scolding because I was wearing a gloomy expression and wasn't on the floor. Already my depersonalization had robbed me of feeling when I came in contact with a female body during a dance. I was bound to be clumsy for I was not in rhythm with the girl's movements or the music. I depicted that lack of feeling and my frustration in a painting by representing myself as a sawdust-filled puppet strung to a carousel. "How can anyone enjoy such a senseless merry-go-round?" was the question I used to ask myself.

In the second term of my final year, the nemesis of my obsessive study habits arrived. Apparently it was a psychological reaction. The subconscious dug in its heels against the conscious and said, in effect, "Stop! I won't be pushed any further. I won't serve." But of course, I didn't know that at the time and it wasn't until five years later, in Maudsley, that the problem was tracked down. It began not with actual eye pain but an awareness of eye fatigue. I got the idea then that I could rest my eyes by using them alternately, covering first one eye then the other as I studied. One evening, however, when I was studying for the Easter exams, something went wrong with my eye rationing program. When I uncovered one eye for its turn to do the seeing, I was taken aback to dis-

cover that it now saw through a blurr. I blinked once, then twice. But the blurr wouldn't move. I went to the bathroom and rinsed it with water. Still no luck. A cold sweat of fear came out on me – WHAT IF I WERE TO GO BLIND!

And why was the thought of going blind so appalling? It seems that by the time grade twelve rolled around, I had reached a compromise with my father on my profession: I would be a teacher not a doctor. That decision was partially a front. What I really was after was a position where I could indulge in my old desire to do art work. So I promised Father I would teach Latin, History, English and Art. The art teacher had recognized my talent in the one class a week we were allowed at Isaac Newton, and Father Mateyko, seeing the doodles in the back of my Ukrainian exercise book, had had a long talk with Father persuading him that, though there may not be much financial security in art, at least it was an honourable profession.

These were the thoughts that flashed through my mind when the blurr refused to go. John Milton could go on writing poetry even after he went blind but, to an artist, eyes are absolutely indispensable. "Well, I still have one eye left," I said to console myself as I retired that night. In the morning, I was relieved to find that the blurr had gone. But from that time on I was afflicted with eye pains which came almost always whenever I sat down to study or paint. This pain had an insidious spiralling aspect to it. As soon as I became aware of the pain I'd start to worry about it. The worry then increased the pain. The greater pain would get me even more worried. And so on, until I stopped work.

Nevertheless, even with this new handicap, I dragged myself up to second place in the class at Easter. That was a triumph but it was soured by the fact I hadn't made the eighty plus average needed to be publicly presented with an Honours Certificate at graduation. I had Robert Browning's "reach" alright, but I didn't really believe in heaven as he did, so I was bitterly disappointed when I couldn't have the "grasp" too, here and now. It seems my daydreams of Natalie were the only kind of heaven within my ken at the time.

CHAPTER EIGHT
Portrait of the Artist

I had earned enough money from a summer sign painting job to pay for my tuition and books at the university plus a little extra. Father also promised me a hundred dollars spending money which he explained I could repay later. I said, "Thank you, maybe later," but my mind was already made up: not one cent would I take if I could possibly help it. Knowing what a disappointing son I was to him and that I'd helped so little on the farm that summer, I preferred to doom myself to a whole year of penny-pinching poverty.

Nursing pangs of inferiority caused by the well-dressed university students all about me, I went around in a brown corduroy windbreaker, the cheapest I was able to buy. One day while on my bike pedaling to the university, I got caught in the rain. To my great embarrassment the dye of the jacket soaked into my shirt. I tried not to work so hard in order to give my eyes rest. I even dropped Ukrainian night school so that I'd have no extracurricular studies. Since I now had money of my own I ventured to see an oculist. He charged what seemed a staggering sum for a pair of glasses and they only made the pain worse. In desperation, I went to our family doctor in Winnipeg, Dr. Butchko. He prescribed an eye ointment which proved equally useless. After that I gave up doctors in disgust and was left to carry my fears of blindness by myself.

The only important step forward I did make in my health problems was in the area of psychology. It wasn't at all an obvious breakthrough – that came some six years later – but simply being introduced to the subject was like the opening of a door through which I would later escape the pain. It all happened by chance. Because I'd persuaded Father to compromise and let me be a teacher instead of a doctor, I tried to mollify his disappointment about all my extra study of Latin by explain-

ing I would major in it at university so I could teach it in high school. High school teachers, I gathered, usually taught two or three main subjects so I added English and History to my schedule. After those majors were taken care of, I felt free to indulge in and study what I was truly interested in – psychology, art history, geology, and German.

The psychology course was given to an overflow class in an amphitheatre. The presentation was boring, probably because the young lecturer was unsure of herself and more or less just read her notes. Nevertheless, she did a complete survey of the subject and so, suddenly, one day sitting in that classroom, I had an intuitive illumination: "But of course! All my health problems are psychological in origin and psychotherapy is the cure for them!" I had no money of course for such exotic treatments. But I filed the possibility of eventual liberation carefully away in the back of my mind in anticipation of the day when I did.

You'd think that a university student was long ago mature enough to have loosened himself from his parents' apron strings. Not I. That Christmas, when I was already nineteen years old, I made my first outright rebellion against my father. The first two weeks of the Christmas vacation had gone not too badly. Then I was informed that we were going to the New Year's dance in Stonewall. I've already explained what a misery dances were to me. I decided I would stay at home and announced my intention right there and then. Father stood up and ordered me to attend the dance. He wanted me to go and pretend I was enjoying myself because family prestige was at stake. The neighbours, he went on, were spreading gossip about me being sickly (how right they were!) because they rarely saw me at social functions. To my own surprise as well as the family's, I in turn stood up and denounced the whole social game. "I refuse to be offered up as a sacrifice to the whims of the neighbourhood gossip." I never guessed I had such firmness in me. It was only after a one or two hour siege that I angrily gave in. Fortunately, a snow storm had begun so, by the time the car got on the road to Stonewall, there were such deep drifts across it we had to turn back. The whole car load of us came home and played cards instead.

The incident had seriously shaken the apparent previous serenity of the Kurelek home. John even accused me of ingratitude and I retorted that it was cruel and senseless to try forcing me, an obviously square peg, into round holes. During the remaining four months of university I worked with the resolution in the back of my mind to make a bid for

freedom that summer. I'd put myself through university from now on, thank you. After all, had not Father himself told me that day in the field, "William, you look always unhappy. If you don't like me or my dictates you are free to go." I was fed up with him, the vulgarity of the Melnyks, the worry over my eyes and the steady year after year "book-burning." My substitute father, Father Mateyko, was gone, moved to a new parish in Los Angeles and the beautiful hero worship I'd built around him had collapsed. I had to get away, far, far away.

One day I noticed an ad on the university bulletin board which called for students interested in summer work in a Northern Ontario bush camp. That was exactly what I needed! I'd have said it was heaven-sent had I still believed in heaven. It even offered a refund of rail fare. I wrote to them immediately and in about a month the personnel manager appeared at the university to hire Manitoba applicants. We were to leave on May first. All this was done in secret and I kept it secret as long as I possibly could. The day came, however, when I could no longer put off my father's questions on my plans for the summer. The confrontation took place in my study room. He stared at me in angry amazement. "You're plumb crazy, you don't know what you're getting yourself into. I worked in the bush. I know all about it." And he began to describe the terrible hardships and dangers of bush life. It looked like he was ready to kick me out of that house right then and there.

A week later he visited again and started on another tack: why did I want to leave? There was no help for it now. Out it had to come – the whole ugly, smelly brew of my years of resentment against him. But to my consternation it did not come. I was too emotionally constipated to do any sounding off whatsoever. All I could manage were a few faltering phrases of what I'd learned in psychology class, namely, that rebellion in children derives from parental over-criticism. Unlike the Christmas rebellion, I was no longer the cool man of the situation. But Father was. While I nervously drew the craziest doodles on my desk to keep from breaking down emotionally, he dwelt long and with icy anger on the subject of ingratitude, on his superior life experience, on his opinion that I deserved every single one of the harsh words I'd got from him in childhood and boyhood. He ended up prescribing a cure for all this rebellion business – a good spanking. He couldn't of course spank a twenty year old son. So he went back to his farm and I to my studies.

The cloud of depression that had hung heavy over me since I'd applied for the bush job was now really crushing. I couldn't understand

it. Why was leaving such an unhappy home so difficult? Why did I have to feel I was about to commit some unnatural deed when my reasons for it were so perfectly sound? How I managed to write the last exams in such a state of mind I don't know. But I did. I sold all my books and used the money for train fare. Then, since Mother had requested it, I went home to the farm for one last visit. It was an awful night. During the quarrel that evening – if it could be called a quarrel, for it takes two to tangle – Father raged and I now and then raised a feeble defense. I was still determined to go, however, even with the whole family siding strongly against it. John wouldn't even speak to me. "You've gone too far this time," were his last words.

Appropriately, the next morning dawned overcast and cold. Father tried joking sarcastically about my folly. When that too failed he gave in – I could sense the "snap" even as it happened – and offered me twenty dollars. As we set off for Winnipeg, I caught my last glimpse of Mother through the car window. She was standing on the doorstep holding baby Paul in her arms and she was weeping. I felt a great pang of sorrow and guilt drive like a knife right through my heart.

I had some trouble finding my train coach but boarded it just as the sun set. Immediately, to my surprise, my own sun came up, so to speak. Instead of falling into an even deeper dejection I found I was perking up – eager to taste this new life of adventure. The long, long months of gloom were lifting. I even began to feel exhilaration. It seemed that everyone was going somewhere great. Someone began to play a guitar and a few travellers joined in to sing. Eighteen hours later, I and four others disembarked on the shores of Lake Superior at the whistle stop of Neys, Ontario. The lake was so vast and the forests, marching up the round shouldered mountains from the water's edge, were bigger and bolder than anything I'd ever seen before. In fact, I had never seen a mountain in my life. Nor was the trip over. It was a long, two day journey to the north, first by truck, then by slow moving caterpillar tractor before we reached our destination – Camp 77.

There we found that many students, both from Winnipeg and from Ontario universities, had arrived before us. I was immediately drawn into the camaraderie, the joking, the swapping of life stories, the hearty meal-taking of bush camp life. Most of the students were city slickers unused to hard outdoor labour. For them, log driving was tolerable but, as soon as that was over, each boy was on his own and could earn only what he actually cut.

There was a good deal of comedy the first few days that piece-work cutting began. Some of the students had brought power chain saws with them, intending to work in twos and threes. They imagined their method of logging would have all kinds of money rolling in for them while we poor swede sawyers would be sweating tediously along. Unfortunately for them, the chain saw hadn't yet been perfected to run trouble-free. One could see the columns of blue smoke rising out of the forest here and there where the get-rich-quick guys were at it and the terrific racket was scaring all the forest creatures away. One by one the machines broke down and the owners either swallowed their pride and turned to the swede saw or else packed up and returned to the city.

I myself had to admit I was lucky that I had been raised on a farm, because, though my father had been hard on me, he had also taught me to be industrious. George, the sub-foreman, a Ukrainian, would come by my workstrip and see me sweating in my ragged red sweater. He'd scratch his head in wonderment: Why didn't I take it off? I explained that it was a protection against mosquitoes but the real reason was that I couldn't afford a proper lumberjack shirt. After that particular talk, I noticed he was deliberately allotting me better workstrips and donating to me partially filled cord piles left behind by students who'd given up and returned to the city. In the evenings, tired but happy, I'd stretch out on my bunk bed and either read, chat, or write long letters home describing the joys of life in the woods. Some of these had to be sent in two envelopes and included sketches of interesting or humorous incidents. All the while I took care to cover up any homesickness I might feel.

By the time I left I'd become experienced enough to cut two or more cords a day. There were only five of us left by then. I had made over $600 – the most money I'd ever seen and quite a sum for a student to earn in those days. I also got word that I'd won a small scholarship so, when I reached the 104 days-in-the-bush mark when my train fare would be refunded, I decided to go back home figuring my help would be appreciated for the harvest.

Everyone exchanged bashful smiles with me when I got off the bus and walked up to the farm house. Father was away but when he returned he also gave me a warm welcome. My decision to stick it out in the bush had been wise. I was no longer so oppressed by Father's criticisms of me because I knew I could now support myself if we had to part company. I threw myself whole-heartedly into farm work. I cut and stacked a whole field of hay. I cultivated and plowed. I stacked grain

with the others. I was field pitcher to the threshing machine. All this time Father was obviously restraining his criticisms. But as the novelty of having me back wore off, he began to resume his old contemptuous attitude. "You know," he observed one day from his noon nap on the bench behind the table, "I don't believe in book learning! No matter how much one studies, it doesn't make one any the wiser. Look at William there. He has such a high education already and yet he keeps on with his deaf-dumb-stupid reticence." Mother would also torture me with her nagging about my retiring nature. She and Father got after me about my lumberjack boots. I felt manly in them as I worked in the fields and hauled grain to Stonewall. But my stomping around in them irritated them for it reminded them I'd been right about the bush. Finally, for the sake of peace, I took them off.

I went back to university refreshed after grappling with nature in the bush and on the farm. I applied my new-found faith in psychology – I'd abandoned all pretensions to religion by then – to working out a weekly study schedule. It's interesting to look at it today. It's pretty well solid work but it rotates the subjects on the theory, I suppose, that a change is as good as a rest. It always starts the same: 6 a.m., wake up, washup, polish shoes; 6:20, make breakfast, eat, pack books, make lunch; 6:45, study history and Latin; 7:20, leave for university. The most interesting item is bedtime – 9:00 p.m.! I wonder now what notion lay behind the early retiring. To save my eyes perhaps?

Christmas vacation was the time I'd appointed myself to have a tonsil operation. I'd had a lot of nose bleeds at the lumber camp and also sore throats. Dr. Butchko had recommended the operation the year before but my parents wouldn't pay for it. Now, however, I had money of my own and I'd show them. They'll be sorry! On Dr. Butchko's advice, I admitted myself to hospital and he operated. And then something went wrong – or should I say "something went right" for I got my self-pitying wish – I began to hemorrhage and cough. Before the hospital staff discovered it, I had coughed blood all over the bed and the walls around it. I was still in a semi-coma from the anaesthesia but I vaguely recall seeing the droplets of blood all round and wondering where they came from. Then I lost consciousness again. Next thing I knew, I had awakened again and Mother and Father were standing over me. Mother looked concerned, Father more than concerned: he was seething with anger, but not against me; against the doctor. "The butcher," he was muttering. Apparently they did care for me. But

why did I have to nearly die before they showed it?

It was a week or ten days before I was let out of hospital. Still quite weak from loss of blood, I tried to help with the farm work nonetheless. And that's when Father went back on his apparent show of concern for me at the hospital bedside, for whenever I showed signs of fatigue he'd begin to rail at me for "going into that stupid operation in the first place." I decided not to breathe a word about the other kind of doctor I was seeing. That was a neurologist. Because I worshipped science now I believed that the new science of psychology had the power to transform me from a cringing, immature weakling into a balanced, robust, popular he-man. It was very soon evident, however, that he was more interested in my money than me. So I tried another neurologist. He was the same. "No more, no more, no more," I scolded myself as I shelved psychiatric treatment till I had graduated and could afford it.

In February of that year, when I was beginning to worry whether my mental health would hold out that long, respite came. I made my first friend, Zevon Pidhirney. Zevon was about twenty and in my year at university. He had mussed hair, a broad friendly grin and determined, hurried steps. His clothes were threadbare and unkempt and his hands, though artistic and delicate looking, were stained with nicotine and capable of a vice-like handshake. I can't recall who introduced us but at the risk of making it sound like a homosexual attraction, our friendship blossomed out, for me at any rate, like falling in love. I fell for him almost without reserve. To repeat the flowery language I used in the life story which I had written for the neurologist: "Here is a person who has spirit-like dimensions – the material world is merely a medium for him to move in and create. Eating, sleeping, dressing, resting, are only subsidiary activities. A creative and interpretive artist; the very incarnation of what I dreamt of for myself. . ." Etc., etc.

I was starved for a kindred soul with whom I could communicate my mental turmoil and artistic interests, so I followed him every-where – meetings, films, concerts, record shops, cafés. I used to return home to bed at one or two in the morning. This was another part of his attractiveness for me. His life style disregarded time, regulated time that is, and that to me spelt a wonderful freedom. He had ever so many schemes and projects on his mind and some were actually started. Talking with his mother I got some clues to the intellectual atmosphere he'd been raised in. His father was editor of a Ukrainian nationalist newspaper and the house was in the continual ferment of ideas left by celebrities

dropping in. Zevon had natural artistic talent and was called on to do illustrations for his father's paper now and then. I was fascinated by his *Time Magazine* cover-style paintings and drawings and eventually these found their way into my own style.

Perhaps Zevon let me follow him at first because my obvious adulation was flattering. But soon, I don't recall if it was a matter of weeks or months, he began to tire of me and my essentially plodding farmer's intellect. I just couldn't follow to the heights he soared to. He introduced me to classical music and, just as during his philosophical all-night café dissertations, I also pretended I was following his music appreciation. In fact, it was days or weeks later that I caught on to what he had said, or felt what he had felt. I pretended out of desperation for I knew that, once he found out I was essentially dull and insensitive, that would be the end of our beautiful friendship.

However, before the parting of our ways became too obvious, a rather strange reversal of roles took place. His enthusiastic free-wheeling kind of self-education was beautiful while it lasted but, inexorably, the final examinations began to approach. And then I noticed Zevon becoming uneasy. We tried studying together the one subject we had in common, English. As I explained to him my understanding of Milton and John Donne, Shakespeare and Spenser, it appeared that Zevon was actually learning from me, something I found impossible to believe. Not only that, I felt guilty that I had benefited so much from his open style of education while I had only lecture notes to offer in return. I wasn't bright enough to see that those notes would, in fact, have helped him simply because he had skipped so many lectures. It ended up that I passed my year with no trouble at all but, to my shock, Zevon didn't.

After I'd screwed up enough courage to ask him for another summer job on my own, Father agreed I could go off to earn money for my final year at university. I decided to settle for a job listed with the university employment service: working as a labourer with Commonwealth Construction Company in Port Arthur. Winnipeg was grey and rainy and worried because of the rising Red River when I made my decision to go east. Zevon and I visited the flood area and, as we chatted, I realized he wasn't concerned whether he worked that summer or not. It was a rude awakening, because I knew then he had no intention of repaying the money he'd been borrowing from me all winter. He'd become attached to a girl of doubtful character and, among other expenses, he'd ask for cash to take her out. Standing there with him beside the sand bags hold-

ing back the swirling muddy waters, I said nothing outright about it, but I was sick at heart. Here I was, barely able to scrimp enough money together to pay the train fare to the Lakehead and Zevon was as carefree as a bird about my financial sacrifices for him.

When I boarded the train the next day, the loneliness which settled on me was crushing. It wasn't that none of my family came to see me off – I'd grown over the years not to expect it. But not even Zevon. That really hurt. And on the train what a difference from the previous year's departure! No guitar music, no gay chatter, only a foreigner for a seat-mate reading a depressing crime magazine. The other drab coach seats were sprawled over with the vulgar limbs of vulgar people trying to sleep in a sitting position. I guess I hated everything and everyone because I hated myself. I tried to add my vulgarity to theirs and sleep too. But sleep wouldn't come. The train pulled into Port Arthur next morning and I staggered in a sleepy daze out of the station.

I found a room – the cheapest possible till my first pay cheque – in the side porch of a house on Pearl Street. Commonwealth Construction Company turned out to be a giant outfit that had contracted to build a big extension to one of Fort William's terminal grain elevators. The extension would make it the largest elevator in the world. While the equipment was being organized and the forms were being built, we students were given temporary odd jobs. There were about six of us, I found, from the University of Manitoba. Also a lot of D. P. 's (Displaced Persons) and, of these, I found the Klymenkos, two brothers from the city of Kharkov, most attractive. They spoke the purest Ukrainian and I eagerly took the opportunity to polish my own by working side by side with them. I was fascinated by the war stories Dmytro, the younger Klymenko, and other D. P. 's told me – and by what I learned of the frightful life under Stalin's Communism and in Hitler's Germany.

The Klymenkos were believers but not church-goers. Their faith was more akin to spiritualism. One day our young foreman, trying to find work for us so we'd appear busy to the superintendent, sent four of us up a three storey concrete extension of the elevator to fetch a large wooden door. I got there first and chose one of the front corners of it to carry. As the four of us moved off I felt my corner jerk smartly in my hands and heard someone shout. We whirled around to see that Dmytro had disappeared. The door had served as a cover for a large manhole. As we peered down into it we could make out the body of Dmytro lying unconscious in a shallow pool of water from which projected many con-

99

crete butts, bolts and all. It had been a thirty foot fall at least. He should have been a dead man and yet, after only a few days in hospital, he returned to work healthy and smiling and solemnly telling us he had been saved by prayer! He explained that in the split second he was falling he'd had enough presence of mind to say a prayer for salvation.

I have already mentioned that my religious life under Father Mateyko's nationalist inspiration was essentially false. I didn't have the Ukrainian words nor he the English to communicate on theological matters. My whole Orthodox faith, if it can be called that, had muddled along on the strength of Ukrainian lessons and loyalties. The Byzantine liturgy was beautiful but in my heart I knew there were two other reasons – the main ones – why I had been attending services every second Sunday. One was to please Father Mateyko and hold his respect for me. The second and even stronger reason was to catch glimpses of Natalie. All the while my real interior convictions were being conditioned by the intellectual spirit of the university which – nobody made any bones about it – was primarily secular humanism. The more I imbibed that humanism the more I became convinced I myself could answer all life's questions and understand what it's all about – given enough time and health. I guess that's what theologians would call "pride." So here we were: one Orthodox Christian whose formal faith had been taken from him by the Communist State and me, an Orthodox Ukrainian who'd drifted all the way to atheism, arguing about prayer. I explained as patiently as I could that he'd been saved by chance alone. If the fall could be duplicated mechanically right down to the last detail, I explained, then he'd survive once more. Dmytro kept insisting his faith in God had saved him, though it seemed to me a little more thoughtfully, as if considering my logic.

Finally, when I decided I'd stashed away enough for my last year of university, I decided to return home and help with the threshing. Despite my having sworn up and down that I'd have nothing more to do with doctors, I soon went back to Dr. Butchko as well. Having exhausted all his other remedies, such as iron tonics, tonsil operations, salves, and what not, it seemed there was still one more fad left to be tried. "This time you will really feel the difference," Dr. Butchko promised. "This is sure to cure your lethargy, your anaemia, your poor reflexes. It has to do with your Basal Metabolic Rate: your thyroid gland is underactive and I'm prescribing it booster pills." He gave me the prescription and it worked but, just as in fairy tales where the hero has all his troubles dissolved by a magician only to find there was a hidden catch to the

panacea, so I too found I'd exchanged one trouble for another. A few years before I'd become a voluntary teetotaller. I knew that in my chronically depressed state, I was a ripe victim for addiction. It wasn't easy keeping that pledge because Canadians, especially at that time, had little respect for a person's private convictions about drink. You had to be a regular fellow and drink like the rest or they'd hound you until you broke down. I was so busy defending myself against addiction from that source that it was something of a shock to find I had fallen victim to another. I got hooked on Dr. Butchko's B. M. R. tablets.

Strictly speaking, B. M. R. tablets are not in themselves habit forming. But the situation I now found myself in resembled drug addiction very much. The trouble was that Dr. Butchko had given me a perpetually renewable prescription. Once the Basal Metabolic Rate was up to normal I was supposed to use my common sense and stop taking the pills. But I didn't stop because I noticed that when my thyroid was hyperactive I experienced a kind of euphoria. I have a few diary notes from that time which illustrate the private little "drug burn" I'd stumbled on:

In about two months I began to feel the effects of the pills. The flame of life that had flickered anaemically in me before now has begun to blaze forth in violent spurts. Now I feel like Schiller when he wrote those fiery lines:

Ja, ich weiss woher ich stamme
Ungesättigt gleich der Flamme!
Yes, I know whence I came
As insatiable as the flame!

Now I'm really developing. Now I'm capable of great accomplishments. Particularly in the hot peak of each cycle do powerful romantic dreams and idealistic planning come upon me. Yes, alas, there are lows too, the moments of supremacy burn themselves out and I lose faith in myself, I'm in despair. But wait, I'm on a peak again. I'm overwhelmed by a powerful urge to drop everything and plunge headlong to my ultimate life goals. I want to travel and learn and feel and live fully. NOW, in preparation for a great destiny.

It seems that the B. M. R. addiction exaggerated my phoniness which in turn was a cover up for my insecure belated adolescence. In my heart I knew I was a phoney but I couldn't help it and nobody else could either. It seemed that I had to learn by trial and error to suffer on my own,

always on my own. It would have taken nothing short of an angel with its strength and its insight to have been my friend at that time. I sometimes wonder what would have happened to me in the confused, handicapped emotional and spiritual condition I was in if Natalie had entered my life in a real way just then. I'd been avoiding facing the real Natalie for three years. My love for her was no less real than is a plant shoot covered with a stone just because it can't be seen. It had curled up and grown pale and yellow under that stone, instead of growing straight and green in the open air above.

Now circumstances finally forced me to approach her. Father informed the family that we were moving to Ontario. As a matter of fact, the family farm was already gone and the whole family was living in Winnipeg. I had helped at the auction by checking the auctioneer's bookkeeper. "What'd I educate you for if you can't even do that?" was the way Father put it. This left me with only two choices: that winter, well before I graduated, I had to either let Natalie know of my love for her, or else forget her forever.

But it was March by the time I screwed up enough courage to write her asking for a date. There had hardly been a more momentous letter in all history it seemed to me. It wasn't the contents or its language. These were quite formal. I had to be formal or else I'd have been intolerably gushy. The momentousness was in the posting of it – as if my whole life depended on that one teeny push of an envelope into a post box slot. I waited. There was no answer. After a week I sent another letter. Then, at last, the fateful day arrived. I returned home from university to find a letter waiting for me on my desk. It was addressed to me in a very neat hand. It had no return address on it so I knew it must be from her. Covering up my extreme agitation as best I could, I carefully opened the envelope. Like the outside of the letter, what she had to say was also clean, courteous, simple. Its one and only short paragraph: "I'm sorry, perhaps if you'd approached earlier . . . Now there is someone else." My head swam. But I'd been steeling myself for just such an answer for some time, so I didn't go to pieces. Nevertheless, it took me about a week to recover my inner balance sufficiently to send her one more appeal. But there was no answer, ever again.

My friendship with Zevon that year was an on-again-off-again affair. At times I'd cling to him, then again I'd back away, disgusted with his mooching. The feeling of being used was stronger than ever. Moreover I was finally beginning to feel my oats as an intellectual and an artist. In

our English class, we were studying James Joyce's *Portrait of the Artist as a Young Man*. Possibly because of the B. M. R. tablets, that book had a more profound influence on me than any other single volume in my three years of higher learning. I identified completely with the hero, Stephen Dedalus. It was this book that convinced me to rebel finally and completely against my family and become what I'd always half-wanted to be – an artist. And for the first time, like Stephen Dedalus, I decided to travel the road to creativity alone. This decision followed a last vain effort to win Zevon's favour. The way I did it was to write and personally hand over a long flattering character sketch of him. He returned it with a smile. Inside was a cryptic little observation: "I thought as much – I love you too."

Strangely enough, nothing stands out for me that year except the Joyce book. All I have is a mental picture of myself walking in the snow past the administration building toward the bus stop and thinking how wonderful it was to be on fire with ideas. I must have been on one of my B. M. R. peaks. On the other hand, I have these notes to that neurologist I visited:

I feel everyone at the university is better than me in all of some respects. When I come to the art library to study, I sit near the door lest it be noticed I came in. I feel very uncomfortable and actually break into a sweat when I have to approach the desk for a book.

Inferiority feelings notwithstanding, I do believe, looking back on it now, that I was breaking out of a mold. I can't, for example, remember what marks or averages I made that year. The university discouraged that by not publishing any class standings so I no longer had the incentive to compare my progress with others. But my rebellion went further than that, I know, because I refused to attend graduation. I refused to be drafted into a cap and gown or even to let myself be photographed in graduation dress. I was going to be Stephen Dedalus. I was going to wear my own phoney costume, not the establishment's!

CHAPTER NINE
O. C. A.

The whole family except John had migrated to Ontario. He followed part of the way two years later – as far as the Lakehead – when he graduated in Engineering. I now had a small brother, Paul, and two more sisters, Iris and Sandra – almost like a second generation.

I'll never forget the astounding impression southern Ontario made on me when I first beheld it by train. I must have been on a B. M. R. high for I was rushing from window to window trying to drink it all in and not miss anything. Having grown up on the monotonous prairies this was like eating a banana split after years of plain bread and butter. It was so beautiful, so warm, so quaint, so lush, so picturesque, so civilized, so interesting, so mature – I could have gone on and on stringing adjectives together in praise.

But just as the lighted world disappears when a train plunges into a dark tunnel, so my glorious love-at-first-sight affair with Ontario was extinguished. It started during a one week stay at Vinemount when Father asked me what I planned to do with my education. I told him I was going into art. But despite all my brave Stephen Dedalus posturing, I found I couldn't face his anger nor reject outright his philosophy of prestige plus security. I didn't actually tell a lie but I did mislead him by giving him a spiel about the money to be made in commercial art, something I knew privately I had no intention whatever of doing. The talk ended with him saying, "Alright, but don't expect any help from me."

I moved to Toronto then to look for work to put me through the Ontario College of Art. That first month in Toronto proved to be the dark tunnel. I had little money left, enough for a hotel room for three weeks or so. My casualness about the spending of it was an indication that I'd half bought my father's notion that once you had a university

degree, society owed you a white collar job and handed it to you on a silver platter. Two weeks later there was still no job. I'd tried every professional employment service I dared approach. There were banks and insurance companies willing to give me a job at rock bottom salary provided I meant to stay with them, but I just couldn't tell a bare-faced lie when I knew I was going back to school. So I lowered my sights a little and began applying at labour employment offices as well. That's when I first found myself in the situation I was to experience over and over again in future years whenever I'd begin applying for work: The professional offices wouldn't accept me because I was going to be temporary and the manual labour offices didn't want me because I was too well educated.

After each failure I'd return to my room at the Ford Hotel, which was now becoming hateful, to lick my wounds. I was so depressed, so very depressed. Whatever personal improvements in character Natalie had inspired me to in the previous four years now collapsed completely. How I yearned for her! I'd have given anything for even one of my former stolen glimpses of her. The quaintness which had so charmed me about Toronto a few weeks earlier now turned into mere grubbiness as I pounded its sidewalks looking for a job. All I could see were the garbage cans and the drunks stepping out of the taverns to vomit in the gutter and garrish neon lights and the beckoning windows of houses of ill-repute.

At last, after I'd learned my lesson good and proper, I simply stopped mentioning that I had a degree and never again tried to use it to get a job. And as soon as I decided to accept just any job, no matter how menial, I did find employment. It was in a dry cleaning plant, sorting out clothes. I was put to work with a bevy of women who gossiped about men all day, hardly paying attention to me. That was a real eye-opener. Their supply of sexual innuendo and dirty stories was quite as copious as anything I'd heard in the bunk houses of the Pidgeon Timber Company. The manager, Lou Ronson, was the sort of good man one comes across just when one is beginning to lose faith in the human race. He was the first person in those three black weeks who treated me with respect and gave me a break: I'm sure he must have seen in short order that I was more a hindrance than a help but he let me stay on till I got another job.

That was when I decided to step down the social scale in my lodgings too. I had already moved out of the Ford Hotel into more cheerful surroundings in Sunnyside, a part of Toronto breathing Old World charm.

The landlady's pride and joy was a son who was a Protestant missionary in China. When I told her I was leaving in order to save money by taking a room in the slum area, she bristled and began scolding me for being such a foolish young man. "That's Christians for you," I commented wryly to my atheist self as I packed and left. The room on George Street was five dollars a week, and there I lived for the rest of my Toronto stay – nearly a year.

I was now in the low class level where I belonged except for one unusual feature – I had a relatively refined moonlighting job. Besides working on construction by day, I was a waiter at Murray's Restaurant in the Royal York Hotel. How I got the job or even dared apply for it puzzles me to this day. But to my surprise, I liked it – I the shy, asocial, pimply-faced introvert. What attracted me to it? I do know I liked the company of the other waiters, most of whom were working their way through something or other. I liked the tips too. It was like an Easter egg expedition every day. My greatest surprise was that I liked serving people. I even enjoyed the excitement of sudden surges of business such as at the end of conventions at the Royal York. Then suddenly the job was gone. I slept through the alarm twice and the manager said he couldn't take a chance on more of that. The reason I overslept was that I was dead tired.

It was the social ostracism I suffered from my fellow workers which eventually forced me to quit the construction job. Among dozens of workers, I could somehow manage not to be noticed as a non-participant in the talk of cars, women, booze and sports. But here there were only five men: the young foreman, an Ontario farm boy, a tough young French-Canadian they called Frenchie, and one other fellow besides myself. There was no way they could fail to notice that I was different and they very soon despised me for it. I used to eat apart from the others, sitting against a tree in the park, pretending I was happy enough with a book of poetry. One of my favourite poems in that anthology was Henley's "Invictus":

> Out of the night that covers me
> Black as the pit from pole to pole
> I thank whatever gods there be
> For my unconquerable soul.
> In the fell clutch of circumstance
> I have not winced or cried aloud

107

Under the bludgeonings of chance
My head is bloody but unbowed.

All very beautiful and brave but simply not true in my case. For my head was bowed already as I rejoined the others in anticipation of the verbal bludgeonings they had waiting for me.

I don't know which of them I feared and hated most, probably Frenchie. He was forever taking off his shirt to show us his rippling Charles Atlas muscles, and would grin and wink knowingly at the others whenever he addressed me as Bozo. He wore a medallion of Our Lady round his neck but, by the way he swore and talked of women, it was obvious his Catholicism was a sham. Things finally came to a head but not in the way I'd anticipated. Instead of me, it was the Ontario farm boy who got into the argument with Frenchie. Frenchie slugged him just once and broke his arm. Obviously that would have been in store for me had I stood up to him. The farm boy still came to work, however, with his arm in a sling and operated our small hoist. One day, as he was ordering me around and making me feel like dirt, I ventured to answer him back. His face turned livid as he spat out, "Listen, Bozo, you think you can stand up to me now that my arm's in a sling, eh? Well, I can still lick the shit out of you with my one good arm!"

I recall little of the various paving jobs I did next, but I do remember working Saturdays in a car wash on University Avenue. I was bothered by the Prussian-type arrogance of the management towards us workers. It just didn't seem right to me for it was a one family business – even the mother was there operating the till – and they were Jewish. As time went by, however, I felt myself warming to them and even came to partly accept their strictness with the workers. All of us were rehired every Saturday morning. I kept coming and they always rehired me even over the others. If it began to drizzle or rain and no cars came, I was one of the last to be let go. I learned a very interesting thing about myself on that job, that I have what seems like two gears in me: Once I reached a certain speed or intensity of concentration, I shifted automatically into a higher gear. Today, I find this works in my paintings too. At home, in Toronto, it takes me three whole days to produce a single painting whereas I can produce five in one day on my farm when I put myself on a seventeen-hour schedule.

I used to go home some weekends, more for the visit than to help. There was so little land to work on now. Father took a lot of walks or just

sat around pining for his lost kingdom in Manitoba. I played with my little brothers and sisters and so we became attached to each other. They would try to wrestle me down to the ground but I was still stronger than the three of them and would stack them giggling one on top of the other. I was pleased at my affection for them because it showed I was normal enough in relation to children, at least, to consider marriage some day. Once Paul was sitting in a chair in the living room picking thoughtfully and quietly at a guitar while Father and I were chatting on a sofa across the room. Baby Iris came toddling up to Father to bug him about something or other. Suddenly, Father blew his top, propelled her across the floor toward the bedroom, yanking Paul out of his chair on the way, and slammed the door on them. As I heard the two trying to suppress their sobs in the next room, a deep, deep wave of pity engulfed me. Tears come to my eyes even to this day as I recall the hurt look on Paul's face. It was as if I were seeing myself from outside in.

I entered art school that fall, in 1949, and was immediately taken aback to find myself once again out of my peerage. I should have known better because the kids beginning O. C. A. with me were coming straight out of high school whereas I had had university in between. Anyway, I asserted my senior years by refusing to take part in their initiation ceremonies. Beginners in those years took a general art course on Nassau Street. There they decided during the course of the year whether they fitted best into the fine arts or crafts or commercial courses offered for the remaining three years. The only university subject we took was the art history lecture at the Royal Ontario Museum. All the others were cut and dried as in high school, albeit in heavier amounts. There was no escaping it – one had to work in O. C. A. 's first year. There were also marks and class standings and this put me in a dilemma. The old drive to compete was re-awakened. Each student was warily watching his class mates' marks and artistic abilities. I wasn't as slick or as neat as some but still obviously top half in ability. The rebellion I'd launched the previous year was clamouring equally strongly: "Wait a minute. This beating the other fellow – that's not what art is about. Self-development should come first!"

The students were so young it seemed to me they were accordingly transparent and easy to categorize. I chummed with boys like Herb McGregor, Tony Montalban and David Young. I couldn't stand smart-alecs like Jack Dale and Richard Williams. How wrong I was later proven to be about those two. The girls? Well, we men took it on ourselves to

judge they'd joined the college to find husbands for themselves. All except Rosemary Kilbourn, who, besides being wealthy, seemed somehow to have intentions more serious than mere romance.

The divisions among the teachers became apparent somewhat later. First there were those who didn't seem to fit into a clique, like the lady fine arts history lecturer and the sculptor, Mr. Hahn. Then there were the high schoolish establishment types like Sydney Watson, our principal and lettering teacher, John Martin, who taught perspective, and Carl Shaeffer, whose subject was called research. The last group, the one I took to, I fondly nicknamed the Three Musketeers. They were Hagan, Parker and Freifeld. Fred Hagan taught costume, Parker colour, and Eric Freifeld life drawings.

A supplementary life and costume class formed itself voluntarily on Saturday mornings. These were the serious students and several stand out in my mind. One was Graham Coughtry. He was very obviously talented and had a style of his own and already seemed to know he was headed for national fame. Another was Gus Reuter. He had no illusions about being a master painter but he was cultured, serious, sociable and art-movement conscious. In no time at all, it seemed a bunch of us were down at his house meeting his wife Julie and their three little boys. Julie was like Gus, only more intense and down to earth. The student who made the biggest impression on me, however, was Bob Cheng, a Chinese from Hong Kong where his father was a prosperous business man. Bob also wasn't headed for painter fame. In fact, I sometimes wondered why he chose to go to art college. He didn't seem to love the actual production of art, although I recall one beautiful tender thing he did of a Chinese mother and child which the Reuters had on their wall for years. Like Gus, he was absorbed philosophically rather than productively in art. It was his humanity that especially appealed. He was a warm, likeable person. Even his broken English was appealing. We became quite fond of each other and chummed everywhere – on sketching trips, at films, in café discussions.

I liked Hagan's class, though I was rather in awe of him at first, because his approach really loosened me up creatively. He was a shrewd analyst of students' efforts. As for Harley Parker's class, one day stands out particularly. That was when he had us listen to a recording of classical music and then asked us to illustrate it on paper in colour. No objective images were allowed. I was completely, utterly at sea. Freifeld's classes stand out most because I made some real advances in life drawing in them. Work-

110

ing from live models was particularly inspiring. It was the first time I'd ever seen a nude woman and, to my surprise, I felt reverence for her body rather than lust. It was this which got me angry at the kids in one class who began to titter when a rather pudgy, not very bright model took the stand. She worked so hard at holding her poses that perspiration began to trickle from her arm pits.

As I came to know Eric I was pleased to note we shared several artistic sensibilities, despite his being of Jewish and I of Ukrainian backgrounds. For one thing, he was also from Alberta. His water colours of Alberta skies really moved me. His drawings, in an extremely tight, lovingly worked-over style, also appealed to me. And I decided that one of them – that of his hospital room when he had been a T. B. patient – would be the model for me to follow when I was ready to do finished drawings.

All this time, beginning with the reading of *Portrait of the Artist*, I believed myself to be continually, deliberately breaking with my stifled past to become a truer artist. There was another book now, *The Lust for Life*, the story of Vincent Van Gogh, which added to my dreams of adventure and glory. In my money-tight circumstances, he was the ideal hero to imitate. Here is a sample of some writing of mine from that period:

> I have rebelled as I understand a proper artist is compelled to – if he is worth his salt – against convention. I will face the contempt and poverty that being such a social outcast entails. It seems that I must live as full, intense and varied a life as possible to gain a store of experience that will be my subject matter for works of art. I am trying hard to fashion my life on theirs (Joyce and Van Gogh). I am proud of my poverty, of not eating the right food or enough of it, of wearing shabby clothes, of not bathing or shaving regularly, proud of chumming with Communists and eccentrics; proud even of suffering periods of depression because I believe that out of this I am destined to produce great art.

I still have an oil on paper drawing I did of myself, called "Narcissus," showing me picking at my pimply face and reading a novel in my dingy little room. Beside me on the table is a loaf of sliced bread and an open tin of beans with a spoon in it. That's how I ate. One isn't allowed the luxury of hot meals in a five-dollar-a-week room. I also made heroic

drawings of myself in a pork pie hat, walking the streets of Toronto nursing my private artistic visions. They harp back to the big influence a Joseph Cotton film, *Portrait of Jenny,* had on me. I was phoney because, in effect, I was wearing a costume, the costume of my artist heroes instead of being myself. I even changed my name to Wasyl because it sounded more romantic. I have to laugh at myself now because people at the college found it so hard to pronounce they nicknamed me Willie. I was right back where I started from.

Bob Cheng was the one who renamed me Willie. It wasn't long in our acquaintance before I discovered he was a Communist sympathizer and that his brother Dick was a party member. They had been brought up by an ex-Anglican missionary, Dr. James Endicott, then Canadian leader of the Communist-front Peace Movement. Bob took me along to the Endicotts for supper one evening. After the meal we piled into the Doctor's car and drove to a peace meeting where he spoke of his missionary experiences in China and praised the Communist revolution. The Communists had just won the whole mainland that particular winter and the Chinese students attending the meeting were obviously elated. They deliberately talked Chinese in my presence on the way home to emphasize their liberation from western imperialism. There was no doubt in my mind about Dr. Endicott's dedication but it had a steel-like quality to it that I found frightening. Then it began to dawn on me what a force Communism — the aggressive, fire-brand kind — was compared to the comfortable laissez-faire system of the west.

As I listened to Bob's arguments and his attempts to convert me, I realized the confirmed Marxist really believes with the firmness of religious faith that world-wide Communism is coming. In fact, though I didn't know the Bible well enough then to realize it, Bob was paraphrasing Christ's words, "He who is not with us is against us" when he explained to me: "You are either on the side of history or against it, with the people or against them." It struck me then that this is what real Christian faith must be like — not "perhaps" or "I think" but "this *is* so" and "that *will* be so" — the faith that moves mountains.

Yet, though I felt the temptation, I doubt these conversion efforts would have succeeded, even had I remained in Toronto, for the simple reason that I was too proud to submit to anyone or anything at that time. Instead, I decided to leave O. C. A. I had no choice but to go on feathering my little artist's nest for a while longer. Sooner or later, I knew, I would have to choose sides. But which side? I didn't like the greediness,

the lack of high ideals, the hedonism I observed in the civilization I found myself part of. In principle, I was bound to choose the other side, but that prospect depressed me even more. And it was a depression that deepened as I met more Communists and Communist fellow-travellers on my art pilgrimage, for they served to remind me that I could not indefinitely escape the choice.

CHAPTER TEN
Someone With Me

I was working as a labourer in Edmonton but my destination was Mexico. In the art books that our inner group at O. C. A. had studied there were illustrations of the great contemporary Mexican artists – Sigueros, Rivera, Orozco and others. Things seemed to be really in ferment there and my friends urged me to go and see. Hagan, Freifeld, and Parker had even said there was an English language art school down there, in a place called San Miguel de Allende, which might grant me a scholarship if I produced something worthwhile.

As it happens, I was just then preparing for what I hoped would be my first masterpiece, a self-portrait. The psychology underlying such conscious, deliberate preparation was very complicated. I had noticed a kind of dread at tackling sizeable projects back in my Winnipeg school days. Now it was even more obvious as I found myself engaged in all kinds of minute preparations instead of actually sitting down to work. Finally, there was no more escape possible – I had to prove I was an artist or all my rebellion had been in vain.

I started with a minor work in order to get used to the oil medium, at least a little, as I'd not gotten one stroke of oil painting instruction at O. C. A. It was a nightmarish, imaginary scene of our farm in Manitoba. There was a ghostlike fire hovering over the barn such as that over a plum pudding which has been set alight after being doused with liquor. In the foreground my father, asleep, is partly submerged in the ground. As I worked, it became obvious that my lack of training pointed to a possible disaster in the self-portrait. I didn't know how to thin the pigment properly, which brushes to use. Even my choice of panel was wrong: unprimed plywood with pronounced grain.

Yet so determined was I not to rationalize my way out of the

challenge that I pushed ahead regardless. I had already researched the composition with a drawing back in Toronto which I'd titled "The Romantic." It showed the interior of an imaginary temple and me painting murals in it of different incidents in my life. I sent this drawing to Natalie, not because I hoped to change her mind about me or to receive any answer from her, but as a sort of self-pitying gesture. "See what a person you missed getting to know?" And just as I expected, she didn't acknowledge receipt of it. I also researched possible styles I could use in art books in Edmonton's Central Library. I decided it would have the best elements of Zevon Pidhirney, Chardin, Holbein, and the Pre-Raphaelites.

For two or three weeks, after work and weekends, I worked on the background of the portrait. I avoided the actual picture of myself, half-length seated at a table, by leaving it as a rough outline in the middle of the panel. I reasoned that even if the background wasn't very successful, the viewer would accept the story that they were murals painted by an untrained artist such as, in fact, I was. I titled it "The Romantic" because I represented myself as a dreamer: the Joycean artist about to burst into beautiful bloom, but not quite there yet. There was no way I could escape the test of my abilities when I got to the foreground however. On the table in front of me was supposed to be a plate with a round loaf of bread on it. It symbolized the need to earn one's bread without crushing the spirit. I wore a faded old work shirt and the test was to imitate the fabric and model it with paint instead of pencil or pen as I'd done up till then. Even more difficult would be my hands and arms. They had to be obviously living things, unlike the shirt and loaf of bread. But the ultimate test was, could I paint a likeness of my face? I didn't even dare hope for the penetration of character that the great portrait artists are praised for. No, a good likeness, one that would impress an ordinary lay person, was quite enough for the time being.

Fortunately, I somehow got four consecutive days off work. Perhaps it was raining too hard. And so I started. The bread failed. I worked over and over it using a breadroll as a model and still it looked like baked brains instead of the beautiful golden goodness of a fresh loaf. So I ate the roll and went on to my hands. Colour gave me trouble here. The flesh was solid enough, but the skin refused to come to life and resembled brown parchment. Moving ever closer to the face, the supreme challenge, I now tackled the shirt. It didn't exactly resemble the richness of Holbein's fabrics but it had a pleasing albeit clumsy texture of its own. I sensed I was on the verge of a breakthrough now, but when I

tackled my hair I slipped back. It came out too wet and caky. By this time I'd been working sixteen hours non-stop and I was getting red-eyed from lack of sleep. I dared not stop, however, or I'd lose the creative momentum I'd built up. So I painted yet another five hours, till four in the morning. And it worked! I'd made the breakthrough. I could sense that the painting had taken over from me and had directed my brush. I had done the face by natural talent alone. It wasn't a perfect likeness but it was close.

I heaved a sigh of relief and satisfaction and lay down to sleep. I switched off the light and closed my eyes, when – "Oh, horrors, what's that sensation?!" I'd have sworn the bed was turning over and over as if I were a chicken in a rotisserie. I sat up, turned the light on. "Got to get hold of myself. Just my imagination." I turned off the light and closed my eyes. Same sensation. This time I pattered upstairs in bare feet with only my pants on and woke the landlord. "Could I use your phone to call a doctor?" They both got up and looked at me. "You really have been overdoing it staying cooped up down there. Here, sleep the rest of the morning in our sunroom till doctors get to their offices." I did that and this time I fell asleep without trouble. In the afternoon, I went to see the doctor they had recommended.

He was a wise choice. Many a doctor would simply have scolded me and given me a list of rules for proper hygiene. Not this man. I don't know to this day who he was or where he came from but he understood creative people. And so, as a cure, he simply told me a story about the playwright Ibsen. He used to get up in the morning and start to put on his shoes. An idea would come to him and he'd rush over to his desk and record it. Several hours later he'd look down and find he had only one shoe on. After this story he prescribed some standard iron pills but the important thing was he sent me home assuring me not to worry, that as a creative person my life was bound to have abnormal incidents in it.

I was still on the B. M. R. tablets and had several memorable experiences of ecstasy, such as the time I was returning from work through a baseball park. I saw a thundercloud approaching and sensed it was going to be a Russian novel or Eric Freifeld water colour experience. I lay down in the grass to enjoy it. There was a delicious sense of complete abandonment to nature. I had my camera with me and snapped several pictures of the storm closing in on me. Finally I had to run for the shelter of a building. I suppose if I'd been on a true drug "trip" I'd have continued lying there to soak up the deluge. I carried my camera to work

often as I was making records to use in paintings some day. One day, when lunch time arrived, I was dismayed to discover my lunch bag and the camera which was inside it had vanished. I reported it to the police as a theft. About a month and a half later I got a call from the police to come and pick up my camera. It had been found in a dog house. Apparently, the dog had carried it off for the sandwiches in the bag when no one was watching.

* * *

It was late afternoon when I got off the Edmonton city bus which had taken me as far south as it went. I wore a hat, a raincoat, work boots. My satchel carried an extra shirt, a scout knife, a loaf of bread and some apples. I'm amazed, thinking back on it now, that I set out with no provisions whatever for sleeping out in the open, something I did intend to do.

I got a lift almost at once by pick-up truck from an oil man wearing a Stetson. A devil-may-care individual, he'd ride into the ditch and across a field to say hello to someone he'd seen from the road working on an oil pump. I had decided even before I set out that I'd walk a lot rather than wait in one spot using my thumb. After that first lift, which took me half way to Calgary, I found myself, in fact, walking mile after mile till the moon came up alongside me and rested like half a white wafer on a cloud.

Somehow that night I got one more lift right into Calgary, where I found a flop house. The worst derelicts of society slept there for twenty-five cents a night in a long bunkhouse of a room. One man kept us awake all night by coughing violently and spitting blood or phlegm into a spittoon at his feet. Others disturbed me by shuffling by in their long johns to the washroom. I cached my wallet inside my long johns as I was new to the true hobo life and didn't know how far to trust anyone against robbery.

In the morning I walked south into what looked like the Alberta Badlands. I was taking the most direct route for Spokane, Washington, and that meant a south-westerly direction. By nightfall I was in the mining town of Fernie, British Columbia. The last of several rides had been in the back of a pickup truck and I nearly froze to death. There was no canopy. Mile after mile I could hear the whine of the tires and the rattle of the end gate chains. I tried in vain to curl into as tight a bundle as possible to

stop my teeth from chattering. At last, when the ordeal was over, I stumbled into the lobby of a brightly lit old Fernie hotel. It was so blessedly warm in there. A group of Italian-Canadian miners stopped their chatter for a minute to eye me with curiosity as I signed in for the night.

That afternoon I arrived at the U. S. border with something of a problem on my hands. I wished to create the impression on the American officials that I was travelling by legal, respectable means to Mexico. So I told them the truth, but a fishy-looking truth, that I was taking the bus to Spokane. To make my statement true I had to wait around the border post for a few hours. My walking around to kill time got the Americans suspicious, probably because the Korean war made them extra apprehensive about spies, and they got a uniformed man to shadow me. Everybody was relieved when the bus arrived and I got on it as promised.

Time has eroded and broken into scraps my impressions of the next two days. At one point I seem to be on the outskirts of a giant city set in the mountains – could it have been Portland? The road winds dizzily upward and lakes and fiords below glisten gloriously in the setting sun. Now I'm on level country again, walking out of a sleepy little town with ripe apple trees everywhere and I'm singing to myself, "I love those dear hearts and gentle people who live and love in my home town." Then it's misty night again and I'm marvelling at the enormous halo surrounding my shadow which is cast on the fog when cars approach me from behind. A line of Vaughan poetry runs through my mind:

"I saw Eternity the other night
In a great circle of endless light."

Eventually, I was let off in the little lumbering town of Coquille. It was late at night and I was wandering about the town in a sleepy daze looking for a cheap hotel. Half my mind, however, had not ruled out hitchhiking on. I saw one place only, across the road from the police station, that had ROOMS plainly marked in neon light. I spotted two lumberjacks leaning against a lamp post near the open door and went across the street to ask them about the place. I had noticed a flight of stairs through the door and a sliding spy hole in another door at the top. "Are there really rooms up there?" I asked. The men laughed. "Sonny, that's a whore-house." I half-believed them but, in my innocence of such things, I'd have still

gone up there to ask for a room had I not been intimidated by the presence of the two men. I walked around the block only to find they were still standing there talking, so I hit the open road. But as the town lights disappeared behind me, the road looked so pitch dark, with no car headlights to cheer it up, that I made a desperate resolve: "I'll try those rooms. Perhaps they have one minus a prostitute."

I marched back into town and up those stairs and rang the bell. A plump but curvaceous blonde in a tight pink sweater and slacks opened the door and gave me the once over. "Room for the night?" I blurted. She looked puzzled and suspicious. "No. But we have girls. Would you like to see a girl?" "No," I flung the word down hastily and she said, "Oh" and slowly closed the door.

I descended those stairs with controlled speed. But once out on the street, I took off in a near flying walk, now quite free of sleepiness and fear of the road, almost as if the ghost of the pink blonde were pursuing me. My face was prickly hot from embarrassment and indignation. Apparently I'd not realized till then that I'd actually been proud of my virginity. A good half hour's brisk walk cooled me down. And then I became aware of another sensation creeping in. I had to admit the blonde's offer was flattering and had an aura of sweetness about it as if she'd said to me, "You are no longer a child. You're a man." But quite apart from my tight budget, I would not have had the courage or easy virtue to go to bed with a prostitute. In theory, there was no logical reason why I should not, I was an atheist. But my "good boy" upbringing was still strong enough to forbid it.

I spent two nights in a San Francisco flophouse and the one day in between mostly in the art gallery. The following day I got a ride with a Communist fellow traveller that brought me down to within twenty-five miles of Los Angeles. Since he had treated me to two meals I chattered on pretending interest in his attacks on our decadent North American society. In fact, they depressed me because I was reminded yet again of the big choice I would have to make. That night I slept in the open. I'd decided that surely by now I was far enough south. I found some cardboard and newspapers behind a roadside advertising sign and there, in the fog and darkness, I lay down and covered myself with them. Chilled and miserable, I slept fitfully for at least part of the night. When I reached Los Angeles I went straight to Father Mateyko's place, where I recouped my strength and stayed three days.

I was well fed, bedded between clean sheets, even given some clean

clothes. But the cloudless blue skies began to oppress me with their perfectness. Father Mateyko himself amazed me. This was either the first time I'd seen him as a real person up close or else he'd changed radically from his Winnipeg days. He was brown as a nut from the sun and had lost his ascetic thinness. But being in the same house with him and seeing his private life was a somewhat disillusioning experience. It was not so much his increased materialism as his bickering with his wife. It was pointless telling myself he was setting a poor Christian example for I wasn't the least concerned about Christianity's problems. There was no faith left in me to be lost or injured. It was my belief in him as the ideal Ukrainian that was deflated by that visit.

I set out westward on a sunny Saturday morning through groves of orange trees. A good long ride with a salesman brought me into Las Vegas late that evening. I wandered up and down the garishly neon-lit main streets looking for a place to rest. I guess it was too prosperous a city for flophouses so I ended up sleeping fitfully in a chair at the bus depot. A lift of a few miles in the morning brought me to Boulder Dam. After being suitably impressed by that mile-high structure, I walked up the road to where cars would be going slow climbing a grade and could pull off easily to the side of the road. But that still didn't help and I was stuck there the whole day. I didn't want to walk because I knew I was headed into the Arizona desert and, never having seen one, I imagined it dangerously hot in the day time.

I was joined later in the morning by a plump-faced youth. He had absolutely nothing but the leather jacket on his back so I shared some rations from my satchel with him. The bread was for energy, the apples for quenching thirst. Only at sunset was a ride offered us. There was no flophouse in the desert town we were let off in either, so I parted with the youth determined to chance yet one more night without sleep. I'll never forget that night as long as I live. Nobody, but nobody, would risk picking me up in the dark although hundreds of cars passed me by. And so I walked right on till morning – a total of twenty miles.

A desert may be a hot place in the day but, as I found to my grief, the temperature plunges at night. A strong wind was stealing away any body warmth I was building up with my brisk walk and blowing small cloud-like shapes of mist across the road. Soon I began to get so drowsy that I found myself wandering off the pavement into thorn bushes at the side of the road. Some barbs would break off and fall into my boots where they chafed my feet painfully. Finally, freeze or no freeze, I decided to

chance lying down for a sleep or at least a rest. I crawled under one of those useless-looking road bridges which are only for flash floods and, pushing aside some thorns with my hands, lay curled up on the bare ground. This time there were no cardboards or newspapers for covers. Whether I fell fully asleep I don't know, but suddenly I was aware that there was someone with me. He appeared to be a person in a long white robe and he was urging me to rise. "Get up," he was saying, "we must look after the sheep or you will freeze to death." I obeyed and set off at a near run down the road shaking violently from the chill. Presently I noticed that the sheep crowding before me had become nothing but those ragged fluffs of mist floating across the road. And the other person beside me had somehow blended into me and was gone.

I got a ride as soon as the sun came up and the drivers could see who I was and another, some time in the afternoon, with a young cowpuncher. The round-up was just over and he'd bought himself a brand new truck and put his saddle in the back and, feeling affluent, was ready to go on the town. I guess he hoped in picking me up, I'd help him to enjoy the good times. I did entertain him with plenty of stories of far off Canada and flattered him with an intense show of interest in meeting my very first authentic cowboy. But I just wasn't cut out to share a debauch with him. We were passing through Pueblo Indian country – we could see their adobe huts from the highway – and as he talked to me about them, he'd invite me now and then to pull off the road with him and find some Indian women for the night. I guess I saved him some money that day for, seeing I wasn't to be drawn out, he settled for some Indian souvenirs and driving on until we reached New Mexico.

My sexual education was further broadened when I met another hitchhiker in a stiff raincoat, a little ways out of Las Cruces. He was a Frenchman, I gathered, hailing from Florida. We stood together for some time, cars ignoring our thumbs, when he said something which completely mystified and embarrassed me. I say "embarrassed" not because I knew at once what he was talking about but because his remark made me think he was touched in the head. It was like the situation you find yourself in when a drunk forces his company on you and you know others within hearing distance are amused at your discomfiture. He said, "If you lie down behind those bushes and suck me, I'll give you two dollars." I really must have looked puzzled because he repeated his offer several times, each time getting more irritated. Finally it dawned on me that perhaps he was one of those mysterious beings I saw headlines

122

about in newspapers from time to time called "sexual perverts." Politely but firmly, I told him I wasn't in the least interested in his offer and so he walked off in a huff.

Soon I found myself in another embarrassing situation when a Mexican evangelist and his young son squeezed me into the cab of their truck between the two of them and proceeded to try to convert me. "I thought all Mexicans were Catholic," I said. "Not so, not so," they hastened to correct me. "Ours is the pure true religion." Nothing seemed to discourage them. We stopped at the man's sister's home, which was full of flies I recall, and I was treated to a meal. There was further embarrassment when they asked me to say grace. Finally, when they saw I just wouldn't give in, they presented me with a Bible and, with a "God bless you," let me go. That night I slept in El Paso, Texas, in a cheap Mexican hotel. It wasn't a relaxed sleep, however, for I'd noticed when turning in that there were rat holes in the wall at the level of the bed. In the morning I tried hitchhiking still further but, after one short ride and standing half a day in vain, I gave it up and returned to El Paso to catch a bus down to San Miguel.

CHAPTER ELEVEN
Mexico

Crossing the line was a traumatic experience. Passing from El Paso, a generally clean, flashy American city with minor skyscrapers, to Juarez across the river was like passing from day to night. Everywhere there were swarms of people, impoverished people. A minor horde of them surrounded our bus even before it pulled into the bus depot, begging for handouts at the windows. I slept on and off all that night in the bus as it drove south. This was my first experience of a truly foreign country and I was both excited and frightened. I can't remember now whether the bus arrived in San Miguel that day or the next, but, by then, I was carrying with me an indelible impression of the northern half of Mexico as a poor, drought-stricken, semi-desert land. It was, to say the least, an inauspicious beginning.

I had understood back in Toronto that the School of Fine Arts in San Miguel had Sigueros, one of the top Mexican artists I admired, as its leading light. To my dismay, I found that this school had broken up shortly before I arrived. It was in the offshoot of that school, now called Institudo Allende, that I was told I'd find Sterling Dickinson. He was the man I'd corresponded with from Canada and who had promised me a scholarship on the strength of the photo I'd sent him of my self-portrait, if and when I arrived. This new school was just struggling to its financial feet and they seemed desperate for students, especially promising students, so they could build up a reputation. It certainly had the better setting of the two schools, being housed in a former luxury villa on the edge of town. There were five teachers but it was the scarcity of students and their age that bothered me. Most of them seemed to be elderly retired ladies, there as tourists, to whom painting was a hobby rather than a serious vocation. And though I stayed five months I never did quite

make peace with this aspect of the school.

The biggest class was in Spanish and it was taught by Sterling, a bespectacled, professorial-looking American. I did so well in that class that I'd begun speaking Spanish by the time I left the country. Jack Baldwin taught lithography, the one other subject in which I really learned something new. Jim Pinto, a Yugoslav-American, conducted life and costume drawing classes. Jim and his wife, Rushka, I liked most of all and they went out of their way to befriend me. In fact, they were trying to instill in me a loyalty to the school so that I'd stay on. One of the town doctors, a Spaniard by the name of Dr. Olsina, taught us anatomy. Both the Pintos and Olsina, I soon discovered, were Communists. There was one Mexican teacher but my hopes in him were dashed when I found he taught only crafts such as picture framing.

Not only was there a scarcity of students but, of those there were, few regularly attended all classes, so the impression that the school was dying was thus all the more reinforced. "Students wouldn't want to miss lessons," I reasoned to myself, "if the school were alive with creative ferment." And it was precisely that ferment I'd come all that way seeking. I kept bugging Jim to introduce me to the real Mexican artists so that I could boast to my Toronto friends on return that I'd studied under Rivera or Sigueros or Orozco. But he kept putting it off even though he was acquainted with them. Finally, I made a trip to Mexico City by myself, hoping somehow to stumble into acquaintance with the masters. Without proper contacts, knowing next to no Spanish, all I could do was to admire their works in the Palace of Fine Arts. The same disappointment awaited me in England. I wrote to my English artist hero, Stanley Spenser, begging him for an interview. There was no answer.

How I yearned to work under a master painter! But I was a mere beginner, a nobody. How could a master hear about me, let alone take me under his wing, if I'd not proved myself worthy of special training? Added to that was my backwardness. I just wasn't pushy enough, personality-wise, to force myself into the studio of a great one. And there we have it. Eventually I was forced to give up schools, masters, everything, and concentrate on teaching myself.

The Mexico stay was a great growing-up experience nevertheless, and well worth the time and little money I spent on it. First of all, my geographic horizons were widened dramatically. This was my first real experience of the Third World, the under-developed lands with their teeming poverty and handicapped peoples. At first I was indignant at

what I saw. Yet, as the months passed, my eyes began to see deeper than the ragged clothing, the bare feet, the parched, cactusy landscape. These people had a real, non-materialistic culture, and a faith, which stood out in sharp contrast to the values of the gringo colony in town. "Gringo" is Spanish for "foreigner" and inevitably, because of my lack of Spanish at first, that's the circle I had to move in. There must have been at least a hundred of us at San Miguel, Americans mostly. But Canadians and Europeans were also attracted there because it was an esoteric life – something different – and because it was so cheap. Most of the gringos had some sort of outside income that could be stretched in San Miguel without having to work – alimonies, scholarships, pensions and the like. With lots of leisure time on their hands they could meet their own kind in the arts and in love. A good number I found were homosexuals or divorced or living common-law. Almost everyone could afford a Mexican maid to look after their quarters. Thus one could look rich and upper class on an income that would have meant mere subsistence up north.

Almost as soon as I found the school, word got out via Joe Schultz, an art student hailing from Chicago, that I was looking for lodging. Many gringos ate at the hotel where I was staying and so Joe and his roommate, a writer named Peter Black, approached me soon after supper there with an offer to split the rent of their house three ways. This arrangement would benefit all three of our pocketbooks. It was a large house – three storeys if the penthouse on top was counted – called Casa del Inquisidor for it had been built as residence for the Inquisitor at the time of the Spanish Inquisition. This was to be my home for the next five months. It was a memorable time, mostly because of the friendship that grew between Peter and me. He was a man in his forties who'd written and actually published a book about a Greek island people entitled *The People of Porros*. It was a warm and moving novel because it was about real people and because Peter was a warm, sensitive person. He was currently working on another novel considerably more contrived. I sometimes wonder if it eventually passed publishers' approval. Anyway, when I knew him, he didn't really need to worry about its success as long as he stayed in Mexico because he was living off alimony from a rich American wife he'd divorced.

At first the three of us were housed together peaceably enough. Although we shared one bathroom with rather complicated, sometimes irritating, plumbing, we each had a private bedroom. The first signs of

trouble appeared between Joe and Peter. Peter was trying to model his life on that of the Greeks, both ancient and modern. That meant leading a rich, full, personal life, while respecting the individual character of other people, and of things too. Joe, on the other hand, was a working class ideologue. All Peter's refinements were so much bourgeois decadence to Joe. The platform of the I. W. W. , Industrial Workers of the World, was Joe Schultz's ideal. He was always reading the I. W. W. newspaper for inspiration in his free time. Back home in Chicago he'd been a house painter, but he admired the Mexican masters, many of whom were Communists, and waited to produce working class masterpieces like theirs. Unfortunately, although Joe had dogged, almost fanatical, perseverence, it seemed he did not have the necessary talent or spark of genius. I remember watching him working on a life study of an old Mexican woman, going over and over it, each time making it a more depressing distortion of the real life person. One could see in his art that he didn't really love people as people but as "brothers" in the ideological sense.

Peter's philosophy, on the other hand, was one of genuine concern for others. And it was this same concern that won me. He was the first person I had ever met who showed interest in my interior life. Not only did he listen closely to my accounts of my boyhood but he actually drew out of me details which I assumed would be boring to others. My childhood hallucinations seemed to fascinate him. He also asked for my dreams and tried to analyze them. At the same time Joe Schultz's relationship with Peter was deteriorating rapidly and then, one day, just ruptured completely. Up in his penthouse, Peter had found an earthenware pot that had parted with its handle, so he tossed it down into our courtyard. Joe happened to be returning from school just at that moment and the pot shattered at his feet. "Watch where you throw things," he bellowed up at Peter. That was just about the last straw. Joe moved out very soon after and Peter was glad. But glad for a reason I hadn't the slightest suspicion of at the time.

I don't know if it was a week or two after Joe's departure that it finally happened. It was still winter, for the two of us were standing before a crackling fire in the large front room. I was taking out of my wallet sample photos of Zevon's works to show to Peter. I can't recall how it turned out I was holding the magnifying glass at that moment for it was Peter who'd brought it out to study the details. Suddenly his hands closed on my wrists in a steely grip and drew me toward him. "Kiss me," he com-

manded. His eyes seemed ready to pop out of his head, so wild were they. Out of self-protection I put the magnifying glass between our faces. I can still see those lips, trembling with anticipation. After what seemed an eternity of minutes, he decided I wasn't going to surrender so he let go. Walking agitatedly up and down the room, he kept repeating, "I was sure you were asking for it. I was sure. I was sure you wanted it."

That night we each returned to our separate beds in turmoil – for obviously different reasons of course. A dozen and one things now began to make sense. All that special interest of his in my background, my dreams, my art. It was amazing to me how such an intelligent man could so rationalize information to fit his emotions and passions. In the days that immediately followed, he made no more actual passes at me. But he did try to gently sway my will with psychological arguments purporting to prove I did have homosexual leanings. I saw now why he had talked of his wife with such contempt and had praised the homosexual relations of certain pairs of friends we knew about town. Our friendship wasn't completely broken because of that awful evening, but Peter had irreparably damaged it for I could not be sure he'd not try another homosexual advance.

One of those homosexual friends was Roberto Varro, an American Communist, supposedly studying art on a G. I. education program. I could hardly stand the man for he never did a stitch of work. Instead, he went around with a young Mexican lad to whom he'd promised U. S. citizenship in return for making love to him. And he was always moaning and groaning about all kinds of imaginary illnesses. Then there were our nearest gringo neighbours, Chuck Plante and Emilio Cruz. I liked Chuck but thought he was a bit over-clever at gringo social life. Perhaps I was a little jealous of his brightness and handsomeness and popularity with the women. Peter kept stressing Catholicism as being Chuck and Emilio's philosophy of life. That puzzled me. "How," I wondered, "can Chuck reconcile Catholic teachings on sexual morals with an active homosexual love life?" I'm not sure even to this day that Peter hadn't rationalized about Chuck in the same way as he'd rationalized about me. It's Chuck I have to thank for introducing me to Nicolaides. The course in drawing outlined in his book, which I was to carry out a year later in Montreal, taught me more than any art school. I saw very little of Emilio. But I heard a lot from Peter, who was a connoisseur of human interest stories in the gringo colony, about the romance between Emilio and a loud-voiced American girl everyone knew as Chig. According to Peter, she was crazy

about Emilio but his interest in Chuck rather than her was breaking her heart.

Peter and Chig had a bantering kind of affection for each other and she used to drop in at our casa now and then. One of the ways Peter tried to make me more "human", as he put it, and therefore no doubt more responsive to his interest in me, was to try and persuade me to break my teetotalling resolution. So finally, on New Year's Eve, in preparation for a big gringo party, I announced I would drink. "Try everything once." But, unknown to Peter, I'd made a resolution to try "drunkenness" not "drink" and even before Chig arrived at our house to show me the way to the party I'd already downed several glasses surreptitiously. In addition I put on a show of intoxication. Chig screamed in delight when she arrived. "Bill, you're drunk!" I remained in that drunken stupor all through the party too, by stationing myself near the tequila punch bowl. I even got up to dance a few times oblivious to my clumsiness. Peter observed all this with displeasure. "That's not the way to drink, you nit-wit," he scolded me the following day.

There were other Catholics in San Miguel who made an even bigger impression on me than Chuck Plante. One, whose last name I forget now, was John, a Canadian who had a loving Catholic wife. The two had come to San Miguel in the hope that its dry climate would let John live a little longer, for he was dying of T.B. When I met him he was almost a walking skeleton. Thanks to his conversion to his wife's religion shortly before his death, his joyful resignation to it was the talk of the colony. I was also impressed by two young Catholic girls on a school trip to the local volcano. One was a Chinese from Hawaii, the other a rich rancher's daughter from Texas. They sang songs on the train and chattered amiably with all, even trying to be friendly to me. It was obvious that being a Catholic didn't mean being puritanical. The Pintos, despite being Communists, pointed that facet out to me. These girls sometimes took me with them when they explored Mexican towns. They always made a point of dropping into the churches along the way to say a prayer. When they invited me in with them I balked and watched from a distance. They'd cover their heads with *mantillas* which they carried in their handbags and, crossing themselves with holy water, would kneel down to pray, their happy faces now all seriousness. "It's superstition," I told myself, "but beautiful superstitition."

The Pintos had turned the two girls on me during that particular trip to get me out of myself. I tried to oblige but, no matter how I tried to cover

up my unhappiness by clowning and the like, it was still transparent. Well-meaning people such as the Pintos only made me more deeply miserable by insisting that I cheer up. Perhaps I was also on a major B. M. R. hangover at that time. I do know I was worrying more than ever about my eyes. Every day, especially just before beginning a painting or major school project, I'd be visited by twin agonies, mental and physical, fear of blindness increased eye pain and the pain increased the fear.

The field trip should have been a relief for my eyes but this came only at night. I wondered if the strong Mexican light was too much for them. The bull ring at Celaya, where I saw my first bull fight, shimmered in the glaring hot sun. The crowd was monstrous, waiting for the killing to begin and began tossing a bag of red powder about. Fortunately, I had a leather jacket on, for I was one of the spectators it hit. Six black bulls were despatched. My own feeling was that it was unfair to the bull to be artificially infuriated. The last one won my heart, refusing to fight. He was big, white and clumsy, with manure from the farm still stuck to his sides. No matter how many *pecadillos* the *toreador* stuck into him or how many times the *picadors* on their horses charged him with their lances, he just ran away from everyone. Finally, seeing they'd get no sport out of him, they chased him out of the ring – alive.

When we returned I made another trip of my own to Mexico City to see a German eye specialist Jim had recommended. Roberto Varro and another young man went with me and, with them as guides and interpretors, I was able to see the grimier side-streets of the great city. I was amazed at how open the prostitution trade was. One long street was lined with hundreds of prostitutes, like a sex factory assembly line with a dolled up Mexican prostitute in each doorway calling out her wares to us as we passed down the street grinning. The specialist was talkative but obviously an expert and chose my glasses carefully. If these help no more than the ones in Winnipeg, then no glasses will help, I told myself. They did seem to help a wee bit, but a wee bit was only a mockery as each day I had to face the stark fact that the pain was still there. From that time on I went to no more eye doctors but looked foward to the day I could afford psychiatric help.

It was a combination of factors – the eye trouble for which I partly blamed the Mexican sun, disillusionment with the school and the tension of living with Peter after his pass at me – which decided me to leave San Miguel in May. Peter was much more refined and gracious than the homosexual on the Rio Grande had been. That fellow simply got mad at

once when rebuffed. Peter's breaking point came considerably later but he, too, succumbed to frustrated anger. It came out after several days of his confinement in sick bed in his penthouse. A pot thrown by him to shatter at my doorstep early one morning woke me up to hear him calling that his back was so bad he couldn't get up. I was in a predicament. I could, of course, serve him and did so – fetching food and running errands – but when he asked for a back rub I balked. That could be a sexual stimulant. My suspicions concerning the seriousness of his ailment deepened when he also asked for assistance to take a shower. Even the bedside services could be viewed in two ways. He insisted that they be "thoughtful and concerned and loving." My bouncing cheerfully into the sick room was unbecoming, he said.

Finally he blew up, spitting anger and hatred. "Right, you go. Go, go off! Stride down that road in your big boots, with the wind blowing in your face, and the rain falling down the back of your neck." (He was referring to a lithograph I'd done in Jack Baldwin's class.) "There'll still be love and kindness and humanity left in this world without you!" Sick at heart, I walked away from that bedroom to a party I'd been invited to that evening at the other end of town. I gazed over the parapet of the house on the beautiful, dusk-darkened town. It was a good party and I was there in body, but inside I was in turmoil. "What can I do? What should I do?" His homosexuality apart, maybe he did have a point. But I cannot give something I do not have. Having received no love I had none to share out. This was the gist, in fact, of a long letter I'd written to my father from Mexico, explaining to him for the first time in our lives all the grievances I had against him and begging for a new friendly relationship with him when I returned. I went back to see Peter. He rolled over in bed to present his back to me: "I don't know you, buzz off!"

We parted on a formal, friendly note when I took a bus for the last time in the direction of Mexico City. Even two or three months later I still felt an inner rage against the man whenever I thought of him. To my way of thinking, it was quite simply dishonest of him to have built up my respect and admiration and closeness to him as a man only to reveal it all in the end as calculated seduction. A letter from him was waiting for me at Vinemount when I returned home. I replied with a post card that I'd write to him at length when I'd had a chance to cool down. This I did, some two months later, from the bush, describing to him some of my lumber camp experiences but, at the same time, explaining that I was not interested in regular personal correspondence. His response was just

the opposite – a stream of letters – each apparently planned to soften me up by conceding one or two points we'd differed on in San Miguel. He kept repeating there weren't many people in the world worth knowing but that I was one of them and could we remain close. I never replied, and gradually his influence faded out.

It would come back painfully now and then whenever some man or other would start up a friendship with me and seem to be getting too close. This happened, for example, with Ken Staunton at Netherne. As I've already mentioned, Ken, who in fact resembled Peter somewhat, was a patient who seemed to be hanging around me more than the others, craving company and conversation. On one of our countryside walks near the hospital, I could hold the question back no longer. "Are you a homosexual?" He looked startled and then denied it, obviously hurt. Next day he explained his reaction. "Substitute the word 'whore' for 'homosexual' and you'll see the damage your tactless question has done to our friendship." After that we still met by chance on the hospital grounds once in a while and even walked a ways together. But it was never the same as before I put that fatal question.

From Mexico City I made my way by bus to Tampico on Mexico's east coast. Veracruz was to be the jumping off point for yet another experience in self-development. I visualized it as working my way across the Gulf of Mexico on a tramp steamer. For two whole days I hung around the dock area, trying to strike up enough courage to approach a ship's captain. In the end I gave up in disgust with myself and bused up the coast to Texas. From there I hitchhiked to New Orleans and invested in my first sleeping bag.

The route I took along the Eastern Seaboard is quite vague in my mind. I do know I was heading in the general direction of New York where I was supposed to visit several people recommended to me in San Miguel. One recollection is of a scene resembling a Thomas Benton painting. Through an open doorway, as I walked by at night on the highway, I saw Negroes and whites dancing together to the music of banjos. I still can't trust my memory. Could such integration have been possible in the deep south? I had a good sampling of segregation in Birmingham, Alabama. Mindful of the brotherhood of man discussions I had had with the Chengs and Reuters in Toronto, I went and deliberately sat myself in the non-white section of the bus. A white woman, who had taken note of what I'd done, got up and, with a prolonged disdainful stare at me, lifted the NEGROES ONLY sign from

in front of me and put it into place on the seat behind me.

I had two more run-ins with homosexuals as I approached Washington, D. C. One was an itinerant like myself who joined me at the side of the road. After we'd stood there a while, chatting and thumbing in vain, he offered to teach me a new hitchhiker's technique – how to mooch a free meal. Not knowing who he was, I gladly agreed and watched from a distance as he approached a roadside home to ask for a sandwich. The lady gave him a big bagful of them. I'd never have dared such outright begging, I guess because I've never been flat broke in my life. Anyway, he shared the bag with me and I ate with great relish. Then came the catch. He asked me, as a return favour, to share my sleeping bag with him behind an abandoned building nearby. I pretended innocence. "But it's not night yet and how can the two of us fit into one bag?" I'd have felt guilty refusing him outright after he'd fed me so well. He persisted, however, and as we walked further up the road he suggested an old milk truck stuck in the weeds as a likely place to lie down together. "But why can't you just have a nap by yourself?" I continued to feign ignorance. "Because I hate to sleep by myself," he almost shouted at me as I walked away.

By that time I'd come to fully expect frustrated anger from all the homosexuals I'd run into. The last one I met up with, however, said good-bye with no apparent ill-will whatever. He was an effeminate hair dresser who had picked me up on the road in the dark when I wasn't even thumbing for a ride. I realized why I'd been picked up when, after some fifteen minutes of ever-so-quiet, gentle and smooth talk from him to get acquainted, I felt his free hand laid tightly on my thigh. I didn't have the nerve to tell him to unhand me. I certainly needed the ride so I tried to bluff my way through. In fact, we both entered into the sham by continuing pleasant conversation on a dozen topics other than what was really on our separate minds. I had made the counter move of placing my forearm equally firmly across my thigh higher up so that his hand couldn't get by. And so we sat at an impasse in the darkness of the car, mile after mile. Finally, as we approached a fairly large town, I said I had to get out to look for a hotel, and he let me go.

I stayed at a small Salvation Army hostel in Virginia along with about a dozen other itinerants. The Major who was looking after us was obviously trying to play the role of a hale and hearty, one-of-the-gang kind of person to get on the right side of us for possible conversions. But then one of the young hobos spoiled it all by taking advantage of the

camaraderie the Major had got going to tell us all a really dirty joke just as we were turning in. I peeked out of the corner of my eye at the Major. Red-faced, he laughed along with the rest of the bunch at the conclusion of the story. In Washington, I stayed at a hostel run by another Protestant sect. It was organized like a conversion mill. We got free supper and bed all right but, after the meal, we had to attend a haranguing religious service. A few men "accepted Jesus" or pretended to. The rest of us "sinners" were treated with very obvious distaste as we were bedded down for the night.

At last I reached New York where I was due to be put up by one of Peter's old San Miguel friends, nicknamed the Giant. I called him on the phone and then spent the evening at his home in Manhattan. But, despite all the hints I dropped, the Giant refused to take them. I asked him where the Salvation Army hostel was. It was too late by then to get into the hostel so I was forced to sleep on the ground behind it in my sleeping bag. The following night I tried sleeping in Central Park but a policeman found me in the bushes overlooking a throughway on the Hudson River side of Manhattan. My next New York State sleep was already well out of the city in a disused barn on Lake Champlain. There I could definitely feel the climate getting colder as I approached Canada. No memories whatever remain of Montreal, although it was my first visit there and I'd been looking forward to it for years. Ottawa was next. I spread my sleeping bag out in the bushes back of the Parliament Buildings. All night long the giant Eddy Paper Company neon sign in Hull, across the Ottawa River, blinked at me advertising toilet paper.

In Toronto I took advantage of the Chinese hospitality he'd always boasted of and stayed with Bob Cheng. The first evening, in which he described how much our friendship meant to him, was beautiful – like something from a Russian novel. But I sensed that there was going to be a follow-up. There was something even stronger, more important to him than friendship. I found out what it was the following evening. He reiterated his great love for his people, and the great things he wanted to do and would do for them through the New Order in China. I could see he was certainly a more dedicated ideologue than the year before but I still had the feeling the propaganda part sat uneasily on historic humanity. I remembered the difference in humanity between Joe Schultz and Peter White and so I explained to him that, though I admired his wish to work for his people, I couldn't accept his ideology. It was his ideology, in fact, that killed our beautiful, two-year friendship, for he was visibly hurt by

my refusal to follow him all the way. That one evening did it. I never saw or heard from him again.

My long, many thousand mile hike was now just about over. The very last ride brought me to the base of the Niagara escarpment, a mile and a half below our Vinemount farm. I had brought with me in my shoulder bag a few small Mexican crafts as gifts for the whole family. Actually, they were peace offerings, for I anticipated some hard feelings from Father after the letter I'd written him from Mexico. I was more right than I suspected. There was more than his usual coldness toward me. But, because I'd proposed a new friendly relationship, I was foolhardy enough to try fishing for financial assistance for my next artist's voyage of discovery – to Europe. He didn't blow up, just coldly put me straight: Not one cent of his hard-earned money would go toward my foolish dreams.

Feeling half sorry for myself at this rebuff to my proffered hand, I resigned myself to one year's hard labour. I returned to Montreal hoping to get construction work there so that I could learn French at the same time (for later use if I went to an art school in Paris.) Unfortunately, Montreal employment offices had nothing to offer me and I had to settle for a bush camp again. The camp I was sent to was on the northern route of the Canadian National Railway. Conditions were fantastically primitive. No one, except one German, spoke English, and the French wasn't French either, but coldest patois. No one washed their clothes. They just wore their shirts till they rotted off their backs and then bought new ones. Tea was made by each man throwing a handful of tea leaves into a bowl of hot water and drinking straight from that. The young French foreman looked askance at me when I arrived as if to say, "You'll never make it, garçon." And to speed up my demise he gave me a work strip on the side of a hill.

Mosquitoes and black flies were out in force and I'd been out of condition for some eight months. Apart from the fresh, clean air, all the other factors put together made it a first class ordeal. The insects feasted on me. The sweat poured off me. My body ached in every joint and muscle and I was half asleep as I struggled on my hands and knees, pushing eight foot lengths up that hill. But I just had to prove to the French-Canadians and to myself and to Father that I'd earn my passage to Europe. I would go to art school there. I would get psychiatric treatment for my eye pain and I would cure my chronic depression.

With $1,800 in cheques, a very sizeable sum in those days, I left the bush in the first week of December. I could have stayed on but saw no

point in proving myself over and over. I had the money I'd planned to make. I didn't go right home to Vinemount but stayed a few days first in Toronto with the Reuters. The reason was my beard. I'd written Mother a brief note from the bush and mentioned I was growing one. She warned me not to come home with it. The Reuters were, however, delighted with it. They were like second parents to me. I couldn't accept their ideology but shared most everything else. Gus prepared a large gessoed panel for me and I began work on a Cossack picture, an illustration of Gogol's *Taras Bulba*. To my grief, I discovered that all those months of intense physical effort and fresh outdoor life hadn't helped one iota to brush away the psychological hangup that produced the eye pain. Inside I was wild with anxiety but I plodded on nevertheless, alternating the use of each eye by holding my hand over it.

The painting reveals several flaws. For example, the figures of the Cossacks are tightly squeezed into a precalculated geometric composition. Also, being unsure of myself, instead of working the whole thing at the same time, I completed each detail before going on to the next, starting from the upper left hand corner and finishing in the lower right. It was a major work for me at the time, for it took me four weeks to complete it. I offered it to my father and he reluctantly accepted it.

I left home soon after Ukrainian New Year's Day which falls on January 14th. I remember the occasion well because there was a gathering of young people, Winnie's acquaintances, at the Vinemount farm house on New Year's Eve, the 13th. Mother was working extra hard now to get me married. She'd even selected a girl for me from the Grimsby Ukrainian church and tried to get us together. I, however, refused to kiss her at midnight according to the tradition. Mother's hopes of getting me hitched so that I'd become a respectable member of society instead of seeming to be aimlessly bumming around were dashed once again.

I knew, from my failure at Veracruz, that there was no use wasting time and effort trying to get work on a boat crossing the Atlantic. Still, trying to stretch my money as far as possible, I found there was a scheme whereby Cunard cargo ships took four passengers at rock bottom prices – $112. The actual sailing date, however, was uncertain because it depended on spring break-up in the St. Lawrence River and one had to be in Montreal day by day awaiting the phone call. Although it may appear so, I don't think I wasted either time or money in waiting for that boat. For one thing, I was on unemployment relief because I still couldn't get work in the city of Montreal. The $20.00 a week insurance I

got was more than enough for my frugal life style. I even saved half of it. I took the very cheapest room down in the dock area on Rue de l'Inspecteur and, as I was once again not allowed a hot plate, I ate only cold foods for three months. It was a rational diet of bread, margarine, grapefruit and Habitant soup. The soup wouldn't have tasted so greasy heated up but I was hungry and ate it with relish anyway.

But the biggest benefit by far of unemployment and the wait was in my development as an artist. It was then I learned the Nicolaides method from his book *The Natural Way to Draw*. The whole course is supposed to last one year. I crammed it into three months. I found most of the work assignments could be done right there in my room. If anatomy was required I simply undressed myself to that extent and studied my own body in the mirror. The gesture drawings could be done surreptitiously at the Top Hat Restaurant where I treated myself to a ten cent coffee and toast each evening. Or I went to the railway station. Train loads of European immigrants were pouring into Canada then and I drew them all.

The Nicolaides course began with two divergent approaches to drawing. In the first, the essence of a pose or action or the shape of a thing is captured with a quick scribble called a gesture study. The second is a slow, painstaking contour drawing and is done without looking at the paper but by convincing one's self that one's pencil point is touching the surface of the object being drawn. Gradually, during the year's work, as one becomes more fluent, the two approaches meet and marry and the student finds himself doing the right thing without having to worry about it. In the beginning, Nicolaides mentions, it is essential to scrap most of what one has learned already and start all over again. Essentially, the Nicolaides approach gets the student to appreciate the inner reality of things – their weight, their hardness or softness, their texture, and so forth, and teaches him how to report that effectively on paper. His promise to the student, that if he perseveres in the exercises he will make the breakthrough, certainly was kept in my case. I'd have written a letter expressing my sincere gratitude to him had he not already been dead for some time.

My father wanted me, I think, to come back home once more before sailing for Europe. But I'd washed my hands of my parents and had vowed never to return home again. The following is a translation of most of the last long letter he wrote to me in Montreal:

I see that I have been mistaken according to your way of thinking. My own ideas are derived from Old Mother Nature who has it this way:

> If anything is yours, it's also ours, the whole family's. And if it's ours, then it is also yours. If you have a chance on fame or honour, then it's ours too and vice versa. This honour is the family.

In a word I must admit to you that I finished reading that letter of yours from Mexico just two weeks ago. I intended several times to read it but I could not swallow more than two or three pages because something choked me in the throat and my eyes became wet and I could not see further. But I have finished it now. And since you write that I did not educate you for your good but so that I could have the glory and that I tortured you so you'd become a doctor and not some kind of artist, then certainly you won't want me to extol myself with your paintings. I do admit I wanted you to be a doctor or anything else as long as you'd not end up cleaning stables. But you'd have liked it if I'd been like Sam or Art Williamson. Then you would have loved me. But it is not yet too late. I will yet be such a one. I will give it a try too. Certainly I will not make the young ones at home as unhappy as you. They will curse me now because all the other children are going on to higher schools. But I will not be able to afford it and so they will have to work in factories.

I will save your letter for them and for you so that you will know how to look after your children when you have them. And you will see that it's no easy matter, even though you did not arrive from the old country without education and with only seven dollars and didn't have to work for only twenty-five dollars a month as I did. And you know how poor I was and uneducated and young, nineteen years old, and yet I managed. And my father had an even nastier temper than I. I see what your trouble is. It's that stubbornness of yours that's spoiling you. Underneath you know this and so try to divert attention by blaming it on someone else. Look at John now. He is doing the work he always wanted to do. He is earning three hundred and seventy-five dollars a month. He is happy. He does not blame me. Winnie is also happy. They do not blame me that they are not married as you do. But you want me to go dragging myself about a-courting a girl for you because you are too shy. And what of Nancy? She is exactly the age you were when you say I was killing you in such a beastly fashion. What would you say should be made of her? Send

her to the factories or to school? And who's having trouble with whom? I with her or she with me? I want you to write us when you know you are sailing for Europe and tell us whether you'll visit home before leaving or not, because we want to know this.

Father's letter was merely reiterating what he'd been preaching for years at home. So, although it strengthened my resolve to part with the family once and for all, I was no more hurt or angered than I had been. There was one letter I received about then that did hurt though – much, much more. In fact, I groaned as I picked it up at the front door as if I had psychic knowledge of its contents even before opening it. It was from Dick Cheng, Bob's brother. In my letter to him, about a month previously, I'd explained why I couldn't agree with him and Bob ideologically. I had quoted extensively to him from two books I read in Montreal's public library which had had a shattering impact on me. One pointed out that soil conservation and birth control were the two things needed to save the world. The other was Orwell's *1984*, a frightening prophecy of approaching world-wide political tyranny. I had meant to warn Dick what tight Communist control of the people of China would lead to. Dick must have dipped into the first book because he proceeded to punch my arguments from it full of holes. But *1984* he simply dismissed contemptuously without reading. "Pity my brother's blindness," he ended the letter, "in mistakenly taking you for a friend. Goodbye Willie. See you in 1984." It was weeks and months before I outlived the anguish brought on by that letter, so sensitive was I to rejection. I wrote a penitent letter in reply but there was no answer. He had really meant his "good-bye."

CHAPTER TWELVE
Conversion

I was living in a tiny room in London and earning four pounds per week from the sale of my *trompe l'oeil* paintings. For the first time in my life, as a result of the shock treatments I had received, I had the courage to try living off their sale exclusively. True, I was being ripped off by the gallery that bought them. The *trompe l'oeils* – small paintings of stamps, coins, pound notes, so realistic you felt tempted to pick them up – which they paid five pounds for I'd later see framed in their window and marked at seventeen. Nor were they in the least interested in my surrealistic or pastoral scenes. But that didn't bother me. The Catholic faith was the big thing in my life now. My eyes were beginning to see and I was being very excited by what I saw.

Christians have a name for what was happening to me. It is called Grace. To me it was a minor miracle. For years I'd been bored and even nauseated by religious literature and religious art, yet now I found myself avidly devouring and admiring it. For example, church services were still a bore but, instead of rejecting them as dead, useless and meaningless, I'd begun to ask myself why. Could it be that I didn't understand what they were really about and how they had developed? I had gone to Mass a few times with Margaret while still in hospital and now that I was out of it and near a church, I made a point of attending it most Sundays on my own. I had conceded that if God existed and Christ had founded the Church and five hundred million Catholics attended Mass, then obviously the Church wasn't going to abolish Mass just because it bored me, William Kurelek. I also had decided that it wouldn't kill me to give it a year's trial period just as I'd given Nicolaides a try and made a breakthrough. In order to understand the Mass and a lot of other aspects of the Church, I took a correspondence course about it. The lessons came

in plain brown envelopes once a week at no cost to the student. Nor were there any tests or examinations.

I preferred the correspondence course because I could remain anonymous and avoid any proselytizing. Sure enough, just as the course promised, no one called at my place or tried to haul me into church in any way. They did provide a questionnaire at the end of each lesson wherein I could express doubts and ask for answers to my questionings. For example, I asked, "If all men come from an original couple, then how come we have all the different races of men with such marked differences in colour and features?" Their answer was, "Science has not yet found the cause of those differences." "Hey wait a minute!" I thought to myself, "that's passing the buck." But a day or so later it began to dawn on me. "Well, yes, perhaps it is after all a scientific question. Perhaps I have been labouring all these years under the misconception that science and religion are mutually exclusive." I began to realize that, if both the Church and science are searching for the truth, then it's possible for them to be partners in that search.

To my surprise, as I completed the course, I found that I could accept the Church's teachings – they struck me as reasonable and acceptable – but I could not clearly and completely accept the existence of God. And, of course, if God doesn't exist, then the whole Christian faith collapses. I was in a predicament. Obviously I wasn't ready to become a Christian if I didn't believe in every central premise of Christianity. I decided to write them a letter honestly explaining my problem and asking them if they could recommend a priest who could resolve my difficulty. Their reply was that they doubted it would be successful but if I insisted it could be tried. They gave me the name and address of a local priest, Father Norton.

Father Norton was a young man of Italian extraction, vigorous and jocular by nature, one might almost say a smart-alec. I found myself immediately ill at ease. I felt he ought to take into account my recent stay in hospital and the fact that, though it had cured my eye problem and my depressions, the third malady – depersonalization – was still there. It seemed I was destined to live with it. Perhaps it was even this depersonalization that prevented me from seeing the concrete reality of the world and therefore the concrete reality of its Creator. I went straight to the point on our first meeting by explaining that I had difficulty in accepting Christ because I had difficulty in realizing his actual existence in history. He asked me if I believed that Caesar and Napoleon had, in

fact, existed. Or Stalin, who had died two years previously. To all these questions I answered honestly, "Yes and no," meaning that I believed they existed but they weren't sufficiently real to me. "Bill," he said as he laughed with exasperation, "I feel like giving you a good shaking!"

Much as I hated to admit it, it seemed that the correspondence course people had been right. After two abortive sessions with him, Father Norton said I'd better do more studying and thinking on my own. I was crest-fallen. It wasn't only that the urge I felt to enter the Church had been frustrated, my intellectual pride had received a blow as well. I'd always considered myself a clear, logical thinker, yet here was evidence that even with my university education my thinking was hopelessly fuzzy. Part of the trouble was emotional: When I face an antagonist who is more eloquent and more poised than I and who seems to be enjoying the duel as well, my reasoning faculties simply blank out. As a going-away helpful gesture he offered me a copy of a book by Alfred Noyes, the English poet who died in this century, entitled *The Unknown God.* I read it through five times and yet still it didn't convince me of the reality of God's existence.

It did help, however, in a telling way which I comprehended only slowly over the months and years that followed. It introduced me to the question of the existence of beauty in the world. Although I was a professed artist and therefore involved in the appreciation and creation of beauty, it hadn't occurred to me to explain the existence of it. Nor was I aware that materialistic philosophers and scientists had no satisfactory explanation of it either. Noyes beat me to the gun, in fact, by presenting a materialistic explanation for man's appreciation of beauty such as I would have used as an atheist and then debunking it. He selected the beauty of a butterfly wing as a case in point because Darwin, in one of his treatises, had attempted to rather crudely explain beauty using his theory of evolution: the most attractive butterfly had the best chance of attracting a mate. Darwin had overlooked the fact that it is the minute patterns and exquisite shades of colour wherein man recognizes beauty and is moved by it. The butterfly does not. He merely goes after a bright flash of colour as experiments with butterflies and pieces of coloured paper proved.

Noyes then goes on to point out many more examples of beauty in nature being largely optional extras. If man, with his superior intelligence and creative ability, can produce works of beauty, then the original force that created nature must also have intelligence and can create beauty of

an even higher order. And it is this beauty that man observes and is awed and inspired by everywhere in nature, from the most microscopically tiny example to the grandest sunsets and the stars in space. Moreover, there is absolutely nothing in the jungle law of the survival of the fittest which demands that man develop the ability to create violin concertos and appreciate them. What more logical conclusion can one reach than that man is made in the image of a God who is perfect Beauty as well as Truth and Goodness? Thus went Noyes' arguments.

As I studied and pondered these Catholic ideas in that little room in Baron's Court, I was also becoming more aware of the Catholics around me. It was impossible not to study them, for if Catholicism was true I wanted to become a Catholic. And would that, judging by my Catholic acquaintances, make me a better person, a happier person, a stronger person? Margaret was, of course, my main study. I visited her much more often now that I was back in London. During our exchanges of affection, I noticed a new emotional problem which perhaps the E. C. T. had allowed to surface. It was a very acute kind of vacillation and confusion which paralyzed speech and even body movement. I would just sit there on Margaret's sofa, unable to move or even weep to get release. I could not speak because each time an idea would come to my mind a counter idea would follow which told me the original idea was better not expressed. Margaret would then try to say or do everything she could think of to break through to me. But when she saw none of that worked, she'd leave me there on the sofa and retreat to her kitchen to putter around, hoping it would pass over. It always did eventually, leaving me emotionally exhausted for an hour or so.

Inevitably, I also cast my mind back now to all the other Catholics in my past – Frenchie, the two girls from Hawaii and Texas, Chuck Plante – how did they measure up or fail to measure up to the faith they professed? They seemed to cover the complete spectrum from saints to sinners and this applied no less to the dozens and even hundreds of Catholics I was yet to meet. At first, starry-eyed and idealistic as I was when fresh in the Church, the company of all the bad ones was hard to take. I felt the Church should throw them out as they were harming her image with their bad example. It was obvious after a while that being a baptized Catholic did not guarantee that one would be a better person. One had to use another scale to judge them, namely, were they sincerely using the rules and aids the Church provided? The teaching Church, even as early as the correspondence course I enrolled in, pres-

144

ented its stand on bad and lukewarm Catholics this way: Christ has come to call not the just but sinners to repentance. As long as there was one scrap of faith left in them they were still in the right place to repent and change their ways. Leave the final judgment of each individual to God. Only He truly knows the heart of each person.

Toward the end of that winter another adventure brought me further into the Church. In January or February of that year, 1956, I had happened to read in the condensed book section of the Reader's Digest an article entitled *The Mystery of Lourdes* by a Protestant writer, Ruth Cranston. She had gone to Lourdes in France determined to get to the bottom of the many stories of miracles worked there. To do a thorough job she settled for a year in the town. Judging by her account, she did, in fact, become convinced of the reality of the miracles. As I put the magazine down, a bright idea came to me. "Why not do something similar myself? Even a week there with a pilgrim group may turn up something vital." Checking my meagre bank account I found I had just enough money to spare. There were thirty of us in the group. Sure enough, when our plane touched down in the foothills of the Pyrenees, the range of mountains that separates France and Spain, I found that Lourdes really existed. So strong had my skepticism been during my career as an atheist that I had even vaguely doubted that.

In this age of tourism and travel comfort pilgrimages have become more like vacations with a pious flavour. Without intending it to be so, that trip was, in fact, my first ever vacation, the first week in my life I did no work. I struck up an acquaintance with one of the pilgrims, Maria Isabella Da Luz, a nurse of Chinese-Portuguese origin, who I came to know affectionately as Izzy. She and I made enjoyable excursions of our own into the French countryside, climbing the foothills to watch shepherds tending their flocks and peasants sowing the land by hand. When telegraph poles were out of sight it was hard to believe we were in the twentieth century. Izzy and I also browsed in the shops in town but I avoided buying, not only because I had no money but because the religious souvenir shops were cashing in on the spiritual, which I found disgusting. I was relieved to note there was a sacred area surrounding The Grotto, the three superimposed churches and the hospital called the Domaine, where no commercial trafficking was permitted. In all, I had to admit it was a memorable week, much happier than my previous trek to the continent.

There was no vacation, however, from the spiritual task I'd set myself

and I worked harder than ever thinking, meditating, inquiring, reading and, especially, praying for light. It was now a full year since the E. C. T. when I'd begun daily prayer. It may seem strange that I did so in view of my inability to believe in God. It was always more like a deliberate gesture of good will. Actual faith and understanding the faith remained exasperatingly divorced. Were Lourdes miracles perhaps a case of psychosomatic medicine, mind over matter? I personally knew from my own experience with eye pain that the subconscious can affect the body. When Dr. Charatan told me point blank at Maudsley Hospital that there was nothing wrong with my eyes, the pain disappeared the same day. But what about patients who were at the point of death and unconscious at the time of their cure? Or babies born blind or paralyzed? In the Lourdes museum I saw hundreds of photos of patients before and after their cure. Were these faked? I could, of course, go and visit some of the cured, as plenty of skeptics had done before me. But I knew by then that these former patients and their doctors would tell the same story as recorded in the museum. In fact, if I persisted in being suspicious and skeptical I would end up believing in a giant web of conspiracy between the Catholic Church and literally thousands of patients and pilgrims. In a word, it was almost easier to believe in the miracle itself.

And so it went on in my mind, twist after twist after twist. I didn't want to return to the phoney lip-service church affiliation I had acted out in Winnipeg. This time it had to be the real thing. One cannot make oneself believe. One can only open one's arms to receive the gift. There was nothing more I could do except to keep praying for the faith, searching for more clues, more information, more insight.

A week or so after my return to London I decided to return to Canada for a summer visit. This time it wasn't on a tramp steamer but on the giant liner "Isle de France" which crossed the Atlantic in only four and a half days. Several motives coalesced into the one resolve to make that visit. One was that I needed to get away from Margaret for a good space of time to find out my true feelings for her. Another was that some of my eye trouble had returned, probably because I was painting so many *trompe l'oeils*, work that is very minute and concentrated. A third motive was to make another stake, a lump sum of money that would enable me to do research on a giant new project which had taken shape in my mind. This was the illustration of the Gospel of St. Matthew sentence by sentence, eight hundred and some-odd paintings. The most expensive part of the research would be travelling to and living in the

Holy Land. And last but not least, I'd be seeing my family again.

Yes, whatever anybody might say for my then half-faith, it had changed me to the extent that the old Mosaic and Christian commandment to "Honour your father and mother" at long last seemed sweet and reasonable. I'd even begun to realize that I was guilty of having broken that commandment. No matter what my parents had done to me they were still my parents and I had owed them respect in view of their role. In fact, I was bound to point out their virtues to the world and to return good for any ill they might do me that summer.

Father greeted me at Hamilton Railway Station with his first ever kiss and hug. He was evidently emotionally overcome for he and Mother had nearly lost me and here was I back again in apparent good health. It was a week or more before I showed them the scars of my arm wounds. Mother and Father were obviously weighing carefully what they said to me although they still blundered now and then. One of the signs of cautiousness showed in their interest in Margaret. They obviously thought her too old for me but said such a marriage would help me get better for she had a good heart. John and Winnie, now married, treated me with a new kind of friendliness. Father, although he still treated my young brothers and sister harshly now and then, had nevertheless definitely mellowed.

As for my own big change, namely to religiosity, it was obviously not liked. John said so openly. Mother and Father were more guarded. To use their words, "It's something to hold on to, even if not true." I myself avoided preaching even when I defended the faith. It didn't seem right to urge others to accept something I wasn't one hundred percent convinced of myself. The only really sticky situations that developed were when I'd refuse to eat meat on Friday or attended Mass. That last really looked crazy to my parents because when the car wasn't available, I'd walk or cycle to church. It was only about three miles distant but there was a mountain in between. Going down to church was easy but the return climb really worked up a sweat.

After a few days of visiting, I had to get down to work. My brother John got me a job at his company, Standard Tube of Woodstock, Ontario. However, a week later, the company began to lay off people and since I had been the last to be hired, I was the first to go. John seemed more upset about it than I was, for with my new found "faith" I was able to argue thus to myself: "If God exists and wants me to get to the Holy Land, He will provide. Let Him (if He exists) arrange it in His

147

way." I moved back to the farm and applied for work through Hamilton's Employment Office. I got the infamous Grimsby Brick and Tile job from them. It was a foretaste of hell, like something out of Bosch. "God has a strange sense of humour to answer my prayer for Holy Land research funds with such an unholy job!" I wryly commented to myself. On the lowest possible wages, in the humid heat of a hot Ontario summer, we had to hurry daily into the brick kilns, which looked dangerously crumbly, as soon as the fire had been turned off. The foreman was a young man just out of the army. In human conveyor belt formation we had to pick up the hot tile which burned the hands even with gloves on and load it onto a truck outside. Nearly every drop of moisture was drained out of me in perspiration, hour after hour, under the pressure of those cold, unfriendly eyes – hurry, hurry, hurry.

I thought I'd already sampled the worst possible jobs but, as I groaned in bed at night with my bad back, I just couldn't believe it possible that such a sweat-shop still existed in Canada. I guess they saw I was caving in because after a few days they transferred me inside the factory. I was put on the assembly line removing cold, soft tile as it came out of the moulding machine. I was hopeless at that too, gumming up the works in my nervousness. I got paid on Friday. Work continued through Saturday too, but during that night I made my decision: I would quit. I appeared at the plant the next morning and was just about to open my mouth when the supervisor appeared and said, "What are you doing here? You were fired yesterday." Such was the extent of their indifference that they hadn't even bothered to tell me.

My next job was more in line with my ability and experience – pick and shovel work putting in septic tanks and weeping tile. It was a bit of a jolt to find I had to handle the very product I had just escaped at the manufacturing end. But I made a joke of it and settled in very well. It was the exact opposite to the previous job except that I noticed the back trouble was still with me. Only gradually did it dawn on me that it was a bad souvenir of my first E. C. T. shock, one I might have to keep till the end of my days. I went for a chauffeur's driving test, passed it and drove the company truck. I couldn't believe my progress. However, I said a prayer every time I got behind the wheel. I managed to save some $600 plus ship's fare by living at home on the farm and helping Father in off-work hours. I worked with all my heart to please him. It was a bad summer for him. I wished to console him in his adversities but that would have meant talking religion, a subject he had specifically asked me not to

bring up. The last job I remember helping him with was cutting a stand of lush corn. We had to wade ankle deep in flood water and cut it by hand. A corn binder couldn't possible have got in there.

Once again, I was on my travels. The big problem, as the ship neared England, was how to approach Margaret. Finally, I decided to make a tentative proposal of marriage. Fortunately, she had also had time to get her bearings straight while I was away, or so it seemed to me. She maintains there was never any question. She gave me a firm "No" and went on to explain I no longer needed her as a crutch. In the days that followed I slowly came to some realizations about her and me. One of them was that I had been afraid all along that I was seeking the faith only to please her. Her rejection of my proposal revealed my fear to be unfounded. I had really been after the faith for myself.

The other important realization was the priceless strength the faith had given Margaret and how that strength in turn had saved my life. In my helplessness and dependence on her it would have been so easy for her to take advantage of me. The way of the world today is that free love outside marriage is natural and right. Margaret had given me a very real object lesson. She allowed physical affection between us so that I could catch up on the petting I'd missed in childhood from my mother. But she always drew the line when passion began to show itself. In that way I learned there was something stronger than human love and human feelings and passing human passion. It was the love of God. If I could acquire that strength, I too could face life—even if it got much tougher. In other words, had she weakened, I'd have concluded that the faith was a sham that could be set aside at one's convenience. She'd have gone down, and I with her.

A week or two later, as if things were working out according to a hidden plan, I met Father Lynch. I was then settled in Streatham Hill, South London, and painting pictures while looking for work in picture framing. I used to stop in at St. Simon and St. Jude, the local Catholic church, to pray on most days. Father Lynch was the parish priest and, after a while, he noticed my comings and goings.

One day we ran into each other in the church porch and he said something like, "I believe you're new here. Are you Irish?" I hastened to correct him, "No, I'm Canadian." Then I added, "I'm not a Catholic either—just interested." That roused his curiosity further. "Come into the house for a while," he invited. I hesitated, remembering my failure with Father Norton, but a second thought followed immediately: "Well, why

not? I'll at least get acquainted with him personally and that will make it easier later on when I do recommence instruction."

That was how, in next to no time, he had me sitting in an armchair by the fire and was finding out that I was a painter and asking me my opinion of his paintings. His hobby obviously was the collection of curios. He was Irish and, like many Catholic priests in England, he was stout and balding, the remains of his hair having turned white prematurely during the bombing of London. He was very approachable. In fact, even on the first visit we began pulling each other's legs. And he was very generous, almost too much so, with gifts and favours. In subsequent conversations I saw ours would not be a meeting of intellects. However, knowing he couldn't cope with my philosophical doubts didn't stop him from humbly and conscientiously putting me in touch with those who could. It seemed that my prayer was answered at last; this man certainly didn't make me feel small or dull and he really wanted to help me into the Church.

He took me in his little Austin Mini to meet many prominent Catholics and to places of interest in Catholic history. One of these trips was to an enclosed Carthusian monastery in the southern country. Each monk, having taken a vow of silence, lives in a private cell most of each day like a hermit, praying for the world. We drove eastward to Aylesford, Kent, where, wonder of wonders, I found that pilgrims to the shrine of St. Simon were lodged free of charge as was the custom in the Middle Ages. Somehow the discovery that there are still communities of human beings where profit making is discounted and God is trusted to provide was very satisfying. I was introduced to one of the monks there in the hope he might unravel the philosophical or psychological tangle I found myself in over the existence of God. We quickly bogged down. Not to be discouraged, once we'd returned to London, Father Lynch took me to a professional theologian, Father Edward Holloway, who had trained at the English College in Rome.

I had two intensive sessions with him, each three hours long, going over my difficulties. The amount of eloquence and knowledge which the man put forth in those six hours was phenomenal. The fact that he knew science as thoroughly as his theology and wasn't afraid of it finally persuaded me it was "safe" to become a Catholic in our scientific age. He even pointed out to me actual and possible disagreements between religion and science that I wasn't aware of. One question, for example, which I asked him about was the old one of Adam and Eve. Were we

expected to swallow the story literally? He said no and proceeded to point out how the Old Testament, unlike the New, is a mixture of history, theology, poetry and myth. It certainly contains God's word, but the form it's presented in is really suited to the world concepts and primitive level of knowledge of men of very early history. Sorting it all out in the light of present day scientific knowledge is precisely the job of the theologian.

"For example, we read in the Bible," said Father Holloway, "that the first man was chased out of the Garden of Eden and an angel with a fiery sword was stationed at the gate to prevent man from ever trying to return to his lost paradise. To early man with his vague notions of geography this was enough to know. But today, since the whole word is geographically charted, we know there is no such place. Suppose, however, we take the Garden to have been merely a warm, fertile area of land that first man found himself in and that he was happy there in a special way because of an interior state of innocence. Then we can understand men to have lost paradise in an interior rather than an exterior way."

After these sessions of theology, Father Lynch and any other priests who happened to be in the presbytery dining room would relax with us as we shared high tea. Discussing me among themselves they'd come to the conclusion that I already did have the faith. But it still had to be my free decision to act on it and ask for reception into the Church. Somehow, their mere statement of their conclusion clinched the matter for me. The whole issue seemed to hinge on authority – professional authority. They were the official representatives of the Church, the link between God and man, just as surely as a doctor is a representative of the medical profession or a lawyer of the legal profession. If I go to a doctor for a medical checkup and he tells me I'm in good health, do I not accept that? Therefore, if a priest gives me a spiritual bill of good health after examining my spiritual disposition, should I not also accept it?

Father Holloway's last words as we parted at the door convinced me to take the plunge: "In the last resort, the Catholic Church relies on the conscience of each of its individual members for obedience. If you should decide sometime after entering the Church that you had made a mistake, then there is nothing to stop you from leaving. Thus, when you have come before God at the moment of death, He will already know that you were honest in leaving and will say, 'All right boy, come in anyway.' I'd also suggest in view of your still shaky nerves not to keep drag-

ging the matter on and on. Either come in now or drop it for a while."

I asked Father Lynch to instruct me. There was little left to learn after the massive four years of research I'd personally undertaken on the Catholic faith to make sure the wool wasn't being pulled over my eyes. My instructions, therefore, turned out to be a month and a half review instead of the six months they usually take. This time there were no arguments. We would begin by kneeling on the floor of my room and asking for enlightenment of the Holy Spirit. And sometimes, when Father was leaving, he would give me his blessing. At the same time as he was instructing me in the simple basics of Catechism, he had a Jesuit scholar come over to see me about my philosophical difficulties concerning Original Cause. He sat in my one chair and I on my cot. It was every bit as exciting a journey of exploration as my adventures of self-discovery as an artist had been after leaving university. Only this time the journey was taking place in my intellect instead of out there in the workaday world.

The scholar pointed out that even a child knows that nothing can come of nothing. "He may have a mistaken anthropomorphic conception of God but he is not satisfied with a God who, in turn, may be made by something else. Imagine there is a pebble on your window sill. It's there. It really exists. Now on your table there is no pebble. It doesn't exist. Can it make itself become? Of course not, simply because it's not there to make itself become even if it had the power to do so. It's the same with the whole material universe. It couldn't have made itself become because it wasn't there to do so. It follows that there must have been something there in the first place. And that something must have existed since the beginning of time and must still exist."

I was truly fascinated by logic when I had to come to grips with it in a real life need. It was a thrill to find that in my own poor fumbling way I was following the greatest minds the world has ever known: Plato, Aristotle, Aquinas and others. I was delighted to discover that the existence of God and His nature could be argued by using reason alone.

Besides the scholars he introduced me to, Father Lynch also went out of his way to hunt up books that would resolve particular difficulties I was bothered by. There was one little booklet in which things were made marvellously clear by the use of popular examples. I opened it and found the beginning paragraph went something like this: "You are looking out the window and see a leaf or paper moving down the street. You know that the leaf or piece of paper didn't just make up its mind to toddle down the street. It is the wind that's moving it. What causes the

wind? Movement of air due to variations in temperature of the atmosphere. What causes the change in atmosphere? The sun. Where did the sun come from? Some scientists say a nebula – that's a swirling mass of gaseous matter. Where did the nebula come from? It's not reasonable to simply drop the whole matter with a shrug and say, 'I don't know.' The point is that it's there and must have been caused by something, whether you're curious about it or not."

It is this something that Christians and Jews call "God." All things have existence, true, but there's a vital difference in their kind of existence. Everything except God is continually changing and, at some point, begins to exist. In the final analysis they are all dependent on the first cause. This is the whole crux of the matter. God exists and it is He who created the world which we see. This, in fact, is what is told in the Bible and what most men have known by intuition throughout man's history. As I put down the pamphlet for a pause to take in what I'd just read, I could not help recalling how struck I had been when I came across those revealing words in the Book of Exodus. God speaks to Moses from the burning bush and Moses, still resisting the role of prophet that has been thrust upon him, asks Him for extra credentials. "But who shall I say to my people that you are?" And the stark, simple reply that came out of the fire was, "Tell them that I AM WHO AM sent you." In other words, existence itself had sent him. The meaning is exactly the same.

As I read these arguments I was particularly startled to discover this single point: "No one has ever successfully argued the non-existence of God." Nowhere had I come across categorical proofs that God didn't exist. A man like Marx, for example, whose atheistic philosophy is reshaping the lives of millions upon millions of people didn't even bother to begin with a scientific refutation of God's existence. If he had then he might have asserted his philosophy with some justification. Actually, since it can be argued by reason alone that He does exist, while it cannot be argued by reason that He doesn't, it comes to this: Disbelief in God's existence is a blind act of faith and belief in God's existence is reasonable.

There are simple believers aplenty, however, and there have been many more in the past. And it is against them that the skeptic, as I used to be, can hurl seemingly telling arguments. "If your God exists," they say, "and He's all powerful, then why doesn't He show Himself?" Or sincere seekers after truth wonder why the arguments for His existence aren't immediately and overwhelmingly convincing. These two related questions really plagued me but, gradually, I arrived at satisfying answers.

153

For one thing, we simply aren't equipped to see Him face to face. It's like a moth being attracted to a flame and burning up in it, or a fish jumping out of water and dying on dry land. Even if there was some kind of protective shield we'd still have this insurmountable problem: Mankind spoiled the original secure relationship we had with Him in the Garden of Eden. We *can* get back to Him now, under a new plan, but that plan necessarily calls for free choice. God is love and love cannot force love in return or it is no longer love. We have to be free to choose – free to go with Him or against Him – otherwise our love would be meaningless. It is precisely because faith isn't easy that it's called a virtue.

A common objection, raised both by believers and non-believers, is: "If God is Good, then how come there is so much pain and evil in the world He has created?" This is a hard question to answer satisfactorily to sensitive people or those actually suffering because it's emotionally loaded. It's sometimes very difficult but the point has to be made that if pain and suffering prove that God doesn't exist then the human situation is indeed bleak and utterly hopeless. On the other hand, if He does exist, then those who suffer innocently or those who suffer with hope in Him will at least find restitution and an end to the pain after death, if not before. In effect, rejecting God because of the evil in this world is like the man who sawed off the very limb he was sitting on.

My father, I realized on that summer visit to Canada, was a good example of the latter. That summer was too wet but others were too dry. I had the feeling he'd have almost preferred it if there was a supernatural being so his sufferings would have some meaning. "Those clouds," he'd say, pointing in their direction, "they have rain in them. But they can't get here because there's a devil sitting up there and he just gives a swish of his tail and sends them flying of to either side of our district. " There's another story he used to tell, expressive of his bitterness against God and rejection of Him: "In our village a neighbouring woman was about to have her first baby. Too late, it was discovered the birth passage was too small. A Caesarean section was called for but the people were too poor to go to the capital hospital and there was no local doctor. I was just a boy then. For three days, the whole village could hear her screaming with pain. Even the birds were scared to sit on that house. In the room were many women of the village who could do nothing to help but get on their knees and pray. Their prayers were useless, for in the end she turned blue and died. Today, people are smarter. There's a village doctor and ambulance service to Cherniutsi."

To my way of thinking, the only possible explanation for the presence of evil in the universe is that it is a kind of foil. God permits suffering because He, in His omniscience, knows that the good that comes out of it in the end outweighs the evil. I know personally how true that is. It was precisely my suffering which broke through my selfishness and intellectual pride. Even on the earthly plane it helped me become a deeper and more successful artist.

When I use the word "foil" I mean it in the sense that if you paint gold daffodils on a gold background they disappear. Likewise, goodness has no meaning without the possibility of evil and love has no meaning if it's not possible to hate. It's possible, of course, to rail against God and accuse Him of not being something other than He is, but that's asking for the absurd. Black cannot be white, a circle cannot be square. You cannot beat the reality of Him; the smart thing is to join Him. No one, not a single soul is obliged to choose evil as against good. And it's not as if He's expecting us to go through something He wasn't prepared to go through first Himself. In some mysterious way, when He came to earth in the person of Jesus Christ, He suffered more in that space of time between the Garden of Gethsemane, with its mental suffering, and the hanging on the cross, with its physical pain, than any man, woman, or child in this world will ever know. He didn't have to, but He went through it so that He could show us the way to break away from evil and save ourselves by turning to Him.

After my instructions were over, I went through a formal conversion service at St. Simon and St. Jude with Father Lynch receiving me. I had two sponsors, that is, formal witnesses. One was David John, a sculptor friend who couldn't be on hand in person as he was in Liverpool working on the new Catholic Cathedral there. The other person was, of course, Margaret. She was so happy. She had to place her hand on my shoulder when her turn to witness came. It was the same kind hand that had rested on my shoulder when I had caved in confessing my misdeeds to her in my studio at Maudsley. I was only conditionally baptised as we were pretty sure my Orthodox Church baptism, thirty years previously, had been valid.

All this took place against a naturally dramatic setting. Outside it was dark and windy and raining, while inside there was just this little island of light at the alter rail where we three stood. It turned out my reception day fell exactly on the Feast of Our Lady of Lourdes. I'd arrived home at last. Now I could start living.

155

CHAPTER THIRTEEN
Home

The whole of my life was moving towards sanity and wholesomeness as I set about the long but rewarding task of remodelling it on a day to day God-centred pattern. I didn't feel great bursts of joy – few converts do. I knew there was no point in pretending to be extra happy because God can't be fooled and it was Him I was now setting out to please and impress, not people. But, no doubt about it, I was in a quiet way a happier, more glad-to-be-alive person.

There was one very important thing I'd learned about emotion. It is a fleeting, fickle thing. It's good to have in so far as it helps with devotion, but never, never count on it. Witness all the revival meetings that flare up suddenly and then flicker out in a decade or two. No, there had to be another kind of conversion – one of the WILL. It's like discovering that two and two make four. You know it's true. Period. And it will continue to be true no matter what you feel like. You, for your part, must make the best possible effort to live by it. Sometimes it will be easy, sometimes difficult. Sometimes you'll feel uplifted, sometimes dry as dust, or even in that state which religious people know as "the dark night of the soul."

I'd already been working for some three months for a picture framer. I had approached some half dozen shops before I chanced on Pollocks. Their workshop is situated in an old courtyard that goes by the quaint name of Blue Ball Yard, off St. James Street near Buckingham Palace. I had decided to go into picture framing for three reasons. One was that I obviously couldn't make a decent living from painting. Also, my eye pain returned if I painted full time. But the main reason was that I wanted to go into partnership in picture framing with my father if he'd agree. I'd noticed what a hard time he was having when I'd stayed with him that

summer. He complained so much about his health then and in subsequent letters that it seemed it would shortly break down completely. I knew, of course, from our past history that we couldn't possibly work together. But I thought the partnership might succeed if I designed the frames in Toronto, had him build them at the farm and then gave them the finishing touches myself back in my shop in Toronto. I also hoped thereby to introduce him to the Christian faith. He could simply return to his Orthodox faith if he preferred, but what he needed was a firm commitment to Christ so he'd have an anchor, a happy goal in life. However, before any of these picture frame business dreams could be realized, I had to learn the trade myself.

Mr. and Mrs. Pollock were Czech Jews, refugees from the Nazis. Mr. Pollock had a first class reputation as a frame and antique restorer, perhaps the best in the city for he really had taste and skill. We framed many an Old Master, the real thing, not copies or prints, and so it was a privilege to work for him. But it wasn't easy because I was still shaky from my recent illness and their Prussian treatment of their employees reminded me too much of my boyhood. I lived in continual apprehension of pain and embarrassment. They, especially Mrs. Pollock, watched us like hawks to see that we really produced. If we didn't, there'd be a scene. Also, as with my father, if I did a job badly, not wilfully but out of inexperience, I was reprimanded.

Mr. Pollock was fat and bald and worked on a wide table across from me and the foreman, Hans Roeder, a young gilder from Cologne. Completely absorbed in his work, he'd be humming to himself and breathing heavily as he gave the final exquisite touch to a frame or antique. He wore an apron over a suit so that he could be ready at any moment to meet important customers. Once in a while, if he found something missing, he'd peer out over his half-glasses and ask *"Wer hat mein juizel?"* or *"Wo ist mein spritz holz?"* The search usually ended with the discovery that he'd mislaid it himself. German was the language of authority in the shop, although only half the employees were German. There was also an Indian, Mr. Noolan, who was a deaf-mute, and three or four English workers. The deaf mute was perfect for working in the secret back room wherein was practiced a jealously guarded trade secret – the artificial cracking of gesso.

My first job was to strip some antique chairs and give them coats of gesso. It was tedious work but I fully agreed that an apprentice should begin at the bottom. As it was, I was lucky to be taken on as an actual

158

employee because I had no formal training in mixing colours, never having been taught in art school. Mr. Pollock, however, not only knew dead on what colour a thing was to be but also exactly how to mix the colours. In a way, working for him was like a continuation of art school. Many of the techniques I learned at Pollocks, e.g., spattering, smudging, sealing, gessoing the ground, eventually found their way into my painting techniques.

Another task I was given, especially when business was slow, was frame stripping. I was given half a dozen assorted dentist's tools and told to strip a gold frame which might be several hundred years old, inch by inch, right down to the original coat of gold. It might take weeks to do just one frame and if only two inches were done in a day that was good progress. I and a few others who did this kind of work had to be ever so careful not to dig too deep or we'd get hell. It was such intense, minute work that I feared for my eyes again. But this fear was no longer founded. The odd and significant fact is that from the year of my reception into the Church until today, twenty years later, the pain has not returned. Even as I sit here writing this book, I can't help but note that before my conversion such intensive paperwork would invariably have brought back my eye pains. I also work on my paintings seventeen hours a day, seven days a week, for three solid weeks when on my painting trips. Still no pain. Is it a miracle, I wonder sometimes, or can it be explained naturally?

While working at Pollocks, I continued artwork on the side. I no longer tried selling but two summers in a row I submitted *trompe l'oeils* to the Royal Academy Show. They were accepted and even sold. Father Lynch also gave me a few small commissions. But the big project which I'd begun was the St. Matthew's gospel illustrations. There were eight hundred and some odd to do, as I was doing it sentence by sentence, and I prepared sketches for them all during this two-year period. In the end, I made the decision to work on the Passion only, which is 160 paintings. The whole series, at one painting a week, would have taken twenty years to do, I calculated, and times were too uncertain for that. (This was when Russia was testing the Doomsday Bomb in Siberia.) The motive behind the series was simply to give glory to God and provide a teaching aid for missionaries spreading the gospel. The word "gospel" means "good news." It had proven such wonderful news to me that I sincerely wished to share it. Once slides are made of the illustrations, I told myself, the paintings themselves can be sold. But I had no mercen-

159

ary motives in doing them for the simple reason that I knew religious painting, in our modern materialistic society, is not saleable.

After my conversion it seemed to me that there was one more proof of God's wisdom in permitting certain evils because He knows good will eventually come of them. In the bad old days, I'd developed a neurotic drive to keep working and working on a tight schedule, a certain number of pages to study for examinations on a particular evening, so many cords to cut per day in the bush, that many rows of corn to cut for my father, and so on. Now I found all that self-discipline was just the thing to harness my energies to a really worthy cause. While I worked on the sketches, I played classical records, many of which Father Lynch and Margaret had introdced me to. Beethoven's violin concerto, The Emperor, was a definite influence toward my conversion for there was no getting around Alfred Noyes' contention that beauty, exquisite beauty, such as can be found in this concerto, simply did not make mere evolutionary sense.

At the same time, I launched myself on a program of self-discipline in Christian charity. I understood that faith alone didn't guarantee a man's salvation – he had to do good works. It was now comparatively easy to forgive those who'd hurt me in the past. The real test was to do it in the present, right there in the shop.

Sometimes Mrs. Pollock would attack me with ferocious vindictiveness. At one point I even had to explain to her about my recent hospitalization. After that she treated me more kindly. One of the words of abuse they used on me was *Schweinerei*, which means pig shit. I still smile to myself recalling how, after half a year of this name-calling, I suddenly started talking to Mrs. Pollock in German. Her eyes popped and her face turned white. "Kurelek knows German?!" was all she could say. They dropped the *Schweinerei* from that day on.

My struggles to stave off resentment and self-pity sometimes lasted days. The only thing that seemed to be effective was to do something good or say something kind in return for hurts. My old habits of grudge-bearing had worn grooves so deep in my soul that I responded to abuse and supercilious treatment automatically in the old unforgiving way. Hans Roeder, for example, who had a Prussian officer manner of addressing those under him, was Jesse Samson, Victoria Dolensky, and my father all rolled into one.

Mr. Noolan, the deaf-mute, had several embarrassing, offensive mannerisms which added to the difficulty of communicating with him and so

everyone tended to avoid him. I found out that he was a Catholic, the only practising one in the shop besides myself. Since he was my brother in Christ, I set myself the task of conversing with him and going for lunch-hour strolls with him. In the face of all the stares we got, and considering my extreme sensitivity to stares, that took some doing at first. Despite the sometimes doubtful example of charity and patience he set, his child-like, unashamed faith was a pleasure to observe. There was the time, for instance, when a 300-year-old Pieta we were framing inspired him to mime for me in front of the others the whole of Christ's Passion. My deliberate cultivation of Mr. Noolan's friendship really bothered Mrs. Pollock. Since the charity angle was incomprehensible to her, she could only suspect an ulterior motive, namely, that I was after the trade secret of cracked gesso Mr. Noolan worked at!

Each summer the whole shop simply closed down for four weeks paid vacation and I decided to visit Ireland. As soon as I arrived in Dublin, I ordered a hotel room by phone and was walking toward it, suitcase in hand, when I chanced to notice a little sign in the window of a private house offering bed and breakfast at only a quarter of the hotel rate. My old Kurelek stinginess got the better of me, so I turned in there and took the room. However, I wasn't going to get away with it that easy. My conscience went into a paroxysm of scruples about having betrayed the hotel. I even knocked on the door of a church presbytery and asked a priest for help. It was some time before he managed to calm me down.

The next morning I was glad I had dropped the hotel, for I found myself sharing breakfast at a big round table with an assortment of characters straight out of James Joyce. My overall impression of Dublin was of greyness and decay plus economic depression. The sun didn't come out once in my week's stay there. I'd gone over to see what it was Father Lynch and others were always raving about. That trip convinced me the Irish are incurable romantics. Granted, there was a lot of dishevelled green about but it didn't look emerald to me. Everywhere there was that abandoned, gone to weed look.

But there was one bus excursion that did make an impression on me – a whopper of an impression like that experience I'd had in the ball park in Edmonton. It couldn't have been B. M. R. I'd been off the tablets since coming to England. The trip was to Glendaloch, to the ruins of an old monastery nestled in a valley. I noticed the feeling coming on me when we were still an hour or two away. It had something to do with the wind. It was rippling a field of green wheat and a line of evergreen

trees beyond it. It was picking up in strength. Seeing it chop up the surface of a water reservoir as our bus passed by got me even more excited. By the time we got to Glendaloch, the lush valley and the hills dotted with low bushes seemed to be in a frenzy. All the trees resembled blown heads of hair. I was in sheer ecstasy and, because it was a state of soul that demanded physical abandonment, I climbed a nearby mountain, pushing through the lush vegetation which was dripping moist from the fog that now and then dragged itself across the top of the valley. Even as the spell wore off with the dying of the wind in the evening, the heather covered hills to either side of our home-bound bus quietly took up the refrain.

That fall, back in London, I joined the Little Club, a Catholic group which met in a church basement in Soho Square. Now I could try out the dancing lessons I'd been taking all summer. This was part of my program to live a rounded Christian life. I knew by then that being Christian was not the same as being puritanical, that is, wearing a long face and spurning all pleasures. The comprehensive Christian attitude to the world is to spurn the bad – enjoy the good – moderation in all things. It is obviously healthy to practise some self-denial, even of good things, otherwise one gets morally flabby. But to spurn the good things in life completely is really an insult to God for He made them and gave us appetites for them. Wine, friendship, dancing, joking, sports, sex, and so forth, are good things. Since a normal life for most Christians is to marry and raise a family, the least I could do was to get out of my introverted shell and meet the opposite sex. Even if it didn't lead to marriage, the experience of getting along with women on a social level was still healthier than living in daydreams about them, as I had with Natalie.

I have never been happier with any group of people than the Little Club. Just as soon as I came down those church hall stairs and sat myself down to watch the dance in progress, a young lady came over to introduce me to some of the members. It was, in fact, their policy to make newcomers feel at home. I found myself meeting representatives of every nationality, English, Irish, Indian, African, Spanish, Italian, Chinese, Polish, Russian. There were different sections of the club to suit just about anyone's interest – the social, the catering, the Catholic action, the rambling group, the drama group. I took to regularly attending the Friday night socials which consisted of talks, games and dances.

What was it that caused such a revolution in my attitude to socializing? I think the key word is charity. In the past I'd been badgered,

coaxed, ridiculed by friends, ostracized, criticized, even threatened by my parents for refusing to go to dances. And when I did go, I was so thoroughly miserable I was a kill-joy to others there. Here there was a difference, a vital difference, because I knew a seriously practising Christian is bound to try and like the other person. I'd always been afraid my dance partner would dislike me. Alas, it was often all too true. But at the Little Club I found the girls, almost without exception, easy to get along with and kind. The only time I felt something missing was on the club rambles into the countryside. It bothered me to see them walk right past all that beauty, busily chattering on about city subjects. I found no one to commune with about nature, and so I was lonely even among friends.

I was attending evening school as well, two nights a week. One class was in picture framing, the other in cabinet making, both at Hammersmith School of Building Crafts and Arts. For a short time I dipped into book illustration too. I became friendly with the instructor and he invited me to his flat for a party. I hardly remember the party, but while there he let some of us look through his hobby – a microscope. In my life, especially in recent years, I've been moved by the grand beauty in nature, sunsets, mountains, the northern lights, the evanescent play of sun and wind on water. But here, in these slides, I was seeing it on the microscopic level. It was so startling it gave me the shivers. One or two, of corals from the bottom of the Caribbean Sea, had me quietly weeping. What possible evolutionary reason could there be for this hidden beauty down there? It's too dark down there, the forms too microscopic, the fish too blind and stupid to appreciate it. The only possible answer, once again, is that the Creator can't help but create beauty in His own image. If man's senses are often too blunted by over-familiarity, at least the angels in heaven are there to glorify Him for it, for they see it all.

Toward the end of my stay in England, I had begun to date some of the girls at the Little Club. I saw that as a sign I was at last mature enough for marriage and a wholesome physical relationship with a woman. Another sign, which had come some three years earlier when I was taking the Catholic correspondence course, was that I'd given up masturbation. I had chanced on it by accident in bed in Manitoba when I was about thirteen. It got a firm hold on me, rather like alcohol or a drug addiction, giving temporary uplift. But it's also deceitful like drink, for there would follow a hangover – a sickening mixture of inferiority feelings and guilt. I'd had no moral teachings on it whatever and for a while thought I was the only one in the world doing it. Nevertheless, my

conscience told me it wasn't right or normal.

I definitely had more self-respect, even pride, in periods when I did overcome the habit. The longest period of self-mastery lasted three years. This was when I was under Natalie's influence. After her rejection note, I managed to hold out another month or so, but in those black days in the Ford Hotel in Toronto, my morale fell so low I gave in. That, of course, only served to push me even lower. I was also able, in periods of intense physical activity, like those at the lumber camp, to either control it or do without it at all. I took note of that because I was grasping at every possible defence against it I could find. I made self-improvement charts, I gave myself rewards, I went for brisks walks, I recited vows, I even tied a handkerchief over my eyes when having a bath. It was because of my struggle with masturbation that I became a teetotaller for a while – I knew I was a sitting duck for alcoholism in my chronically depressed state. And masturbation, unlike alcohol, is at least free. Still later, I thought talking the problem out with doctors would help. At least one of the psychiatrists at Maudsley advised me not to resist, so, by the time I reached Netherne, I just didn't bother resisting anymore whenever the temptation came.

Finally, having left the hospital, about the time I was studying the Church's attitude on sex, I noticed I wasn't masturbating anymore. How long would this last, I wondered. To my amazement, I had no further problem and after my reception into the Church the sacraments of Communion and Confession were added to buttress my defences. After all those years of failure, I repeated over and over to myself, I had finally beaten it. It was too good to be true. Sexual temptation still came and in a way I was glad it did, for it showed I was normal. But I didn't need to fear it anymore because I was able to put it aside in a matter of fact way as something reserved for marriage.

* * *

Seven years of my life had now passed in England. Partly because of the E. C. T. , when I lost my memory for a while, the time span appeared even longer. I had visited the Holy Land and felt confident that I had soaked up enough local colour to enable me to complete the St. Matthew project I had begun. Now all I had to do was return to Canada, set up my picture framing business, and paint, paint, paint. My brother John, in fact, had written advising me not to return because of an economic

recession, but he reckoned without my new-found faith in God's providence. If he wants me to succeed, He can and will make it possible, I reasoned.

My family and I were glad to see each other again. Relations between us were now very much improved and destined, miraculously, to become even better. They didn't like my actual conversion to Catholicism anymore than my serious interest in it two years previously. Oddly, or perhaps significantly, it didn't so much matter to them that I'd changed my denomination as that I took Christianity seriously and tried to live by it. My mother gave me a lecture one day when I was staying at the farm to the effect that religion was an obstacle to my happiness and success in life. I reminded her that, if it weren't for religion, I wouldn't be alive and moving around in her presence at all. She was obviously stumped for a reply to that argument. But there was no escaping the impression on her and Father that I was just hanging around when, in fact, I was exploring every possible avenue to get that picture frame business started in Toronto. I got literature from Ottawa on how to start a small business. I talked to people already in the business to find the best location for it. The one thing holding me back was lack of capital. The banks wouldn't lend it because I had no collateral. None of my family believed in picture framing as a business and refused to support it. And my few friends likewise either couldn't or wouldn't.

After a few weeks of fruitlessly soliciting help from others it became obvious I'd have to somehow earn that capital myself. It meant, of course, a delay of a year or two in my original plan, which was to start the business as soon as I returned to Canada. Unfortunately, John's prediction of an economic recession proved to be all too accurate and there were no jobs at all except in the teaching profession. I decided to get a permit to teach Latin and history by using my old B. A. degree and taking a College of Education training course. That decision delighted my parents because it seemed to them I was at last coming to my senses after ten years of "bumming around" following my graduation. Father went so far as to try getting me a Royal Bank loan for tuition and living expenses, using his farm as collateral. To both his and my surprise, the bank refused. Undaunted, I applied for and easily obtained an education loan from the government. I moved into a room in a nice Hungarian home on Huron Street owned by Steve and Mary Szombathy within easy walking distance of the College.

But man proposes and God disposes. Crash! Down came the whole

thing. It took about half a year before I managed to pick myself up and understand why it had happened. There must have been some 400 teaching students enrolled that year, but teachers were in short supply so there seemed no earthly reason why I shouldn't be accepted. And I was accepted – for exactly four days. Then a call went out from the Director's office for five of those 400 students to go see him. I was among those five. What about, I wondered. When I entered the office, I found myself facing a panel of four staff members who proceeded to ask me a battery of questions. Then, after consultation amongst themselves, they called me back in and asked me to leave the college. "But why?" I managed to blurt out. They were kind but very firm. "Because you are obviously the sensitive type of person who couldn't take the nervous strain of controlling a class. High school students are cruel – they'll kill you."

I went back to my lodgings in a hurt daze. I promptly returned the government loan. That left me with only two months' subsistence money from my old savings and no prospects of finding a job in time. I reported this unexpected reversal of fortunes to my family when I next saw them. It happened to be some kind of family reunion so that they all heard the news at the same time and were able to express their reaction right then and there. To my surprise, it wasn't one of annoyance with me but of almost tender sympathy. In the past they had not wanted to believe my intuition that I'd be a misfit in the generally acceptable professions. Now, at last, I had in fact tried to do things their way and they could not gainsay the final verdict of the authorities. John in particular, I recall, showed understanding. They left me to help myself, of course, but at least it was a great weight off my mind that after all those years they were no longer against me.

I had no unemployment insurance coming to me because I'd been out of the country too long. I began a systematic canvas of all the picture frame shops in the city of Toronto, asking for work. It was the only official skill I had. And I thought for a while that my former employment with the great Frederick Pollock would, in itself, get me a position. Alas, the Pollock emphasis on quality rather than quantity simply was not as yet appreciated in Canada. After each rebuff I retreated into my room and licked my wounds. The Szombathys helped out financially by letting me repair and decorate their kitchen and bathroom in exchange for two months' rent. And always there was my faith. Sometimes, when it seemed that I couldn't take any more, I would repeat to myself the

words of the Prophet Job: "Even though He slay me, yet will I trust Him."
I used the loads of free time I had on my hands to work on the St. Matthew Passion project. I recall I began the series in earnest on New Year's Day, 1960, promising God I would do one painting a week for three years until it was finished. And almost as soon as I did, cracks began to appear in the apparently hopeless solid wall before.

I should explain here that back in June when I first returned to Toronto, while I was exploring the picture framing business, I'd also asked at several galleries whether I could get an exhibition of my work. They all politely but definitely said no, not interested. All, that is, except one – the Isaacs Gallery. Av Isaacs seemed more interested in my paintings than the frames which they were in. "Could I see you later this year about possibly exhibiting your work?" he wanted to know. I agreed readily enough but after eight years of rejections from galleries, I could hardly be blamed for doubting anything would come of this show of interest from him. Then he appeared at the Reuters', where I was staying for a while, and mentioned March as a possible date for a one-man show. Still I refused to count on it and risk disappointment. A few days after my beginning the St. Matthew series, a tentative job offer came from him. He had a picture framing shop that employed three men but, he explained, that was all he could afford. "However, maybe we could create a market for your gilded frames. Make me up a few corner samples to show to my customers and we'll see if they're interested." He even gave me work for two days, repainting the walls of his gallery. The earnings from those two days came just in time to pay another month's rent. I was down to my last few dollars.

After the corner samples were done, orders did start to come in and he was able to give me work, first a few hours, later a whole day, still later two days a week. I could now buy groceries and pay my rent. Here was sure proof that God provides. At first the young foreman, Emmett Maddox, who jokingly referred to himself as an immigrant from Prince Edward Island, didn't have much to do with me because I was off in a corner, preparing those exotic samples. His main concern was to keep Stan Ross and me apart. Stan was a Belfast Irishman, a staunch Protestant who had no use for Catholicism and was endlessly full of wit and gossip. I would get into theological debates with Stan which would exasperate Emmett and have him calling out, "Break it up, you two. You should have been a minister and you a priest!"

In November, while I was still unemployed, I discovered the Catholic

Information Centre at the corner of Bathurst and Bloor Streets. I had decided to serve the Church with active works of faith as I had in the Little Club in England. The Centre is, or at least was, something like a school where anyone interested could learn about the Catholic faith. Most of the enquiries were from persons planning to marry a Catholic. To keep the classes of instruction going, the Legion of Mary had four groups, or Praesidia as they are called, doing follow-up teaching work. The College of Education's rejection of me as a possible teacher was still hot in my ears and so I avoided the teaching Praesidia and settled for a fifth Praesidium that gave technical and clerical assistance to the other four. I found myself downstairs in the building two nights a week where I worked mostly on the artistic projects such as making signs and displays. I should have been satisfied there but I wasn't. The urge to communicate the faith which had saved me so wonderfully was just too strong. I decided to flaunt the College of Education's pronouncement and join a teaching Praesidium regardless.

The highlight of the Centre's social life was the annual picnic at Beausoleil Island. There'd be swimming, novelty races, corn roasts and community singing, as well as the feeding of mosquitoes by those who ventured on a walk into the interior of the island. I took the cue from that picnic to organize one at the farm: I deliberately meant it to break down still further the barrier between me and my family. I asked my parents if I could have a party for my friends on the high ground between the two ponds. I built a wigwam and made seats of logs beforehand. For the evening itself, I and others at the Centre planned games, sing-songs, even a skit with three Indians to go with the wigwam. I invited Jake Hoday, a jovial, hearty man, to M. C. the whole evening. Then, with my heart beating in apprehension, we descended on the farm in a fleet of eight cars. They spilled all over the yard, these wonderful people, laughing and chatting with my parents, brothers and sisters. Father Stone, the Centre chaplain, came in a cotton jacket, Father Bader, our Praesidium chaplain, in a sports shirt. Everyone contributed his or her act to the gaiety as the camp fire blazed high. My father rigged up a lantern for them, Mother helped brew the tea. I tried playing my mouth organ but it was hopelessly weak outdoors. To add a religious touch to the evening, we sandwiched in some popular Catholic hymns. We had only one near disaster. As the party was breaking up in the dark, one of the cars almost plunged over the pond escarpment. One thing sure, after that evening, Mother could no longer claim that religion was a kill-joy. Success!

They say love is blind. My experience is that the lack of love is blind. There was a certain redhead at that picnic who I simply did not notice. In fact I would swear she had not even been there did I not have a photo in my album which plainly shows her in a dance round the camp fire. She belonged to a teaching Praesidium which met alternate days of the week to the one I was in. The only time the Centre gathered all together was on occasions like the annual picnic at Beausoleil. But toward the end of my first two years at the Centre, a new kind of Praesidium was formed which had nothing to do with regular Centre work. Named Our Lady of the Wayside, it was devoted to rehabilitating prostitutes and dope addicts – a rather brave kind of Christian charity work that I admired. Their group met immediately after ours and many of them would be waiting at our door as we emerged. One of them was this smiling redhead whom I found myself, after a while, beginning to turn and look for. She not only had a charming smile, she was a real beauty too. One winter evening she was leaving the Centre with her friends and I, at the same time, with Bob Owen, a Welsh boy I was instructing. I was in a gayer, more forward mood than usual and ventured to ask, "Say, what's on the tag of that note book you're carrying?" She smiled and offered it for my scrutiny. She was friendly too. "Jean Andrews," it said.

Success in the world was still my parents' ambition for me although, after the Teacher's College episode, they no longer told me the way to arrive at that success. I gathered from my conversations with them that there were four outward signs or criteria which would mark me as a successful man. One, I would wear a hat in winter; two, I'd get a car; three, I'd move out of my bed-sitting room to an apartment; four, I would marry. I was by no means out to fulfill these criteria but I noticed they were being eliminated one by one nevertheless. The easiest one was the hat. Jean started me on number four by answering my note with "yes" instead of a "no" as Natalie had done twelve years earlier. Actually my acquaintance with Jean started off even more normally. Before I decided to approach her for a formal date, I'd had a few dances with her at the bi-weekly socials held at the Centre. I'd romantically imagined I'd meet my mate in some adventurous situation like rescuing her in distress or on a blind date, not as most people do at a dance. The only adventure happened on the very first date. I'd not yet achieved success number two, namely acquiring a car, so I went by street car to pick her up at her place. It was a snowy evening and I noticed I'd missed my stop just as the street car pulled away. The next stop was a dark one at a cemetery gate

which no one ever used, especially on a stormy winter night. "Are you sure you want to get off here?" the driver asked incredulously. "Yes, I'm getting off here," I answered almost in desperation. How could I possibly get him to understand?

Jean and I were married that same year in October at her parish church, not too many blocks from that same cemetery. It was a beautiful Thanksgiving Day. Many of our friends from the Centre attended the wedding, as did my whole family. Jean's sister Joan was the bridesmaid and my brother John was best man. I thought it would be hard to get him into a Catholic church but he didn't seem to mind. I was pleased how well my parents accepted Jean even though she was of British origin. I couldn't get over how I had managed to get such a charming beauty for a bride and my father confirmed my feeling with his statement of wonderment: "She's like a beautiful flower!" The reception took place at the Catholic Information Centre which I and some of my friends had decorated in Ukrainian style the day before. Then we left for a week's honeymoon in Quebec City, Montreal and New York.

I cannot describe our marriage because, for one thing, after fourteen years and four children, that would make a book in itself. I have talked about Jean and now, if I might be allowed a few paragraphs, I'd like to boast about our children. All were born at inconvenient times during the night except Barbara, our second girl, whom we adopted. A call went out in church one Sunday for foster parents and Jean volunteered. Since she'd been a public health nurse she chose a baby with a handicap, in this case a heart condition. She was so tiny and black-haired when Jean carried her into the house. The jet black hair is still there but the hole in her heart has healed over naturally. She's a prime example of heredity over environment, a distinct, self-assertive personality. The others wore out the knees of their trousers in the crawling stage. Barbara wore out her bottoms for she slid around on her behind till she walked.

Cathy was our first born and was even tinier than Barbara when she was delivered at St. Joseph's Hospital. She had her mother's winning smile from the very beginning. She gave Jean the most worry, unfortunately, having inherited allergy tendencies from both sides. That's why I've been hearing at least once a day for years, "Cathy, have you taken your hayfever medicine?" But she's the scholar of the family and is going to high school at Notre Dame girls school.

Steve is the only redhead, oddly enough, although there is red hair on both sides. I found out I had it on return from a trip to India where, in six

170

weeks time, I grew a sizeable beard and to everyone's surprise, it was reddish. He is slight in build like Cathy and a dreamer. But, I'm so glad, not as I was, an asocial dreamer. In fact, on our street, he's the gang leader, the man with the ideas and the gall to organize the others to carry them out. Tommy, our youngest, like Steve, is also an avid hockey fan. He was the closest to me as a toddler and would crawl up on my knees while I worked at my paintings on the dining room table. Eventually he grew a mass of golden curls, but for a long time as a baby it seemed he might stay bald for ever. He's the most home loving of the children, a simple, good soul.

The children had begun to arrive by the time we settled into our first apartment on Evelyn Avenue. I was now a full, unqualified success. Just two months before our marriage, I'd also bought a new Volkswagen bug which my sister Nancy nicknamed "Sweet Pea." But fulfillment of my parents' concept of success in no way could be classed with the astonishing success which God had granted to me in my career as an artist a year and a half before. Av Isaacs and I had managed to get together enough of my paintings to form a one-man show. A good third of them were loaned by friends and relatives (not having been able to sell, I had been giving my works away.) Being entirely new to the game, I had a lot to learn about such things as brochures, previews, newspaper reviews, refreshments, commissions, reserves, sales, dealer-artist contracts. Av, in fact, arranged for me to have not one but two openings, the first for a Jewish women's organization. Ironically, it was the Jewish community that first discovered and patronized me, followed hard on by the Anglo-Saxons; the Ukrainian community became seriously interested in my work about four years later.

Finally, the big day arrived. The show was an immediate success both in sales and in critical reviews. Not only had my financial worries suddenly vanished, I just couldn't get over the excitement and interest the show seemed to generate. Standing there in the midst of the crowd on both opening nights, I couldn't believe my eyes, ears, nose, anything. I had a distinct feeling of unreality. "It can't be my pictures these people have come to see – must be someone else's!"

That feeling of unreality was to cling to me for several years longer. It was even more pronounced when the Ontario Art Gallery sent a taxi to pick me up to meet Mr. Barr, the head of New York's Museum of Modern Art. He had just selected my painting, "Hail Storm in Alberta," for its permanent collection. It persisted when, at the opening of a show

171

I did in honour of my father, Mrs. Pearson, the wife of the Prime Minister, appeared and was introduced to him. I had to smile at the conversational *faux pas* my father made. I guess he was somewhat flustered. He confided to me later, "I never thought a great lady like her would pay attention to us." He was talking about our education with her. "Yes, I tried to raise my children well, and so I was concerned about the bad influences of Winnipeg when I sent my kids there to school." Now Mrs. Pearson happened to have been raised in Winnipeg herself, being the daughter of a doctor practicing medicine there. "Oh, I don't know about that," was her half-amused but gracious reply. "My father was pretty strict with us children."

A big and pleasant surprise was that both my parents, and often other members of the family, came out to my show openings, starting with the very first one. Privately, however, it was some years before my parents became fully convinced that this might be my vocation for life. My mother put her doubts about my success in a nutshell with a remark she made from time to time: "It's alright – but will it last?" It was somewhere around 1967 that my father came right out and admitted he'd made a mistake about my vocation. This was after seeing me on television describing my early struggles. "Back in those days I had no idea really what art was all about," he explained. I, myself, had matured enough, especially in Christian patience and charity, to be able to put myself in his position: He had never known any art more sophisticated than the grocery store calendars that had decorated our walls back west and even in his native village.

Here, by the way, was another prime example of God's wisdom in allowing suffering and evil. Had I become successful during my atheist days, I would very likely have gloated as vengefully as some famous artists in the past have done and I could well have become impossibly conceited. I was ever so lucky to arrive at the understanding, before my breakthrough to success, that I could not paint a single stroke if God had not given me the talent and the means and the drive to do so. It doesn't make sense for an artist to boast, "It's all my own work, I deserve all the credit." Even on the natural plane, in terms of history, no artist can be sure of immortality. Only time proves that – about two hundred years – long after the artist is gone and no longer there to bask in the glory.

But the acclaim that God blessed me with, from both critics and general public alike after a while made me think that perhaps I might

172

really have something of the true artist in me, significant enough to stand out in my lifetime at least. If this was indeed so, then I had to settle in my mind the direction of my work. Fundamentally, I saw life in religious terms, my art in terms of a vocation, a calling by God to serve Him in a specific way. It wasn't that I didn't enjoy painting nostalgic pastoral themes drawn from my farm experiences. It was simply a case of my having a sense of urgency about producing socio-religious messages in paintings. In fact, by the time my second show at the Isaacs Gallery rolled around, I was quite aware there were now two main streams in my subject matter.

I even began to wonder whether Av Isaacs, a professed agnostic, was really the right person to represent my work, despite all the good he'd done for it. There was no Christian gallery in Toronto at the time, so I made a special trip to Montreal seeking one. I dropped into the Montreal Museum of Fine Arts and had a rather long talk with the director, Dr. Evan Turner. "There's no such gallery here either," he said in answer to my problem. "My advice is to go back to Av Isaacs. At least with him you'll have a chance to preach in the market place. What's the use of preaching to the converted? That's what will happen if you retreat into the cloistered security of a specifically Christian gallery."

When others urged the same I decided to do both kinds of paintings. The pastoral ones are just as important because they gain a much wider audience than my socio-religious comment paintings would do. But the church is not my patron. It's a poor customer these days and rightly so, spending its money instead on the salvation of souls and the bodies of the needy. And because it doesn't buy from me, it doesn't dictate or suggest what I paint. I choose the subject matter myself. Abortion, the plight of the underprivileged countries, social injustices and moral pollution are just some of the subjects I feel strongly about. Sometimes these paintings are displayed every second show, sometimes every second painting within a show. Perhaps someday, when I'm completely financially independent, the two themes will become married as they are in a big painting which was bought by the Canada Council called "The Burning Barn." As the title suggests, it's a pastoral scene but, on second look, the pastoral element is really a matrix for my personal concern about the decline of morality in North American society.

When I do moralize—either subtly as in "The Burning Barn," or overtly as in the abortion paintings—I do so in the belief that it would be dishonest for me to simply produce art for art's sake. Our moral decline is

bound to lead to nuclear war and political tyranny during which most of our art may well be destroyed. What's the use of painting beauty if that beauty is soon going to be lost anyway? The logical thing for me would be to turn to actually preaching the good news Gospel of "repent and be saved." But it's obvious that if God had meant me to be a preacher He'd have given me a talent to avow, not paint. So all things considered, it seems that I'm doing what I'm supposed to be doing. Paintings may not have nearly the power to convert people that the printed or spoken word or even films have. But each believer has his or her role to play in the drama of mankind's salvation – some just a few lines, others whole pages. To refuse to play a role at all is not the answer. In the divine economy, no good that is done is ever lost. It may seem so to human eyes but later it will surface to good effect, sometimes in a most surprising way.

Five years ago, Jean and I were in Britain for an exhibition of my paintings in London and Edinburgh. While there, I showed a film which had been made about me called "The Maze" at Maudsley Hospital and spoke briefly on it to the hospital staff. I really appreciated that opportunity, for it enabled me to see the enormous distance God had helped me travel in the twenty years since I'd been a patient there. Jean joined me and the staff for dinner in the canteen afterwards and charmed everyone, including Margaret, who had come to see the film for the first time. I was also invited to show the film in Edinburgh by none other than Dr. Carstairs, the one doctor I had really liked. Jean and I were invited to stay at his home and there he showed me an article he had written about me, which I quote:

> A few years ago, the writer had occasion to treat a self-taught Canadian painter, whose pictures showed certain affinities with those of Bosch, except that where Bosch was obsessed with the imminent destruction of humanity, this patient was for a time preoccupied exclusively with his own tortured ruminations, his own nightmarish fantasies and his sense of being trapped and helpless.

> He depicted these feelings eloquently in a series of paintings, particularly in one entitled "The Maze" in which he drew his own prostrate form with his skull open to reveal a maze, enclosed with no escape.

> Bosch, if one can judge from his work, never ceased to be tormented by his acute awareness of the peril which threatened mankind. His

favourite image, to be found in many of his works, is the owl which represents human folly.

Where, I wonder, is the contemporary artist who can turn his innocent eye upon the nightmare realities of this era with its threat of nuclear annihilation? We need a Goya or a Hieronymous Bosch today to quicken our sense of urgency of the human predicament before it is too late.

I doubt whether Dr. Carstairs was aware at the time of my Doomsday themes, but you'd almost think he was. Yes, it would appear I am his man, except that he and I are poles apart on the solution, he having no use for the Christian world view. On the other hand, not even all churchmen accept my artistic premonition of approaching cataclysm. Some think and say openly that I'm crazy. What can I do? It's there. I make no pretence to be a prophet or to predict the exact date as some of the Adventist Sects do. I take refuge in the general knowledge that intuition and vision have always been legitimate sources of creativity for poet and painter. Even if the vision is manic, as in the works of Goya, Bosch, and others, the world accepts their right to the expression of it. No one is forced to act on it—a picture is democratic. You look at it and if you don't agree with the sermon therein, you leave it behind when you walk out of the gallery. But the signs are there for all to see: nuclear weapons stockpiles, the increasing violence in the world, the rapid erosion of authority, the increasing poverty of the have-not nations, the moral decay of the affluent west. All these point to some kind of explosion.

People can walk away from my pictures or my talks free to agree or disagree, but I have no such liberty and I have to suffer for it. My wife says I am unhappy because I'm too much of a perfectionist. Perhaps. But to my way of thinking, most of us professed Christians have dozed into a kind of spiritual torpor brought on by creeping materialism so deep that nothing but the eventual crash of the whole material structure will arouse us. The whole of secular society, too, appears in my "crazy," manic vision to be like the prodigal son who has taken leave of the Father and gone off to enjoy His goods in his own way. And as in the parable, there seems to be no way to persuade people to come back except by letting them find out the hard way that it won't work.

People insist on thinking of me as a pessimist and I insist with equal emphasis that I'm not. I'm not a pessimist because I believe the story of my comeback to normalcy and success will dispel still further the social

175

stigma that lingers on about psychological illness. I believe those who suffer mentally, both in hospital and out, will take hope from the fact that someone like themselves – a real person with a real name – did eventually recover. Not only it is possible for them to recover, it is possible to take advantage of and put to work the suffering they are going through.

And I'm not a pessimist because I don't believe the coming holocaust will be, by any means, the end. Man is not the boss. He will not wipe out the world on which he lives. It is God who will end the world when He knows its purpose has been fulfilled. That purpose is a happy one: the population of heaven with souls who want to share existence with Him for all eternity. For me, getting in with that crowd is all that matters really. We see only the underside as yet of the tapestry God weaves and so we can't make out the whole pattern of the human predicament. What I am sure of, however, is that I am not really alone anymore in the rest of my journey through this tragic, puzzling, yet wonderful world. There is someone with me and always has been. And He has asked me to get up because there is work to be done.